OBJECTS OF GRACE

OBJECTS OF GRACE

CONVERSATIONS ON **CREATIVITY** AND **FAITH** BY **JAMES ROMAINE**

Square Halo Books

First Edition 2002

Copyright © 2002 Square Halo Books
P.O. Box 18954, Baltimore, MD 21206
www.SquareHaloBooks.com

ISBN 0-9658798-3-6
Library of Congress 2002105651

Printed in Korea

AN ACKNOWLEDGMENT OF **GRACE**

The evidences of God's grace are everywhere around us. Too often we fail to see or recognize this grace because we live in a fallen world and look with human eyes. God's grace, evidenced most profoundly in Christ Jesus, can be part of our lives through the relationships He enables us to have and the creative expression of which we, as artists and viewers, are capable. In her book *The Mind of the Maker,* Dorothy Sayers contemplates what it means when God says in Genesis 1:26 "Let Us make man in Our image, according to Our likeness..." The clues to the answer, as Sayers points out, are found in the question and in the words "Us" and "make." That we are relational and creative beings seems to be what it means to be in God's "likeness." These two things, relationships and creativity, are the subject of this collection of conversations between myself and some of the artists with whom God has brought me into relationship.

In 1999, I was asked to edit a membership directory of Christians in the Visual Arts (CIVA). Part of that task was to recruit artists to represent their work in the directory. Through that process, I was privileged to meet Tim Rollins and his collaborators K.O.S. (Kids of Survival) who allowed their work to be the cover of the directory. Knowing that not all of CIVA's membership would be familiar with their work, I did an interview with Tim Rollins and K.O.S. members Robert Branch and Nelson Ricardo Savinon. Around the same time, I was working with an organization in New York called the International Arts Movement and its director Makoto Fujimura on a project entitled "Art as Prayer." Tim, Mako and myself co-curated an exhibition by that title and printed a small pamphlet including my interview with Tim and one with Mako, both of which are included in this collection. The success and momentum of "Art as Prayer" led to more conversations with a wider circle of participants culminating in this text.

This collection of conversation represents the hard work of many people. First, I would like to thank Tim Rollins and Makoto Fujimura for their friendship, support and encouragement through "Art as Prayer" and in this project. I am also grateful to the other artists Sandra Bowden, Dan Callis, Erica Downer, Ed Knippers, Mary McCleary, Albert Pedulla, Joel Sheesley, and John Silvis who willingly sat for conversations and sacrificially took the time to review and edit the results. I would also like to thank Ned Bustard for his generosity and

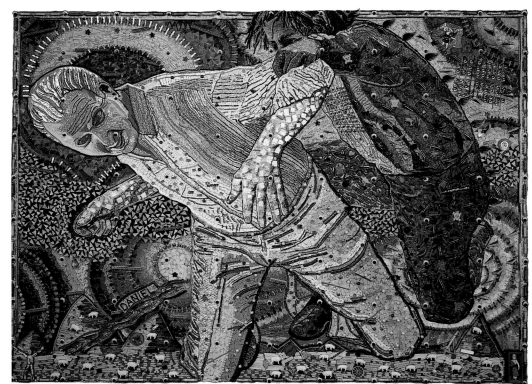

COVER and RIGHT
Gabriel Being Detained
by the Prince of Persia
Mary McCleary
Mixed media collage on
paper, 45" x 59.5".
Collection of Edwina
Hawley Milner & Charles
Porter Milner, Santa Fe,
New Mexico.

everyone at Square Halo Books for their unwavering support of this project. Peter Corriston and Vito Aiuto not only encouraged me with their friendship but assisted me in parts of "Art as Prayer" and *Objects of Grace*. Finally, I would like to thank my family and especially my wife Susan for giving so much of herself, and giving up so much of my time, to see this project through. I thank not only each of them for being evidence of God's grace in my life but I acknowledge and thank Him for His mercy which they represent to me.

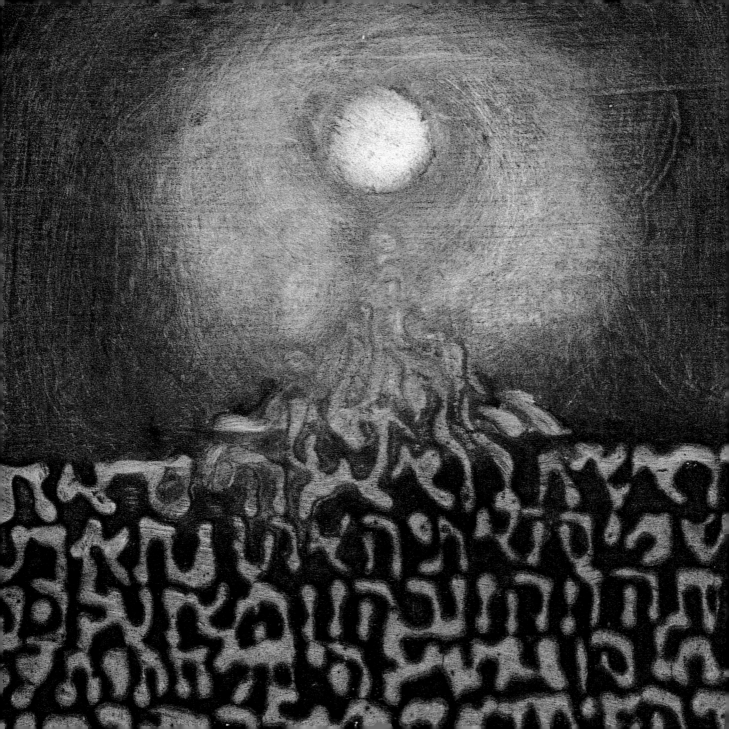

CONVERSATION WITH **SANDRA BOWDEN**

October 2001

James Romaine: I want to begin by reading a statement that puts things pretty boldly, "Western art was Christian, is Christian and for the foreseeable future, can be only Christian, we cannot evade the Gospel's continuing presence in our culture. Their meanings, their imagery, have determined the way we think, the way we create." Let's discuss the last sentence first; how has your faith determined the way you create?

Sandra Bowden: My faith affects who I am; it governs my whole thought world and imagination. I believe we were created with a need to communicate which is manifested in the impulse to create. I can't fathom not being an artist, or what my life would be without the presence of art to enrich every corner of my existence. I have never felt that my faith stripped me of the freedom I needed to pursue being an artist. As an artist, my faith has given me the freedom to search and to explore. This rich spiritual life has enhanced my work as an artist. Many Christian artists struggle with the question, "Is what I am doing worthwhile?" This was never a problem for me. Being created in God's image, as a creative being, what could be more natural than to be an artist? Art is an extension of Creation, what the Russian philosopher, Nicolas Berdyaev, called "the eighth day of Creation."

The statement I began by reading was by Bryan Appleyard in the Sunday Times *of London in a review of the exhibition* Seeing Salvation: The Image of Christ *at the National Gallery, London. What did you think of that show?*

SB: Although I wasn't able to get to see the show, I have read the catalogs. What struck me most profoundly was why the show was conceived. Neil MacGregor, Director of the National Gallery, found that visitors to the museum, most of whom were not believers, were nevertheless gripped by the imagery of Christianity. Their interest in the work was not in the formal elements, those qualities that the Modern critics have focused on, but rather in the stories behind the images. He found that many of the visitors did not know the Biblical narrative, even the story of Christ's baptism, and therefore struggled to understand the meaning of a work such as Piero della Francesca's *Baptism of Christ*. Since about one third of the works in the National Gallery represent Christian subjects, MacGregor wanted an exhibition that would emphasize the narrative aspects of these works. Initially, he had resistance to mounting a show of this nature; however, the exhibition proved to be a blockbuster. I think that demonstrates our

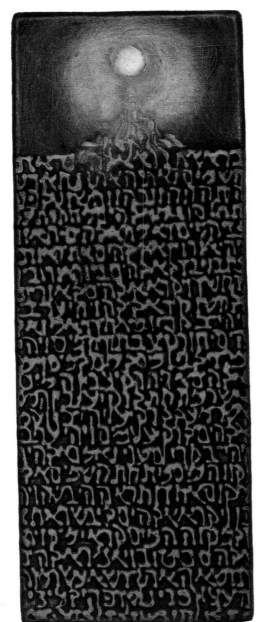

culture's hunger for more than just "the spiritual" but a substantive source of meaning which Christianity offers.

The exhibition seems to have made the case that, as Appleyard noted, Western art has been dominated for the last two millennia by Christianity. Would you agree with that assessment of art history?

SB: Well, I'd love to agree with that. I know that there are many who would be irate at Appleyard's statement. Some would point to Greek and Roman culture, certainly two important forces, as the foundation of Western art. However, no one can dispute that Christianity has influenced the visual arts over the last two millennia more than any other single paradigm. The Christian tradition has provided artists with compelling subject matter and a strong patronage base. What I think Appleyard is getting at in this pronouncement is that Christianity has framed and guided Western culture, our values, our traditions, our social and legal structures. We rediscovered this profound influence again after September 11th, 2001 when it became politically correct to pray and talk about God. It was evident that Christianity still existed at the deepest core of our society.

Observing the long history of art and Christianity that* Seeing Salvation *represents, Appleyard concludes, "From the persistence of the images, one can only conclude either that Christianity is true or that it possessed some special genius. No other religion is so humanly accessible and so imaginatively available." Outside the question of patronage

**PREVIOUS
and RIGHT**
In the Beginning was the
Word 1980, collagraph,
30" x 18" paper

12

O B J E C T S O F G R A C E

by the church, which we can discuss later, why do you think that Christianity has been so compelling for artists over the past two thousand years?

SB: Maybe it is the narrative element. Christianity is a compelling story of God's interaction with those he loves. The Old Testament begins with the story of creation and continues with the history of God's people. The New Testament portrays the life of Christ and chronicles the beginning of the church. Some of this special genius has to do with how these powerful stories carry and create images in the mind; if you listen to a story, you recreate it in your imagination, you internalize it. Therefore, the Biblical narrative has driven two thousand years of art. The church, for centuries, has commissioned works of art as a way of telling the story. The narratives and characters of the Bible carry meaning which can be applied to every generation anew. The artist reinterprets these stories in ways that reflect their present resonance. Herein lies the challenge for contemporary artists.

The Incarnation has also probably played an important role in the formation of a Christian art. There is no other religion in which the deity becomes a human being with a dual nature as fully God and fully man.

SB: When Jesus came to us in human form the prohibition against creating a likeness of God was lifted. Because God was made visible in Jesus we are free to image creation and the creator, to retell the story of God's continued work and presence in our culture.

Art is an incarnational activity. Madeleine L'Engle described the artist as a "birth giver." She explains that an idea comes to the artist and asks her to give flesh to it. Like Mary, the artist responds to obediently accept the responsibility of carrying this idea to term giving it material form. The artist is a form giver, one who gives flesh to an idea. Giving birth involves: conception as the idea comes to the artist; gestation as it begins to take shape inside the mind of the artist; labor in the struggle to make it take shape; and finally birth, a finished piece.

The work of art, in turn, gives birth to an idea in the viewer's imagination. Is it an ongoing process of making the invisible visible?

SB: That's it. The role of the artist is to portray what the camera alone cannot capture and what the eyes of others do not see. The artist's mission is to help all of us see. Artists do not merely put on canvas what can be seen with our own eyes, but they uncover for us something we have not observed, or have only imperfectly realized. The artist does not deal with things just as they are in themselves; science does that. Art is not merely illustration, but the illumination of unseen realities. Paul Klee said that "Art does not reproduce the visible, rather, it makes visible."

Yes, he said that in an essay entitled "Creative Credo" in 1920. In that same essay, he also said, "Art plays an unknowing game with ultimate things, and yet achieves them!" But before we get too far away from it, I'd like to discuss the second half of Appleyard's statement, namely that Western art is and for the foreseeable future, can be only Christian.

This is perhaps a more difficult case to make. For example, **Seeing Salvation** *only featured the work of one living artist, Mark Wallinger. What do you make of Appeyard's prediction about the continuing impact of Christianity on art?*

SB: I don't think Appleyard is saying that everyone will be a Christian, but rather that western culture cannot move too far from its Christian foundation. We can't always see this in our culture, but it's there deeper than many would like to admit. Certainly many issues in our culture create a powerful resistance and tension. But the whole idea of human worth, the concept of human dignity, is rooted in the notion that we were created in God's image. Western culture embraces this concept. *Seeing Salvation* showed us an historical record of how deeply Christianity penetrates and how widely it has and continues to permeate our culture.

In the New York art world where I live and work, the art world one sees in **Art in America** *or* **ArtForum,** *Christianity seems to be on the short list of things that it is politically correct to deride. Do you see that, and how do you respond to it?*

SB: Sure, there are many in the art world who will have nothing to do with Christianity. The prevailing view in the arts community embraces the use of religious symbolism and imagery only if it questions its own validity. Artists coming from a sincere position of faith are viewed as suspect.

To be part of the contemporary art world doesn't mean we have to set the agenda, but I hope that Christians will be given a place at the table, allowed a legitimate voice in the discussion. If we are to be engaged in the cultural dialogue, the artists of the Christian community must continue to produce work so compelling it cannot be ignored.

Appleyard suggests that we are at a crossroads in our cultural life and the way we deal with "content." He states that Modernism's "heresy was formalism," which suppressed content. But interest in content is on the rise, even for secularists. Is this an opportunity for artists of faith to impact the direction of art?

SB: It is indeed. I believe that, as Christians, we have much of substance and meaning to share and celebrate in our work. Artists whose creativity is rooted solely in themselves or "self expression" have found their confidence shaken. The challenge for artists who are Christians is not to settle for sentimentality but rather to draw from a richer and deeper source to fuel their imaginations. It is time to reengage the idea of truth and beauty, and by beauty I don't mean pretty. Leon Alberti, the most important art theorist of the Italian Renaissance, said, "Without beauty, God cannot manifest Himself." The challenge to the artist whose creativity is rooted in faith is to find inventive ways to show forth this beauty and meaning in their art.

How does your work engage this meaning?

SB: I have always been interested in the powerful mystery of language and words. Written language is a pictorial system of shapes that we call letters, grouped together to form words, which have in turn enabled us to share complex ideas across the barriers of time. Individuals perish, but written words communicate from one generation to another. These writings connect us to the past, convey meaning and share ideas across the barriers of time. I hope that my art has added to the contemporary conversation an appreciation of the sacred writings of the past. As I have literally collaged these ancient texts into the picture plane of my work, I have also attempted to have these words give associative meaning to other elements in the piece. It is important that we see ourselves in relation to the ideas of past generations, find comparisons, and draw from that wisdom.

Like the written word, art is a visual language which makes us privy to ideas across time and which is the same language artists depend on today to communicate meaning. How does your work engage the art of the past, these images that have crossed time and are now part of our present?

SB: I have been attracted to the artists whose work demonstrates a strong sense of design, artists such as Robert Rauschenberg, Robert Motherwell, Antoni Tàpies, Georges Braque or Pablo Picasso. The way artists have divided space and, of course, the innovative use of collage has been an important component of my work. Also, Medieval illuminations, from an ear-

lier time in the history of art, with the delicate beauty and sacred quality that permeates these holy manuscripts has been a source of inspiration for some of my work.

As you are preparing for an upcoming retrospective of your work, it seems an appropriate time to think back over the themes or issues that have persisted throughout your career.

SB: I have come to realize that an artist builds a life's work by following the art itself. Each creation reveals another question or uncovers a new direction that in turn gives birth to the next work. It is important to trust the work; the work is always a little bit ahead of me and it pulls me along. The process of art making is a great teacher. If I follow the work, the results are richer than if I undertake to control the outcome.

Reading and seeing, image and text have provided a rich well of materials from which I have drawn my inspiration. In 1966, I constructed a collage entitled *Inscribed,* and in retrospect this seminal piece contained the seeds of everything that would flow from my hands. Fabrics were applied to the surface and a section of calligraphic impressions added textural interest. This piece initiated a series of very abstract collages that found their inspiration from archaeological finds. Then, in the mid 1970s, I became serious about studying Hebrew in order to use biblical texts more specifically. In 1978, I started making collagraphs, a kind of printmaking in which collage elements are adhered to the surface of the plates; a natural extension of my textured oil paintings. Several years later I completed a suite of collagraphs relating to ancient

biblical tels. From there I turned to collage constructions on paper using segments of previous prints. Each of these changes in direction was a means to more fully explore the relationship of word and image.

Much of your work deals with the relationship between word and image. Christianity is a word-based faith and, despite what we saw in Seeing Salvation, that has created a contentious relationship with images. How do you put the two together?

SB: I came out of a tradition in which the Word was central. This tradition holds firmly to the belief that God's Word is the Bible, alone, and clear answers to all of life's questions could be found in these words. I am thankful for the rich tradition of Bible study and encouragement to know and revere God's word, but I sensed there was more to the picture than black and white theological cognition.

My spiritual journey has awakened me to the power of mystery, a realization that all is not fully understood and we only get a glimpse of the truth. As I studied Hebrew and archaeology to mine the scriptures more profoundly, I came to see that the Word was not just written in a book, but that Christ was the Word. Here lies the mystery of the gospel. "In the beginning was the Word, the Word was with God and the Word was God... the Word became flesh and dwelt among us." This epiphany brought my work full circle, connecting the Word with the Image of the unseen God.

You have said, "The Word has a power beyond cognitive thought, beyond logic. That's the mystery I've spent a lifetime hunting for in my art, that veiled kind of expression that doesn't explain itself right away." How has that worked itself out in your art?

SB: For nearly forty years, a signature element of my work has been the inclusion of Hebrew texts, compacted by eliminating spaces between words and lines, carefully inscribed, but not intended to be read. The theme or title of each piece usually finds its source from that passage. It is critical for me that the scripture be accurately present; however, it is not necessary that we decipher the words. The textural impact of these sections invites the viewer to look closely and wonder "what is here?" In the mid 1990s, I began gilding these text panels to add another veil and enhance the richness of the surface.

Another obvious device used in my collage process is the layering of one text upon another. My collages often begin by laying down a page from an old Bible or musical facsimile, then adding layers of thin Japanese papers to veil the text beneath the surface. To further enhance this visual exchange, I may add a handwritten script from another source. By the time the work is finished, it is nearly impossible to readily decipher any of the inscriptions. I am interested in that fleeting moment when we catch a glimpse of the truth, or momentarily grasp an association. This glimpse is enough to open the conversation if we are willing to be sensitive and attentive. The Apostle Paul writes, "We see dimly now as through a glass, but then we will see Him face to face."

OPPOSITE
Heavens Declare 1981,
collagraph, 23" x 12" paper

Faith's pilgrimage is like driving at night. We have a long trip to make and the headlights don't reach all the way to our destination, but they illumine the path just enough to make the journey. Art can be one of the lights on life's path.

How does this collage technique relate to the issue of narrative, which, as we discussed earlier, is one of Christianity's contributions to Western art?

SB: Collage was introduced in the early twentieth century as a deconstructive device, but I have used the technique as a way to connect ideas, to build rather than break narratives. These mixed media collages have allowed me to make associations between seemingly disparate elements, develop connections from one source to another, thereby building a more complex narrative. The story of God's presence in our life and world is at the center of each piece I construct.

This narrative is constructed, in part, within the elements of the work but it is only completed in the imagination of the viewer who finally ties all the pieces together. This is an important point for artists to consider. To suggest something to the viewer, allowing them to reconstruct it for themselves is usually more powerful than stating it outright.

SB: Yes. This allows the viewer to internalize the work.

Let's talk about a few of the series you have done beginning with the Text Series, works like In the Beginning and Heavens Declare.

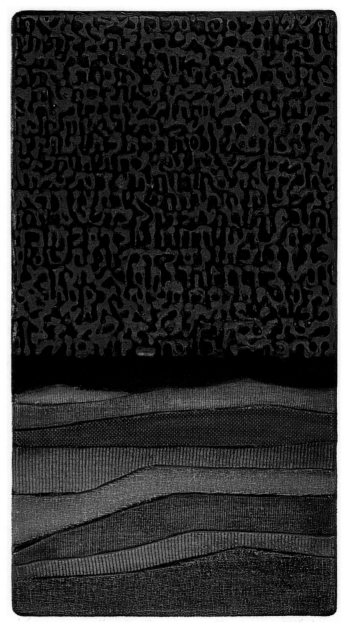

SB: *In the Beginning* was one of my first collagraphs. It contains the Hebrew text from the first chapter of Genesis. The first line reads, "In the beginning God created heaven and earth." The words "God created" rise from the text giving shape to a celestial form. Psalm 33 says that "by the word of the Lord were the heavens made, He spake and it was done," making the connection between word and image, word and creation.

BELOW
Breastplate II
1990, collagraph assemblage, 30" x 22" paper

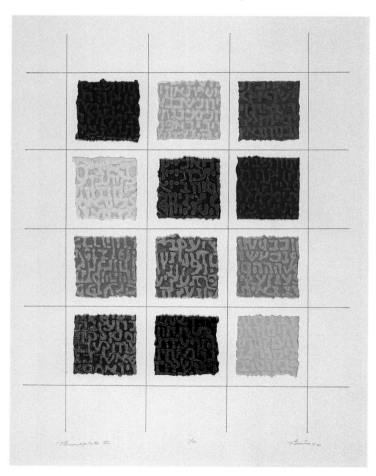

The psalmist describes creation as an inaudible language, a written tablet, understood by all peoples. In *Heavens Declare,* the sky section contains the entirety of Psalm 19 which says, "The heavens declare the glory of God; the skies proclaim the work of His hands. Day after day they put forth speech; night after night they display knowledge. There is no speech or language where their voice is not heard. Their voice goes out into all the earth, their words to the ends of the world."

Like a work of art?

SB: I see the physical world as a celebration by the Creator. In response to the psalmist's reference to the heavens as a language, I filled the sky with the words of the psalm. The text has a rhythmic movement that resembles a night sky. This piece sets up a conversation between the text as the Word of God and creation as a way in which God has manifested Himself. If you look at my work over the last forty years it becomes apparent that it is a visual record of my artistic, intellectual and spiritual journey. Each piece shares insights and offers itself to others in hopes that there are common threads of understanding and inspiration.

If nature is one example of a work of art by which God tries to communicate or set up a relationship with humanity, another, more direct, example is through the Old Testament Law and the establishment of the priesthood. How do you engage that in a work like Aaron's Breastplate?

SB: In *Aaron's Breastplate*, I took images from the Old Testament that implied or designated color. Exodus describes Aaron's priestly garments as made "for beauty and for glory." His breastplate was inset with twelve stones etched with the names of the twelve tribes of Israel. In my interpretation their names are not only inscribed, but also the story of Jacob blessing his twelve sons is encoded into the textured paper. As the high priest wore this breastplate he symbolically carried the people of Israel into the Holy of Holies, where God resided. The breastplate is a rich image, an emblem of Christ, our High Priest as he ushers us into the presence of God. I found this to be a wonderful image of the priestly function.

Aaron's Breastplate *suggest a certain paradigm of creativity. As a work of art that represents the people symbolically, it takes them into the presence of God. How can our creativity be guided by these Biblical examples of creativity and may we say that works of art can act in this way?*

SB: Two examples come immediately to mind which show how a piece of art can be a powerful instrument of grace and healing or usher someone into the presence of God. One is from the thirteenth century when a work of art was an instrument of change in the life of St. Francis. Kneeling before a painted crucifix which inspired his conversion in the year 1205, Saint Francis wrote this prayer, "All Highest, Glorious God/ Cast your light into the darkness of my heart./ Give me right faith, firm hope,/ perfect charity and profound humility,/ with wisdom and perception./ O Lord, so that I may do what is truly your most holy will. Amen"

The second example comes from a letter written to me from a person who had purchased my crucifixion collagraph and experienced how it offered healing. She wrote, "My brother Warren was killed suddenly in a car accident in early July. It seems so trite to say my world collapsed. But it's the bald truth. I hung *It Is Finished* in my living room, and for the next several months I sat and stared at Christ crucified hour after hour. It was common for me to spend entire evenings and many weekend hours as well staring at that picture. I didn't read the Bible; I couldn't study. I couldn't pray—certainly not aloud or even in coherent thought. I just sat and stared. It was the only act of faith I could manage. I could hang on to Christ. Sandra, I want to express to you how much God has used your art to bring me through [that] 'dark nights of my soul,' recurring nights that for me have lasted months and years. God has used your work to focus my attention on Him when nothing else could even get my attention. Meditating on Christ crucified and on the implications of His grace has brought me through to a place of stronger faith and renewed joy."

It must be truly rewarding and a sign of God's grace to see your work used to minister in that way. Let's continue with the Old Testament and Hebrew themes in your work, will you talk about the Tel Series?

SB: Psalm 85 says, "Truth will spring from the earth, and righteousness shall come down from the heavens." I see the physical sciences, such as

geology and archaeology, as a means of unraveling or revealing truth. My *Tel Series* brings together earth, time, and the Word. The tel series depicts the stories of specific archaeological sites in ancient Israel. A tel is a mound covering the site of some ancient city, usually formed by many layers of rubble and artifacts left by successive civilizations. Discovery, new findings, uncovering, and connecting specific finds to the record are the work of the archaeologist. When a site or object is found, meticulously the workers literally brush away layers of dirt to uncover the secret hidden for thousands of years beneath the surface of the earth.

Obviously uncovering what lies beneath the surface is of particular interest to me. Peeling away layers of earth, finding a tablet, stone or artifact connects us to the past and illumines our way as we uncover secrets from another time. These layers of history help us see our own day as a brief moment in the vast chronicle of human history.

Could we think of archaeology as an analogy to how we find meaning through peeling away the layers of a work of art?

SB: Archaeology is certainly a good analogy of how I have searched for meaning. Life is kind of expedition, a journey of experience, knowledge and spiritual insight that offers meaning and light to life. It has been through the creation of art that I have joined life's exploration to find nuggets of truth and beauty.

Can you give an example of this discovery processes and how it impacted your work?

SB: On my first trip to Europe in 1986, I was fascinated with medieval manuscript illuminations and early private altarpieces. Up to this time I had been primarily concerned with contemporary art, so I was somewhat surprised by how these works captured my imagination. I was struck by their intimacy and awed with the luminous quality of the gold surfacing. I began to recognize that the use of gold in these works was a way of expressing the richness and eternal preciousness. I didn't respond immediately by making art, but over time, their impact began to reveal itself in my work. Eventually the illumination series emerged.

After the textural layer of gesso is applied to my illuminations, I alternate layers of paint and gold leafing, then calligraphic gestural marks are scratched on the surface thereby uncovering hints of secrets embedded, forgotten and partially revealed. In scraping away the surface of these works, previous images and text combine the present and the past, innovation and tradition, to reveal a new presence. When I first started doing them, it was so exciting; I became so ecstatic with the pieces that I didn't want to stop working, even to eat or sleep.

My contemporary illuminations are a reverent response to the extravagant beauty of these medieval manuscripts. I was not interested in being a calligrapher, but was fascinated by the exquisiteness of the rich surfaces on these illuminations.

OBJECTS OF GRACE

Was it a natural step then to make books?

SB: I can see that looking back on it, but I didn't anticipate that from the start. But it was a sort of natural sequence. The idea of making art books had been fermenting for some time, when I came upon some book-boxes made for hiding valuables in one's library. It seemed to be a perfect canvas, so to speak, for launching my book making.

Concealing objects inside these books appealed to me as another means of exploring the delights of searching and finding. Perhaps the most important parts of these boxes' covers, and the illuminations, are their sensual surfaces that evoke mystery and preciousness. Little gilded paintings await the seeker when opening one of my books. Inside *Book of the Golden Rule* is a gilded page incised with subtle ruled lines. Opening the *Icon Book* discloses a miniature Russian icon.

The book idea is one that will continue to capture my imagination. I can imagine embedding other objects on the book surfaces, with openings that lead to more surprises.

What about a work like Trinity Book?

SB: I am always searching for ways to communicate the truths of the faith; I wait for those epiphanies when something so apparent becomes new and filled with unexpected insight. It dawned on me that, in three simple symbols, I could explore the theological implications of the Trinity. Three small paintings

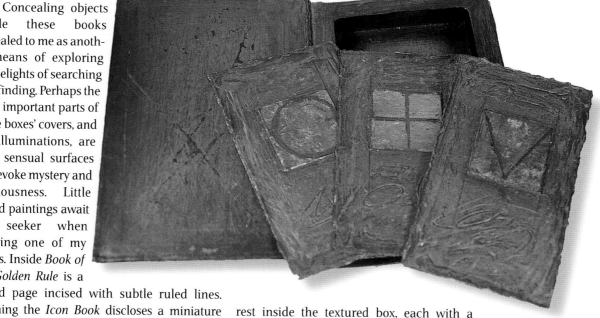

rest inside the textured box, each with a square incised at its center: one contains a circle, a cross divides another square into four quadrants, and in the third a triangle points downward. Visual interpretations help unravel some of the mystery surrounding very complex theological concepts. I liked what Terrence Dempsey wrote for the catalog of "Like A Prayer" about *Trinity Book*. He suggested that

the circle suggested the eternal, as a form without beginning or end; the triangle as a sign of the trinity, three in one; and the square as a symbol of the earthly reality, the season and the four corners of the earth.

Yes, I read his piece. I thought he was correct in his assessment of Trinity Book, *for example the square representing the earthly reality, but I also thought the work could be taken even further by looking at each of the three panels as a different, but particular, member of the Trinity. The circle, the eternal, is the Father. The fact that the circle touches all the sides of the square, suggest His omnipresence. Because the size of the square is defined by the circumference of circle, which because it has no beginning must be the first of the two forms, we are reminded that God is the defining presence of the universe. The triangle, which is pointing down, suggested the Holy Spirit descending; the fact that the top fills the whole length of the square but then it focuses down to a single point implies that the Holy Spirit is all of God, His full infinite length, but compacted so that He can dwell in me as a finite individual. Finally, the cross in the square is the Son, the divine incarnate in the earthy reality. This last one is, for me the most complex, because it connects his Incarnation, represented by the earthly square, with His Passion, represented by the cross. It drives home the point that the purpose of the Incarnation was the Passion; they are not independent of one another. Also, all three panels are part of one work, contained in one book; three in one. As I see it,* Trinity Book *suggests a very complex picture of God.*

SB: It is interesting that many times others see further implications of a work's meaning than the artist knowingly intended.

I guess this is an example of the building of complex narratives you described earlier when we discussed your use of collage. Are you going to be continuing working with the collage technique?

SB: I have worked with collage my entire career. My first important work was a collaged oil painting. Then the collagraphs were built by applying a collage of materials to the surface of the plate. The illuminations and books all used collage. But in what I now call my collage series, I am collaging materials to a paper surface.

These collages began with fragments of previous pieces I had already begun as part of other series, but which hadn't worked out right. By mixing parts and pieces of things, I was able to take these pieces and make them new. Over time I had accumulated a storehouse of exotic papers that immediately enriched the exploration. Now instead of uncovering, I was covering, layer upon layer, segments of Bible pages, musical facsimiles and other written materials beneath the surface of the work. Eventually even old leather book covers, ancient coins, dried flowers, leaves, and even nails found their way into the collages. The response to these have been really good.

What has been the response to your work in general?

SB: I have been very fortunate as an artist in finding avenues for my work. I should note that where my art has found its home has changed

over the years. Early on in my career, when I lived in upstate New York, I participated in regional museum shows, and won a few awards. My work was shown in regional commercial galleries at that time, then, as I began to incorporate Hebrew texts in my pieces, I became recognized within Jewish circles. The Jewish community has consistently supported my art with commissions for synagogues, purchases by Jewish museums, use of my art in its publications, and of course through a circuit of Jewish galleries.

What about the Christian community?

SB: Approximately twenty years ago, the Christian community began to show interest in the work and I have continued to find patronage from churches, colleges and publishing houses. I know that many artists have felt abandoned by the church, but I have always benefited from the encouragement and interest given to me by members of my congregation and the larger Christian community.

Some of this success may be because my work deals with texts. The use of Word within my art creates a kind of bridge for the viewers who have never been exposed to contemporary art. Because of the word content, many Christians, who might not otherwise be able visually to engage the work, have been willing to look at it and have been surprised to discover that they could interpret a contemporary artist's work. I think this holds an important lesson for artists. I'm not saying that artists should compromise their work but we should think about ways of building bridges to our audience. Once

a viewer has crossed that line, their imagination has been set free; then they can engage more and more complex work. As artists, we need to learn how to share our work with humility.

The fact that we need to "build bridges" acknowledges that there does exist today a divide between the Christian community or the visual arts that runs counter to how the Church has historically been a home for visual artists. Why do you think this problem exists?

SB: This is not just a church problem. Our entire society suffers from a divide between the visual arts and the public. The arts struggle at every level within American culture. But turning to the church, Protestantism, which had a founding influence on America, from its beginning has always had a mistrust for the visual. I suspect that is because the visual has more variation and subtlety open to personal interpretation than the written word. Identifying meaning is more immediate with words than with images. Personal interpretation and the impreciseness of the visual has been a little unnerving for the church. The Reformation focused on words. It denied or suppressed our intuitive nature, that part which hungers to imagine, explore and just be, ignoring the fact that we have another dimension that is not swayed by systematic theology.

From the Reformation on, the church has put ears before eyes, viewed art as peripheral rather than central to conveying the gospel, and placed symbol above sacrament. Art has been viewed as decorative rather than substantive.

Have you seen improvements in this issue over the past decades?

SB: Yes, I see fences falling everyday. Many artists of my generation came out of churches where we were not encouraged to be artists. Being an artist was not an acceptable vocation. Thankfully, it is becoming evident that churches are more aware of the need for the arts to communicate the Gospel in new and fresh ways, as well as realizing how the arts can again enhance their worship and community life. There are numerous churches with galleries; congregations are sponsoring arts festivals; arts groups are forming and commissions are being given to artists; denominational publications are using quality art by contemporary artists; seminaries are offering art related courses to integrate the visual and theology; denominations are considering how they can bring to the forefront the work of their artists. The list goes on. A quiet renaissance is emerging within the church in which artists have a lot more freedom and opportunity.

To break down a fence that I often come across, how would you answer the question, "Why do we need art?"

SB: The question presupposes that art is almost a waste of time, a self-indulgence instead of a calling. As Christians recite the Nicene Creed which affirms that we believe in "the visible and the invisible," the artist lives out that creed making visible the invisible. It uncovers something and makes visible something that we otherwise only get a quick glance at. The artist is able to capture that moment in ways that focus our attention more specifically. Art helps us celebrate and offer praise. It can prompt us to think, to explore and work out ideas, to see things we hadn't seen before. We need art because it adds meaning. It seems to me that artists and the church have some common goals.

There is a terrible dilemma in the church's suspicion of art because as soon as we move outside the walls of the church, we are in a world saturated with the visual. I see the church beginning to recognize that it doesn't stand a chance of reaching a generation that has grown up with TV, movies and computers unless it begins to embrace the visual. We have to find ways to bring the arts back into churches and encourage denominations to embrace the arts with imagination.

How can an organization like Christians in the Visual Arts (CIVA) play a role in building bridges?

SB: Its very presence builds bridges. The fact that CIVA has been in existence and growing for more that twenty years means a lot. Artists benefit from the vast network that has been generated and fostered within CIVA. We are the source that people in the church turn to when they have questions about the visual arts. Secular sources seek out our organization for contemporary religious art of quality. We supply information, resources and materials to a wide range of sources. But the greatest resource for building bridges lies in our artists—they are the vital links, strengthened through an association like Christians in the Visual Arts, to reach out to their church and local communities.

O B J E C T S O F G R A C E

How did you get involved with CIVA?

SB: In 1979, I received an invitation to come to a conference on Christianity and art in Minneapolis. When the by-laws of CIVA were adopted at that gathering I remember becoming emotional because, before this conference, I had only met one other artist who was a Christian. I found myself in a room with two hundred fellow artists and believers. That conference changed my life. I cannot imagine the last twenty years outside the family of friends and colleagues within CIVA.

What has CIVA meant to you as an artist?

SB: I've grown artistically, spiritually, intellectually because of the many challenges and opportunities CIVA has afforded me. It has given me friendships that are so deep and meaningful that they are like family. These friends share two of the most central focuses of my life—my faith and my art. It is a rare thing to find such rich relationships that share so much.

What about the problem of the "Christian ghetto?" How can CIVA be a greenhouse, which nurtures vegetation to be transplanted outside, and not a hothouse, which sustains plants which could not be viable outside?

SB: I don't believe CIVA is a hothouse. For one thing we are not together that often. With one thousand and five hundred members and only

about three hundred gathering biennially at our conference I see CIVA as more of a greenhouse. It is CIVA's goal to encourage and enrich those who go out into the world with their art. I think of someone like Tim Hawkinson, a CIVA member who just had a show at Mass MOCA. He will be in the next Whitney Biennial, and has had his work in a recent issue of ArtForum. A lot of artists from CIVA are serving communities that are ignored by the art world but we are also gaining recognition in the established arts community.

Yes, there are a lot of artists of faith who are doing very good work and some are even being recognized in the art world. Almost by contrast, the communities from which many of these artists come are not supporting them. One of the great hurdles facing today's artists of faith is the absence of patronage from the Church or Christian community. What do you think can be done about this?

SB: There is no easy answer to this problem of patronage. I do see some hopeful signs that, over time, we are building a patronage base. The new Catholic cathedral being built in Los Angeles, the Lutheran Brotherhood's collection, and the new collection of contemporary art at the American Bible Society are examples of the church again taking the role of the patron seriously. There are a few serious individual

collectors in the Christian community and more should probably be done to exhibit some of these collections as models for other potential collectors.

We could discuss how these collectors and patrons of the arts are potentially participating in history. I mean, for example, the Seeing Salvation *exhibition, and the history of Christianity in art, would not have been possible without a history of patrons that bought this kind of art. What will a similarly-themed show in the year 2500 look like? If patronage of Christian art in the next two hundred years is anything like the last two hundred years it will be a sorry show indeed. So, patrons who seek out the best possible artist of faith and give them the opportunity to make their work free of financial constraints are making the future of a Christian presence in art possible. The alternative is something like the* Sensation *exhibition which caused such a stir at the Brooklyn Museum of Art. That entire show was the collection of one individual who had decided to be a serious and daring collector and consequently has created an explosion of art in his native London. Christians need to engage in culture and support, and buy, the art that represents the kind of culture they want future generations to inherit. Art is either important or it isn't; if it is important, then it should be supported when it's good but if it's not important, then there is no point in complaining from the sidelines of culture about what isn't any good.*

SB: You are absolutely right. There are some Christians who want to build serious collections of contemporary work. We need to do more to examine and understand what motivates collectors and then nurture that. I have a small collection of both historical and contemporary work and I see myself as a caretaker of that work. If someone doesn't take on that role of caretaker, then the work is lost. We must be participants in gathering the best art, and particularly art coming from a perspective of faith, because, if we do not do this, who will? It will be lost and there will not be a record that faith was real in our generation.

Yes, this is true both for individual pieces of art also and an entire tradition. The tradition of the relationship between Christianity and the visual arts has been seriously neglected for so long that it was in danger of being lost. Fortunately, there have been some attempts to recover our understanding of the history of Christianity and the visual arts. We started this interview by discussing an exhibition covering the two millennium of Christianity and art and I'd like to conclude by discussing another, similar, exhibition—Anno Domini: Jesus Through the Centuries curated by David Goa. Did you see that show?

SB: I was able to attend the opening of that exhibition and it was an exhilarating experience. The Canadian/British flare added a distinct atmosphere of pomp and circumstance to the opening, with processions, music, and dignitaries. It was a privilege to be present for such an historic event.

How was Anno Domini *similar to and how was it different from* Seeing Salvation?

SB: *Anno Domini* celebrated Jesus through the centuries, not just in art, but in music and literature as well. So it was multifaceted and represented many different perspectives. Both of these showed, with overwhelming evidence, that for two thousand years, artists have left a record that the Christian faith was alive and well at every juncture of history. One comes away with the question, "Will succeeding generations leave that kind of record?"

One difference was that Anno Domini *included more contemporary artists, including your work.*

SB: Yes, it was encouraging that the contemporary art in the *Anno Domini* was covered extensively by the news media. People were very excited to know that strong religious work is continuing to be created. As an artist, it was enriching to see the diversity of work from folk art to pieces from the more established cannon of Western art, and then complemented with the work of several contemporary artists, four of which were CIVA members. *Anno Domini* was a very diverse picture of how we image Jesus.

David Goa spoke about some of the motivation and spiritual philosophy behind Anno Domini *at the 2001 CIVA conference in Dallas. He quoted Saint John Chrysostom, Bishop of Constantinople and Doctor of the Church saying, "God created the arts in order that life might be held together by them, so that we should not separate ourselves from spiritual things." This would suggest that, without the arts, we could be in danger of life falling into disorder and worse we might become separated from the spiritual world. What do you think of this quote in relation to the history that* Anno Domini *described?*

SB: One of the reasons *Anno Domini* was so successful was that it offered reflection on the meaning the life of Christ has offered successive generations for two thousand years. Many of the works in the exhibition were objects used in worship, some in domestic and others in liturgical settings. The show demonstrated how the arts give meaning and constantly join us to the spiritual realm that is greater than ourselves.

Goa noted that Creation is neither a battleground nor something to overcome. But we too often miss the point of art, and life, is to dwell in the presence of God.

SB: Art serves as a point of departure, a kind of visual pilgrimage. Both formal and narrative elements can offer a place of meditation, a focus for contemplation where we are invited to dwell in God's presence. If the artist is successful, and the viewer is willing, the work can be a place where the finite meets infinite, and where the intimate and ineffable intersect.

David Goa said that "prayer is the art of coming anew into the presence of the Creator." And "To teach us to pray, that is the work of art. To teach us to see, that is the work of prayer." Would you agree?

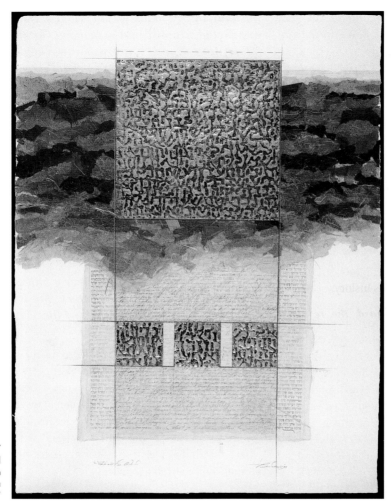

they can experience a kind of wonder, thrill, celebration, that is full of anticipation but short of words.

Prayer is an exchange, a conversation, with God, not always with just words. I may start off with words but then I begin to journey beyond where words exist. The visual releases me of words. My art is a communication between me and God, it is a personal doxology. If no one else ever saw the work, I believe it would not be wasted. There are flowers in the forest and birds singing, that no human eye or ear ever perceives, nevertheless, they give praise to God. As I think of all the time I have spent in the studio, hour after hour, that time is not lost because I think God was enjoying being part of that creative process. I have grown the most spiritually in the process of making art. If the artist sees the time spent in the studio as a conversation with God, then the few pieces that make it out into the world are a bonus. That belief has given me enormous freedom.

SB: That is a rich and wonderful way of expressing it. When I visit a museum, I often leave feeling as if I have wept, it is a very intensely religious experience because it offers me an intimate exchange with the work of art. Once a person has learned how to engage a work of art,

OBJECTS OF GRACE

Goa's faithfulness in putting Anno Domini *together demonstrates that curating can be an act of prayer, beyond words. Do you know what kind of resistance he faced, either in Canada or from potential lenders of work, to putting together such a show?*

SB: David Goa had a difficult time launching the show because many considered it was too "controversial" or "dangerous" a subject; Christianity was not the most politically correct topic. He also had problems with lending institutions who, according to one French intellectual, had "just purged ourselves of this heinous story" and were now, supposedly, presenting art objectively. But, thanks be to God, the exhibition was a blockbuster with the highest attendance of any show in the museum's history.

Yes, from what I have heard, the response from the public was overwhelming. I would think that this kind of attendance would indicate that there was a real hunger for "meaning" and "mystery" that the Christian tradition represents.

SB: The public response to *Anno Domini* and *Seeing Salvation* suggests to me that more museums need to have the courage to mount exhibitions with Christian themes, offering something more than just "spirituality." These shows were risks for their organizers but they turned out to be just what the culture needed.

Perhaps the response to Seeing Salvation *and* Anno Domini *suggests that Bryan Appleyard is correct in suggesting that art "for the foreseeable future, can be only Christian," at least if the public and artists like yourself have anything to say about it. What do you see as the most important thing for people, artists, and viewers to know about making the future of Christianity and art as rich as its history?*

SB: I believe that when the visual arts are a vital part of the life of the church, then, in turn, the culture can be deeply influenced by the power of art. I think it is essential that the church develop a clear theology of the arts to become comfortable again with the visual as a means of grace and healing. Then a community of arts must be developed within the life of the church that will encourage and foster the creation of powerful and important works of art. We cannot, as artists, be lone rangers, going solo against the tide. We need the support and benefit of each other as we reach out into the world around us, offering our gifts to the world and to God.

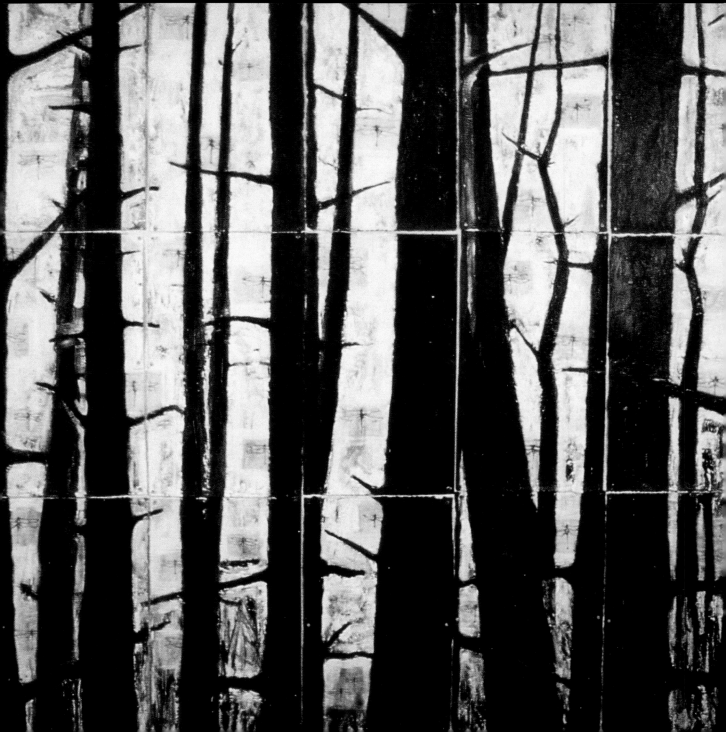

CONVERSATION WITH **DAN CALLIS**

December 2001

James Romaine: Your recent work dealing with representations of nature reminds me that in Genesis 2:15, one the first things the Bible says about Adam is that God put him in the Garden to tend and keep it. Do you see a connection between this gardening and art making?

Dan Callis: Absolutely. I see many relationships between gardening and art making. These are both activities in which I am engaged, two spaces I frequently occupy. As a young person, my grandmother, who was a mentor to me, also occupied both of these places. She raised me in her garden and her studio where a special kind of sensual magic accrued. Her small studio, much like her garden, was full of rich sensory experiences like the glistening pallet, which was situated right at my eye level as a small child, and the rich odors of turpentine and linseed oil. There was the flat rectangle of canvas, a window of cloth, where I watched the landscapes appear. Her painted landscapes were never familiar locations. The painted spaces were always exotic, majestic mountains, vast deserts, turbulent seascapes and dark, inviting, river deltas. We never really talked much about her paintings; they were always just there. I would rush into the house, situate myself in front of one and disappear into its space.

I don't mean my intentions are the same in the garden and the studio, but there are strong parallels. There is much to learn in the garden that can be brought to the studio. They both demand a sort of relinquishing of control; finding a balance between control and loss of control, self will and other will, speaking and listening, assertion and submission. Madeleine L'Engle talks about this process in *Walking on Water* where she likens the creative process to, "chaos to cosmos," bringing order from chaos. I certainly don't think that everything was chaos before I arrived, though that can be a flattering idea. I would extend her formula to something like: cosmos chaos cosmos. As the gardener or the painter, I take the existing materials, dislocate and reconfigure them, and something new accrues because of our interactions. There is a very important relationship here between the materials, myself and who I understand God to be.

Can you expand on this process of relinquishing control and exerting control over your materials?

DC: In both gardening and art making there is a creative interface with a very physical material—material that is loaded with potential as well as limitations. Both gardening and art making

demand knowledge of the materials, their history and the traditions in which they are being used. Both involve a process of preparation, of bringing all the resources to bear. In both, there is a time of instigation and transformation where your presence instigates action. Then there is the time of occupation where you are present but the action is worked on you.

There is also an issue of stewardship, which is part of both art making and gardening. A commitment of time and resources all expended for a potentially immeasurable outcome; you do your work, you set the resources in motion and you step back and watch where it all goes (grows).

How do you select your materials?

DC: I select the materials by or because of their innate qualities, and because I believe that a specific material would work best for a specific task. I am also a firm believer in the idea that each material brings with it a rich history and potential that is present within the material. The material is immediately malleable (to varying degrees) but it also has specific limitations. It is often my experience that the rich characteristics of the materials far exceed my assumptions of them. It is not that I relinquish my intentions completely to the work, but there is certainly a consistent yielding to it on my part. I have an intention or purpose that drives the work, but I don't feel the work is really succeeding until it begins to generate its own momentum. In this momentum there is a place where a dialogue begins—the dialogue between the work and myself. I assert something and the image and materials assert something back. My job, in part, is to find that dialogue and respond to it.

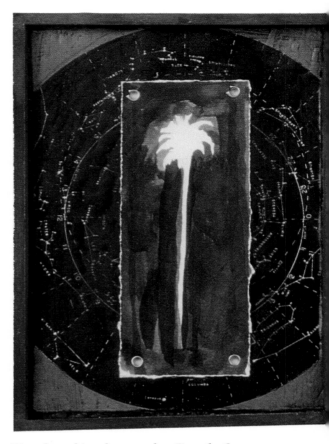

How does this relate to what Dorothy Sayers says in **The Mind of the Maker** *in her chapter on "Free Will and Miracle" about us as creators in relation to our creator?*

DC: There is a strong relationship to Sayers' "Free Will and Miracle" where she talks about the playwright achieving man's desire, that is, "the creation of a living thing with a mind and will of its own." That's what I am talking about—seeing and/or feeling the will of the work and moving

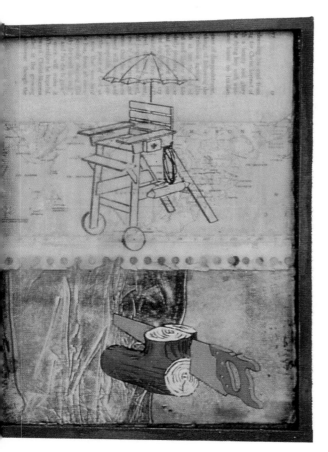

with it. I am also interested in her idea of working within the limitations of the medium: the idea that there is a freedom within those constrictions. This idea that we don't "bully" or "escape" the limitations but that the artist "serves" the limitation. By "serving," I mean relinquishing control and exerting control (listening and speaking). There is a sort of collaboration that goes on. As Sayers would say, "allowing the work to develop in obedience to its law of nature."

These are issues that are strongly present in the garden as well. I have been particularly interested in regional specific gardening. This involves working with native or native sympathetic plants. In this form of gardening I must consider the characteristics of the site that I am engaging. What are the native resources of the site, i.e., natural soil conditions, light, water as well as what kind of insect, bird and animal populations are present? What kinds of plants naturally flourish in this location or in regions that are similar? I must ask how I can work within the parameters of the site, how can I steward the site's potential and submit my will to the outcome of our collaborations.

How are you impacted by this process of creativity, the wrestling with materials?

DC: I think this is a particularly poignant issue for the Christian artist and more specifically the evangelical artist. As an evangelical, I am often tempted to put a heavy emphasis on the assertion of language, that is, to say something. If this is the case, then I also must assert something with my art. I might not think of my work as saying something back to me—that it might teach me something about myself or God. But, in fact, I have always found this to be the case. My work has something to teach me. That is what I am talking about when I mention listening to the work and submitting to the work. The work tells me about my need to control, to dominate, to stay predictable about my lack of faith or my fear of misunderstanding. The work demands risk, it may be that my current solution is inadequate but resolution will only come through the

destruction of that image to which I have already given so much. I might be forced to lose control or rework areas that I thought were initially working so well.

So the work is a process, a journey through the work.

DC: The landscape is a journey space, a place for myself (and the viewer) to move through, to negotiate. Some works imply a difficult passage while others imply a reflective and contemplative journey.

The garden/studio can be a space where the tasks are often clear, each step moves from dis-ease to reconciliation. By the time I notice, the literal is becoming metaphorical. The workspace becomes the landscape into which I am moving on the journey. It isn't always the trip I had planned, not even one I had desired. It is the journey I found myself on. In this place I am alone, isolated, quiet. I can see and hear the specifics and catch only glimpses of the whole. It is learning to be happy with glimpses.

In recent years I have approached my work as an opportunity to ask questions and look for relations. This process allows me to sort out issues that are prevalent in a manner that is meditative and self-informing. The current body of work explores the issue of landscape and our relationship to it. Space defines landscape, whereas space combined with memory defines place. This space, this landscape, is the place I locate myself. It is the space I dream of, the place I remember myself "in." It is the only way I can locate myself, and in this place I locate my neighbor and my Creator.

Can you say more about that journey and the specific work or works that relate to it?

DC: "The journey" is an idea that I have been working with for sometime now. In earlier works there have been several images that reference the journey. There is the image of the boat or vessel. At times the boat has had occupants and at times it is empty. In a series of works, the boat and its single occupant have capsized or have taken on great amounts of water. I began to liken this imagery with journeys gone bad. Well maybe not bad, but that the course of the journey has taken an unexpected turn.

In a small series of works, an interesting process occurred; I was layering a set of images. Included were references to the site of the journey. The site was demarcated with varying images such as maps (land and sky maps), architectural references, waterways, and trees. The trees at times were grouped and at times single.

At a certain point in the process I was aware that something was missing in the work. It needed a small clean image to float over an ambiguous space that was in relation to a map. I started thumbing through my resource material. In my "boat" image file, I came across a diagram on how to build a wood hull boat. It started with the felling of a tree and then the splitting of the tree. In the simple, almost iconographic, image there was a saw splitting a tree trunk in half. It occurred to me that this image would work wonderfully in the piece. One reason was its visual kinship to early church martyr icons. This was an image of martyrdom. The sawing in half or splitting of the trunk. It also worked

wonderfully because of the fact that the site (the tree) was becoming the vessel (the boat) for the journey. The site becomes the vessel. The painting becomes the vessel.

By vessel, you mean that the work was carrying you on the journey.

DC: I became aware of the journey as something that is going to happen whether I am conscious of it or not. In C. S. Lewis' *A Pilgrim's Regress,* John is well aware of the fact he is going on a journey and that it will have a life-changing impact but he is unaware of the full impact of the journey. My favorite scene is, when at the journey's end, John comes to a deep pool that is blocking the trail. On the other side of the pool is a sheer, rising cliff face. Clearly the only way to finish his journey is to go into the dark and seemingly bottomless pool and perhaps go under the cliff. With much annoyance John asks his guide how he can proceed. His guide tells him that he must dive into the water. John asks if it would be possible to lower himself into the water feet first (this would be far safer, John states). His guide tells John that he must dive in headfirst. John, both fearful and angry, insists, "If I dive in headfirst surely I will kill myself!" "Exactly," the guide calmly states, "That is exactly what is supposed to happen."

How does this relate to your current work?

DC: The current body of works starts with a large, ten-foot-by-eight-foot, expressive, black-and-white forest landscape. The bulk of the trees push up into the foreground in a mannerist fashion. There is little space between the trees and where there is space the pigment

pushes forward almost filling in the space before the viewer can see past the foreground trees. The work is entitled, *Sojourn and Tilling: Between Odysseus and Telemachus* (I was reading Homer's *The Odyssey* at the time I started this piece). My intentions were to create an image that on one hand seems impenetrable and at the same time enticing to enter. To create an image that appears hostile and inviting. I didn't know what would come next in this body of work. I didn't know what was just inside the trees but it was a journey that I had to take. I would have to enter the work for this work was paralleling my life.

There is a strong concern emerging between the role of the canvas as a bracketing device of space and as a surface for the material to assert itself. I am also interested in the idea of an image from nature, that is, the phenomena of an isolated image and its immediate absorption into the larger field or ecology of the site (painting). It is the dominant image, but it is also a part of the constellation of the images in the space it occupies.

You described the space that the image occupies as a "constellation of images." How does that relate to the internal working of things occupying space within the work?

DC: Even as I formulate an answer, I think in terms of constellation. What I mean by that is that there are several things occurring concurrently and they all feed into the work. While I am working on the art I am thinking about journey and/or pilgrimage. I am thinking about how I discern "road signs" or "markers" in life

journeys. What might appear to be a hazard sign or a danger sign might turn out to be something else all together. What does Christ mean when he says, "for those with eyes to see and ears to hear" and how do I read this metaphoric landscape for signs?

I came across the idea of a philosophic constellation in the work of Theodore Adorno and Walter Benjamin. The philosophic constellation is the configuration of concepts "near" the object, which are assembled to reveal what is normally concealed when concept and object are simply equated as they are in various forms of the "correspondence" theory of knowledge. Adorno wrote, "Cognition of the object in its constellation is cognition of the process stored in the object. As a constellation, theoretical thought circles the concept it would like to unseal, hoping that it may fly open like the lock of a well guarded safe-deposit box: in response, not to a single key of a single number, but to a combination of numbers."

When I read this, it struck me that he was talking about a poetic language as opposed to a pragmatic language. I, as the artist, place things in relation to each other in such ways that a new resonance begins to occur, displacing things and rearranging things in such a way that perhaps the viewer might see things anew. Eyes to see, ears to hear.

Can you connect that to a specific example of your work?

DC: In a work like *Witnessing My Own Demise*, I look at nature in a variety of ways simultaneously. On the bottom level is an image that I found in a turn of the century book for field botany. The image is a close up cut away of "the life cycle of the pond." In the image there are several narrative style images of insects in their full life cycles. The thing I loved about this image is that it is from a science text. Its authority resides in the assertion of objective truth. It asserts an image of truth concerning the landscape with

O B J E C T S O F G R A C E

its supported life systems. But what is actually pictured is a scientific impossibility, the pond waters separated (like the Red Sea) and the full narrative life cycle of insects as if painted by Masaccio (the *Tribute Money*). This microcosmic landscape was on the bottom layer. I then painted a series of three star constellations on top. These were the traditional, flat schematic star drawings found in any astronomy text. As I was painting them, I was simultaneously thinking of Jasper Johns' flags and targets and Byzantine icon painters. I was painting flat schematics of deep, deep space (macrocosmic space) on top of an illusionistic shallow space. Then, on top of both of these layers, I placed another image from science, the bell jar with a plant specimen inside of it. Among other things, I was intrigued by the idea of the plant being located inside an observation container, the bell jar. This was a nod to the idea of landscape painting; the bell jar / the picture frame, the plant singled out for observation / the observed landscape captured for aesthetic observation. All of these layers of observing nature and histories of painting moving around each other in relation to each other. The title, *Witnessing My Own Demise* makes at least one reference to exposing the limitations of my language to describe the profundity of the world around me. And at best I can only place these observations in some form of poetic relationship (constellation).

The bell jar in **Witnessing My Own Demise** *both fixes the viewer's gaze on its contents, in this case a plant, and also creates a certain, clinical, distance between us and the subject. How do you create and use this tension?*

DC: On a formal level, I attempted to create this tension in several ways. The primary tension is in color. The first two layers are constructed with muted, analogous cool colors. And though there is no attempt to create a smooth visual

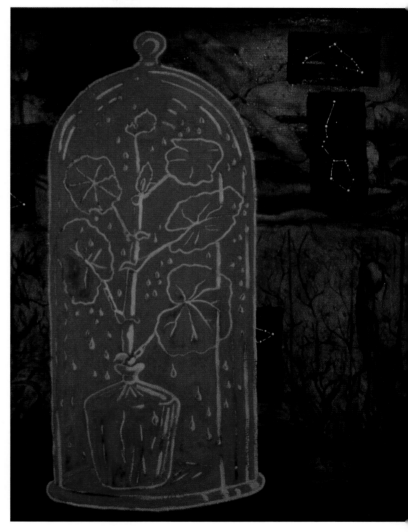

transition between the star constellation images and the pond image they still "sit" together very comfortably because of their color relations. The bell jar, on the other hand, has an abrupt color transition. Equally present is the abrupt placement. What I mean by this is that the bell jar image at first read does not have any visual relationship to the images behind it. The jar's only reference (particularly in scale) is to the outer edges of the canvas itself. This is important because as I stated earlier the jar is a like the canvas, they both are bracketing devices for us to see. It is as if the jar winks at the stretcher bar acknowledging they both understand their roles.

The "clinical distance" as you call it is at the very core of the question I am asking with this work. How do I, as an artist, as a university–educated intellectual and as a Christian, enter the landscape at the beginning of the twenty-first century? Because of the history of science, I have learned to enter the landscape with a certain objective distance. Because of aesthetics and particularly Romanticism, I have learned to enter it with my emotions and intuition. As a Christian, I enter the space as holy, because this is the garden of God and it is littered with chips and fragments of His love. I should enter the landscape with an equal balance of heart and mind, of art and science but alas I am a product of my time and so there is a tension.

OPPOSITE
How to Watch the Night
Sky 2001, oil and wax
on paper, 18" x 24"

How does this tension impact your experience, particularly your visual experience, of the landscape?

DC: One of the things that I have noticed and in fact I have experienced myself is that when I enter the landscape there is a strange kind of negotiating that occurs. An example of this is in the field classes that I have been taking. I have noticed that most of my classmates are drawn to the landscape for aesthetic reasons. We all talk about it in a quasi-religious fashion though most, if not all, of these people would quickly describe themselves as non-religious, relating their position to science as opposed to faith. The way that the class negotiates this relationship with the landscape is by learning the names of things in the landscape. We go out and learn the names of the birds, insects, and plants. We learn about their relationships to the places they occupy. And, while the majority of the class cannot mention the strange stirring they feel in their souls each time they enter the garden, they take great pleasure in naming names. There is a striking tension here. Because it is a good thing to learn the names of the gifts of God, but if the name is as far as you get it is not enough. If it is only the name you have then you have isolated the miracle and like the manna from the Exodus story what you hold in your hand (or your gaze) is a finite and fleeting thing.

I believe that there is much promise in this tension. In Annie Dillard's *Pilgrim at Tinker Creek,* she unpacks with great poetry the promise of possibilities for those who name names and dare to see. She writes, "This looking business is risky. But there is another kind of seeing

that involves a letting go. When I see this way I sway transfixed and emptied. The difference between the two ways of seeing is the difference between walking with and without a camera. When I walk with a camera I walk from shot to shot, reading the light on a calibrated meter. When I walk without a camera, my own shutter opens, and the moment's light prints on my own silver gut. When I see this second way I am above all an unscrupulous observer."

Annie Dillard is absolutely right. I had experienced that many times but had not found the right words to name that experience. A writer like Dillard enriches us by giving us the words to help us understand our visual experiences, without removing any of the mystery of those moments of seeing. Similarly, a work of art can be an education in seeing. For example, an artist like Jan Vermeer makes a painting of some small street in Delft, but that image is very carefully and cleverly constructed to convey a way of seeing. Thanks to him, I can see my own street in Brooklyn in a richer way.

DC: It's true, isn't it! Dillard and Vermeer have seen it and in their sharing we have the potential to see. Elsewhere in *Pilgrim at Tinker Creek* Dillard states, "The secret of seeing is, then, the pearl of great price. If I thought he could teach me to find it and keep it forever I would stagger barefoot across a hundred deserts after any lunatic at all. I cannot cause light; the most I can do is try to put myself in the path of its beam." I think this idea applies to me as artist as well as observer.

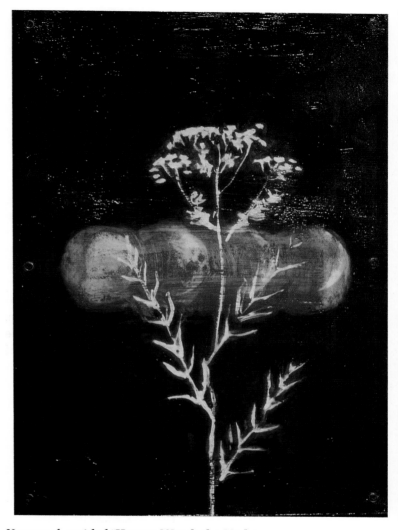

Your work entitled "How to Watch the Night Sky" *suggests some insight into this mystery of seeing. Can you expand on what that work is about?*

DC: "How to Watch the Night Sky" is in response to this problem of seeing. The title is positioned to function between the question and the assertion: "how do I?" and "this is how." The image is dense, a building up of surface by use of pigment, image, and color. And then in the process a slow reduction or elimination of information. A sort of harvesting or gleaning of the essential elements in the works.

The surface is wax encaustic and oil. At first glance the wax surface appears to be opaque; it is not. As your gaze adjusts to the dark earth tone you can begin to make out some very subtle underpainting. Some of the information below the surface is readable but most is not. Located, on the surface, is a single line rendering of a plant. This "fixes" the viewers' gaze and then invites them to look past the image into the painting for something more (or less).

The specific plant was selected because it is a seasonal producer. I have rendered the plant in the last state of blooming or just as it is going to seed. Above the plant is a horizontal band of four moon images. Each image represents the quarter stage of the lunar cycle. The four combined indicate a month cycle. What I am eluding to is the cyclical nature of time. A time for birth and a time for death. Things on the surface and things below the surface. I want to be more aware of a Hebrew sense of time, as it is referred to in Proverbs. How do we "see it?" King David encourages us to look to the heavens for God's unfolding story and glory. I wonder if we even know how? And if we do know how, do we know what we are seeing? Christ encourages us to keep a watchful eye on the season to be aware

of his return. I wonder if we can we see through the near opaque atmosphere weighted heavy with pollution (this could be literal or metaphoric pollution). The work is about seeing, seeing and watching. Seeing that is difficult. Seeing that is intuited. Seeing that is from the loins, not from the head.

The question of how to watch the night sky raises the issue of constellations as a way of mapping and mapping as a way of making sense within our limited minds of material that is greater than us. Many artists have taken on this question of mapping or used it to explore their own work, from Vermeer's **Astronomer and Geographer** *to Johns' maps and Anselm Kiefer's recent work of constellations. Do you connect with the idea of an artist as mapping, whether it be literally or metaphorically, a certain terrain?*

DC: Absolutely! Both literally and metaphorically. Several years ago I started traveling in Baja, California with a scientist friend. We have repeated that trip three years in a row, going every January. Part of the reason we began traveling together was to work with the question of how we see the landscape. He is a trained field biologist, and I am a trained artist. Both disciplines pertain to seeing. The first year, we read John Steinbeck's, *The Log from the Sea of Cortez*. This work is the traveling account of Steinbeck, a writer, and Ricketts, a marine biologist. The writings map their journey giving literal accounts as well as anecdotal stories, musings and insights. Ricketts maps the peninsula with biological specimens and

Steinbeck maps the peninsula with stories. One particularly poignant statement that Steinbeck makes is when he is asked by a local fishermen what he is searching for (the fisherman had found John wandering in the tide pools late one afternoon and had assumed he was looking for something). John answers, "We search for something that will seem like truth to us; we search for understanding; we search for that principle which keys us deeply into the pattern of all life; we search for the relations of things, one to another."

There, again, is the idea of constellation. In this case, Steinbeck uses his writing to search. In my case, it's painting. In Sojourn and Tilling it is about the terrain of a personal kind. I paint the trees not because those particular trees exist somewhere but because they represent to me a place. It is a place that is brooding, dark, dangerous, yet at the same time inviting or intriguing. The painting is very physical, the surfaces are aggressive, the pigment scumbled and dragged. This is the literal part. The painting is real. It is present, as I am. But the image begs to be entered, to be "read," and in doing this we are moving forward.

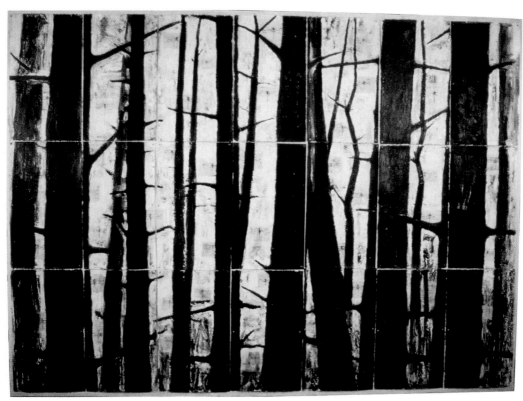

The grid is a crucial element of any kind of mapping; it suggests an underlying foundation, whether it be intrinsically natural to what is being mapped or is imposed onto it from without. The grid, perhaps for these very reasons, has also been important to a lot of artists, such as the Minimalists. How do you use the grid in Sojourn and Tilling?

DC: Again, one of the basic questions that I ask myself is "How do I, as an artist and Christian at the beginning of the twenty-first century, enter the landscape?" As an artist, I enter it through my tradition. In *Sojourn and Tilling,* I tend to bracket myself between Romanticism and Minimalism. The grid references mapping. It represents the imposing of the human intellect on the landscape, it is reason, measurement, order. It also implies a certain promise, that is, control and predictability. You can locate yourself or your destination on the grid of a map. You can know where you are. It levels everything. In my work I have been using the grid as a rational structure to receive a more emotive process. The work is large and expressive. The marks are gestural and the pigment very physical. As I am moving the materials (vis-à-vis, Abstract Expressionism) I keep bumping up against the grid (the rational of Minimalism). There is a tension where these two meet. The tension is not only about painting, it is about reason and emotion. It is about the construction of an emotional map. You are here, and here. As a Christian I know there is purpose and design but there is also chaos. Scripture tells me that God is the same yesterday, today and yes, forever. But scripture also tells me God is wild, dangerous, and beyond my imagining and I am relegated to the cleft in the rock when He passes by. You are here, and here, be careful.

Perhaps it is this use of the grid or it may be the contrast of the areas of darkness and light, but I am made very much aware of "positive" and "negative" space in Sojourn and Tilling. *Also, perhaps because both the "positive" and "negative" space of a painting are both treated with the same density of paint, even these categories seem to be called into question by the work. Can you discuss the issue of "positive" and "negative" space in your work?*

DC: I'm glad you asked about this because it has been a very important issue in my work. Formally, it has to do with my place in the history of painting. My early training was in the seventies and the dominant conversation pertaining to painting in the art department was the last vestiges of formal abstractionism; process, surface, gesture. This was the vocabulary in which I was immersed. I was reading Hans Hoffman's theories of push / pull and listening to John McCracken lecture on the speed and density of color. And at the same time I was learning traditions of illusionist rendering; light logic, value, figure / ground relationships. Over the years as a painter and a teacher of painting I have celebrated and have been conflicted about the dual roles of painting. That is the tradition of icon making and the tradition of image making. By icon making I mean that the painter is making something that is clearly operating as a constructed symbol such as an orthodox reli-

gious icon, or a target by Johns or a Barnett Newman Zip. What I mean by image painting would be Winslow Homer or Edward Hopper, Jean-Auguste-Dominique Ingres or Peter Paul Rubens; painters that brought all the elements to render a reference to an observational world. In these two traditions, the authority of the image appears to be located in different places. One is located in an observational and rational experiential place and the other in imaginative / symbolic or intuitive experiential place.

As a student painter, the artists that I was most excited about were the Fauves and the Expressionists. They seemed to be the most effective at bridging these two places. At the same time, as a young Christian I was trying to work out what the scripture meant when it made reference to living in the world but not of it or to be first you must be last or that we were seeing through the glass dimly. When I read C.S. Lewis' statement that the strongest argument for the Christian faith was the strange yearning in each man's heart to see the other side, well, this was embodied in the works that I was seeing at the time: Chaim Soutien, Georges Rouault, Max Beckman, Käthe Kollwitz, as well as Henri Matisse, Edvard Munch and Vincent van Gogh. They all seemed to be straddling the two worlds of icon and image. So, I have grown up as an artist with this dualistic heritage as a painter. I continue to be interested in painters who occupy a similar space. Artists like Anselm Kiefer, Francesco Clemente, Mimmo Paladino, Enzo Cucchi, Lawrence Carrol, Sigmar Polke, Philip Guston, Susan Rothenberg—these are all painters who are unabashed in their embrace of the potential and limitations of painting and at the same time "touch the other side," as Lewis puts it. So as I am working up the negative spaces between the trees with as much purpose and velocity as the trees themselves, I am thinking about my lineage as a painter from the Byzantine icon painters to Johns, from David Casper Friedrich to Kiefer.

This issue of "positive" and "negative" space can also have spiritual implications. I live on the top floor of a small building in Brooklyn, New York. From my roof I look out over a view of a series of rooftops and chimneys that make up the Brooklyn Heights skyline. Right behind them is the skyline of Manhattan, with its majestic thrust of human ambition and achievement; now broken, it is also a reminder of the futility of our ambitions. I love that definite line where the buildings touch the sky. I always used to attach meaning to those solid forms. But I have begun to be more liberated by looking at the space, that patch of sky, between the buildings. Because of insecurity and fear, we all concentrate on the subject. But, through faith, one can begin to look at the void, the gap between a parked car and a mailbox, and see something. I have to constantly depend on the words of the Apostle Paul, "for the things which are seen are temporary, but the things that are unseen are eternal." There is something in that theological statement for the artist, isn't there?

DC: Absolutely, for the artist and everyone else. This may be the most important gift of the artist. To see and then to teach others to look into that space between things with anticipation, with hope. There is the rub. We think it is about where we touch the earth and it is about where we touch the sky. But we occupy both spaces; maybe this is why art is so important, it can help us to navigate this occupation.

One of the dangers of this discussion of "positive" and "negative" space is that, unchecked, it can devolve into a form of dualism. Perhaps because a work of art has both material and immaterial elements, both of which are equally important and interdependent, it can serve to break that dualism, that divide between heaven and earth. This reminded me of your work Connifer Cycle, Green. *In that work, there are two realms,*

RIGHT
Conifer Cycle, Green
2000, oil and wax on
paper, 18″ x 24″

44

one of a wooded landscape and the other of phases of the moon; yet the two are held together in the one work. Can you discuss that work, what motivated it, and how it might relate to this issue of dualism, heaven and earth?

DC: I mentioned earlier the road trips to Baja and the field ecology classes as well as trips to my own garden. In all these cases I am painfully aware of my desire to be present and how difficult that can be for me; to be disciplined to be fully present. This issue of material and immaterial elements, both of which are equally important and interdependent, is so apparent in the landscape. Whether it is the solid objects that occupy the landscape, i.e., geological forms, flora and fauna or the unseen presence of water, minerals, and even the air. Each time I am in the landscape I am reminded of a different sense of time and occupation, of occupation and celebration.

In *Conifer Cycle, Green* I was thinking about these various aspects of time and occupation. So I divided the picture plane into two spaces and arranged these spaces vertically. The lower space is terrestrial and the upper is a celestial space. In the terrestrial space there is a dense old growth forest. The image in the top panel is the lunar cycle consisting of four moon images. The upper image represents the passing of time; a month, a season, a year. While the lower image represents the time that is occupied or lived in. The actual motivation for the work came from an event that happened at my home. My wife and I have restored a turn-of-the-century home. In doing the restoration we researched the history of the house, the architect, and the families that have occupied it. We have attempted to restore the house being sensitive to the original intentions and at the same time expressing our own presence as we occupy it. When we bought the house the front yard was shaded by a magnificent cedar tree. The base of the trunk was approximately seven feet in diameter and seventy to a hundred feet tall. It was also dead. It had occupied the hillside well before our home was built and had watched over the house for the last ninety-one years. The arborist estimated that the tree was approximately one hundred and fifty years old, a mere child compared to the old oak that stands at the other corner of the property. He estimated that the oak was around three hundred years and still going strong. As we felled the dead cedar I was acutely aware of time—mine, the tree, the house, even the hill that supported all of us. I occupy my time. I will be here for a season and then be gone. But according to scripture that time was informed by the generations before and generations in the future will be informed by my time and my presence. My very being was known before the foundations of the earth where I was formed but all I can touch is what is at the ends of my fingers.

Both Sojourn and Tilling *and* Connifer Cycle, Green *remind me in a way of some of Anselm Kiefer's paintings, particularly a work like* Father, Son, Holy Ghost *which has these two realms of a wooded landscape and an attic studio, very much the idea of the studio as a magic realm as you described it earlier.*

DC: When I think of Kiefer, I also think immediately of Vincent van Gogh. In both of their art there is a sort of sensorial celebration of materials and a longing of the spirit. I just saw several major works by Kiefer at the LA County Museum of Art, including Germany's Spiritual Heroes. There is such a visceral connection with his work because of his use of materials—the sheer physicality of the surfaces: the paint, straw, plaster, mud, etc. The work is undeniably present. It occupies the same space the viewer does, in some ways it is even more present than the viewer. Also, it is his imagery. There is a strange sense of longing and mourning, also a sense of reckoning. The layering of imagery and material makes the work operate somewhere between memory and vision. They really do occupy the space you mentioned earlier, between the material and immaterial. The work is so grounded in the history of painting and at the same time it transcends the issues that have hamstrung painters in the last two decades. This is what I hope for my work. To acknowledge my traditions and use those traditions as a vehicle (or at least the fuel) to break free of the current orbital confines.

One of the issues your work may share in common with Kiefer's is a connection between memory and place. How does he make the connection, in your opinion, and how do you make that connection in your own work?

DC: I would agree with that observation. Memory is made in place. Place is the ecosystem for memory. Memory is story, individual and/or collective, and that occurs in place. This is history. That idea has been the common connection of all my work, the idea of memory, location (place) and community.

Dr. Ronald Wells, history professor at Calvin College says it so concisely, "History is the memory of the stories about people changing over a time span. History untold is not history at all. People suffering from amnesia can live and function, but they lead pitiable lives because they have lost contact with their own story." I first read this statement about twelve years ago and it continues to resonate for me as an artist. I understand part of my role as an artist is to be a storyteller and I understand this role to be a redemptive act. I think that is one of the things that our works share: this belief in the redemptive quality of the art. The redemption comes, in part, from remembering. I would hope to evoke something forgotten, something important yet forgotten. I see that in Kiefer's work. I also see in his work the role of the artist as a mediator or facilitator between memory and place. The word I really want to use is shaman because of its ritualistic and magical connotations (but I also know this word can be problematic).

As a culture we are creating images at such a rapid pace and the bulk of these images are purely for consumption. Our memories are so meshed in the audio and visual drown of our commodity economy that we desperately need places to slow down, to reflect, to remember. And in this remembering there can be mourning, there can be celebration, and there can be reconciliation. I hope in some way my work

O B J E C T S O F G R A C E

locates or fixes the viewer in the space they are occupying and at the same time transcends that space. Kiefer's work does that for me.

Kiefer's work brings the eternal into the moment. It transcends the moment without negating it or trying to escape from it. It reminds us that we have to locate ourselves in the place that we are and journey from that point. But the space we occupy is often uneasy; for example the place of the Christian in the visual arts. What do you think is the terrain of the contemporary art world today for an artist of faith?

DC: I think it is a very exciting and dynamic time. It is a time ripe with opportunity. With artists like Kiefer, Robert Gober, or Kiki Smith, there are serious, spiritual questions being asked. It appears that we continue to be in a major period of flux and that means everything is up for question. As an artist of faith I believe it is paramount that we maintain a relevant place in the conversation. I think of the Southern California artist Tim Hawkinson, who showed in the 1999 Venice Biennial and is slated to show in the next Whitney Biennial. He and his wife, Patty Witken (an accomplished painter and professor at UCLA) both are committed artists of faith and very active in the contemporary scene. I also think of Canadian artist, Betty Spackman, and her Austrian collaboration partner, Anja Westerfrolke. Both women are strong and committed believers and very active in the European art scene (including exhibiting their work at *Documenta*).

When I became active in the Los Angeles area art scene in the mid-eighties there was a small handful of professional artists of faith. We met on a monthly basis to build a support network as we pursued our individual careers. Over the past sixteen years I have seen that network grow and expand. The questions and struggles we were facing in the early years are just not issues anymore. There is a large population of artists of faith in the LA area now. They are on the faculty of area art departments, in galleries and museums and active in curatoral responsibilities.

There seems to be a disengagement between the art world and the general public. Why is that and can it be overcome?

DC: "Why is that?" That's a big question and it is certainly multifaceted. I think it lies somewhere in between Tom Wolfe's *The Painted Word*, Suzi Gablic's *Has Modernism Failed*, and Robert Hughes' *Shock of the New*. It has to do with the bifurcation of the arts, the development of the camera and

the cinema. It has to do with aesthetics and entertainment and the confusion of the two. It has to do with a young nation and world wars and an influx of avant-garde ideas and intelligencia.

As for the question, "Can it be overcome?" yes I think it can. Again, this is where I see the opportunity in this time of flux. With the dethroning of the authority of modernity and its prevailing aesthetic, there has been room for an influx of style and image over the last twenty years. Pick up a dozen art periodicals and you will see a whole range of concerns, conversations and applications of styles, from performance to time-based work, from realist painting to process abstraction. With the popularity of PBS programming on cultural trends by people like Hughes, the big blockbuster Museum shows like Vincent van Gogh and Winslow Homer, or exhibitions that explore the relationships of popular culture to art, like the wildly popular exhibition *Made in California* at LACMA, there is kind of a populace interest happening as well.

The examples represent an art that engages the public and a public that engages art. How can we encourage more of this?

DC: I think that each of us, as a spiritual creation and as a citizen, needs to develop a visual literacy. We are a people who have historically separated our ethics from our aesthetics and have a very difficult time reconciling them. As I mentioned earlier, we are a culture creating images at such a rapid pace and the bulk of these images are purely for consumption. We don't know how to separate a sublime experience from a beer or automobile advertisement. Our minds effortlessly stream the audio and visual fluxiun of our commodity economy and we begin to think these images are metaphors of real meaning. As a people we have trouble being still and listening. If the image doesn't read within fifteen seconds or at sixty-five mph we assume it is not worth reading. We begin to assume that images are suppose to tell us something, because all the ones around us do. They tell what to drink, what to wear, who to be. But the truth is that images ask questions, i.e., who are you, where have you been, where are you going, what does it mean to be made in the image of God? It is the image of God who asks us in everything, "Do you love me?" If we don't know how to read poetry or look at art or listen to music it seems as if our imaginings of God will be profoundly limited.

That is certainly an important point and it is a powerful argument for incorporating more, and better, visual art into our everyday activity and our acts of worship. (Of course these two need to be intimately linked and the arts can be a catalyst for that integration of the everyday and the eternal.) But the work of art is only as powerful as the imagination of the viewer will allow. That imagination is like a muscle—it has to be toned and maintained by the exercise of looking and ingesting a healthy diet of good art. Otherwise it will be lost. If we have weak imaginations, that will, as you pointed out, impact our spiritual lives. Our engagement of art on a spiritual level,

O **B J E C T S** OF GRACE

art as prayer, can be a valuable exercise regimen preparing our hearts and minds to engage our Creator on creative terms. Nevertheless, many Christians see the arts and culture as hostile terrain, and it often can be, but their response is to withdraw from it. Should that perspective be challenged and how? On what grounds or for what reasons should it challenged?

DC: It is an issue of stewardship! I have been on faculty of an evangelical college for fourteen years and the whole time this has been a significant bone of contention. I have preached this sermon for fourteen years. In some arenas the church seems very responsive, but in many others there is suspicion and even outright hostility.

In the nineties there was a very popular metaphor being used concerning this issue of stewardship—culture wars. I believe the term was coined by Dr. James Hunt. The evangelical community latched onto that metaphor like an old bulldog. Years ago, I was sitting in church and the pastor opened the Sunday service by announcing that he wanted the congregation to boycott a local municipal museum. They (the congregation) were instructed to write "letters of protest" and to "flood the museum with righteous indignation," this was after all a "culture war!" He did profess that he had not seen the show but had heard some very disturbing things about it. As an artist I knew the museum well. It was a small community site, always struggling with funding issues, running mostly on volunteer staff that were generally elderly women. This particular museum hosted an annual watercolor show, an annual "art of the car" show, a local high school art show and the annual contemporary art show. The show that the pastor was talking about was the contemporary show. I had three friends, who were Christians, that were in the show. As the pastor passionately called the congregation into civil action, I couldn't help but think of those sweet, retired, blue-haired women pushing their way through the angry crowd of Christian boycotts only to find their information counter spilling over with letters of accusation and threat.

I wrote that pastor and let him know that there were Christians on "the inside." I also encouraged him to reconsider his strategy. We (the Church) had, after all, abandoned the house of art about two hundred years ago. Didn't it seem to be a bit pretentious to show up at the door and kick it in demanding the whole time that, "We own this house! Now you get out!" Needless to say, the pastor missed the metaphor. I guess war is not the time for metaphor. I should say, war is what you get when metaphor no longer works.

In the introduction of his book on environmental stewardship, Christian biologist and ecologist Calvin DeWitt describes the vision that drove him to write his book, *Caring for Creation, Responsible Stewardship of God's Handiwork.* It was an image of humanity standing at the judgment seat of God, their hands dripping with oil and chemical waste, their feet crusted with concrete and asphalt. And God asks the simple question, "What did you do with the garden I loaned you?"

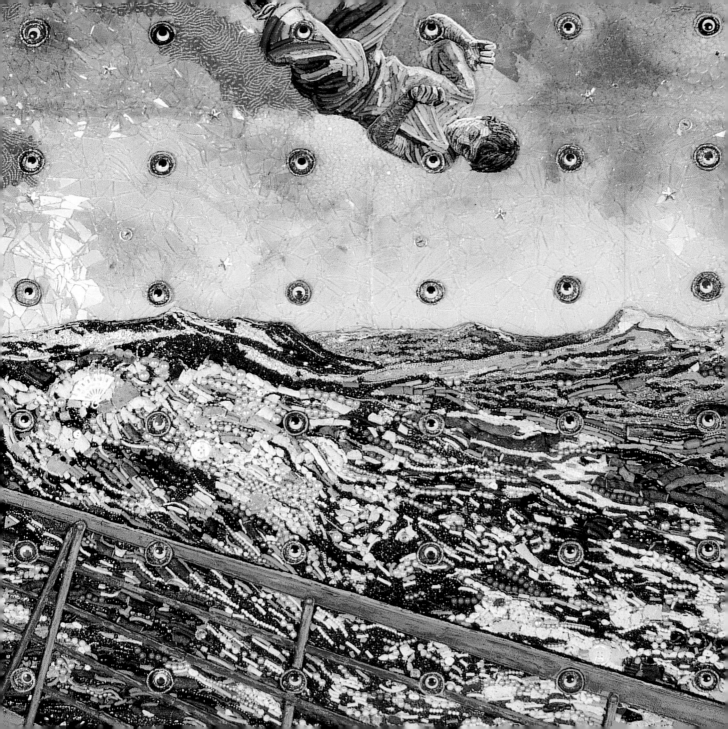

CONVERSATION WITH **MARY MCCLEARY**

June 2001

James Romaine: Something that impressed me about your works is the visual pleasure of their surfaces, materials, and textures. What sorts of materials do you use?

Mary McCleary: I've used colored wire, painted sticks, string, paper and cord of various sorts to create the illusionistic parts of the pictures. I've also included other materials such as compasses, watches, plastic animals, plastic plants, shredded money, gumball machine toys, plastic skeletons, printed materials and tiny globes as well as glitter, all kinds of beads, stars, and other shiny materials. I could use just about anything, as long as the material is archival. Elements are often repeated in collages, but occasionally they are specifically chosen to match the subject and surface of the work. For example, in *Icarus,* I struggled to come up with the right material for the sky. I ended up breaking various kinds of glass into fragments and gluing them on piece by piece into the sky to create a sense of atmosphere.

How did you end up developing this particular collage technique?

MM: While doing a series of intuitive abstract drawings from 1975-78, I began cutting little bits of paper out of the drawings and folding them back like an advent calendar. Gradually, I glued additional bits of paper onto the drawings and finally other materials. These developed into layers of intricate and colorful patterns.

How did these evolve into your more recent work, which is very colorful and patterned, but also figurative and narrative?

MM: My work gradually became more narrative when I became a Christian. After my mid-life conversion, I tried to make up for lost time and devoured every bit of scripture and commentary I could get. I loved rediscovering the Bible stories I had known as a child, studying them for the first time as an adult. An artist's work will usually reflect what they are thinking and reading, for me that meant Biblical narratives.

Did your faith impact your treatment of materials?

MM: Not that much. I have always been enticed by beautiful things. I grew up in a family where the women were very interested in American decorative arts, and I would accompany them to museums, restored houses and antique shops. Through our discussions about furniture, needlework, ceramics and other things, I was taught a respect for craftsmanship and good design. Related to this is my concern with making my work as archival as possible. While nothing is permanent and everything will be dust one day, I feel like I owe it to the people who collect my work to be as good a craftsman as I can be. Also, because the larger collages take about a year to make, I'd like them to last a while.

One of the materials that you use is the plastic doll eyes which are placed across the images in a sort of grid. How did those become part of your work?

MM: I needed a metaphor for God's omniscience and omnipresence within the Biblical narratives I was exploring. The eyes were a reminder that He is in charge, superintending over events. In addition, the two-dimensional grid created an interesting contrast to the three-dimensional objects and materials from which the works are made, as well as the three-dimensional illusion of the subject. They anchor the image in place and hold the work together. That in itself could be a metaphor. I'm not sure I will always use the eyes, but, at this point at least, they work both technically and conceptually for me.

What consideration do you give to the resulting relationship between this grid of eyes and the scene which is either supported by or set behind that grid? The plastic eyes never replace the eye of any figure in the image.

MM: They can't. I wouldn't want to confuse the mortal and immortal. The grid is laid out in different scale in each work both to make the image work visually but also to avoid the confusion of the plastic eyes with the eyes of the people in the work.

Because they are toy eyes that are meant to bounce around and give the sense that the doll's eyes are moving, they have a sort of comical presence along side some pretty serious subject matter.

MM: Well, I hope I won't be called to answer one day for using these eyes to represent God. I'm more comfortable using something obviously dumb and stupid for something I could not seriously represent if I tried. Using the google eyes acknowledges the impossibility of representing anything like God's omniscience and omnipresence.

Is this a childlike faith?

MM: Perhaps. My attitude towards materials is as childlike as it is sophisticated. There is a sense of playfulness, amazement and wonder with the "stuff" of our world. I also like the idea of recycling the "worthless" into an expression of the transcendent.

One of the issues your work seems to deal with is seeing the invisible.

MM: This is what art does. Good art often alludes to something beyond the physical.

Looking over the past decade of your work, there is a progression away from flatness to greater illusionism or representation. How did that develop?

MM: The collages made prior to the figurative works were abstract, geometric and had a flat or ambiguous space, so it was natural to approach the early figurative works in that way. The flattened figures had more in common with those of medieval manuscripts than the more baroque or classical figures in the later work. The creation of illusionistic space was gradual and not particularly conscious. As one work became more illusionistic than the one before, I liked it, so the next one became a

little more representational. It was an interesting challenge for me to push my materials and see what they could do. Unfortunately the physicality of the collages is usually lost in reproduction, and the collages appear to be normal flat paintings, instead of being composed of hundreds of small parts. People are often surprised by the work when they see it for the first time in person.

Yes, I was far less prepared by seeing your work in reproduction than is usually the case because they are so visually complex and materially dense.

MM: There is a tension in my life between the material and spiritual. I love looking at beautiful things and visual art. In fact, the vanitas theme has been in my work for years. At first, I only knew that theme from art history classes and looking at 17th century Dutch still life paintings. It was a real surprise for me when I read the Bible as an adult and discovered that paintings I had been doing for years came from Ecclesiastes. I'm a lot like those Dutch merchants who loved to collect beautiful material things, including art, and wanted to remind themselves that those possessions were ephemeral and that they should focus on more permanent things.

Continuing with this theme of perilous attractions in your work, how did **Icarus** *come about?*

MM: As with many of the recent works, it is allegorical and inspired by a renewed interest in poetry. It is based on the poem, "Musee des Beaux Arts," by W.H. Auden, where he refers to the Brueghel painting of Icarus in which the

ship sails by and the farmer continues plowing, everyone ignoring the boy who falls from the sky. There is much happening around us that we don't notice or choose to ignore, because we are caught up in the details of our own lives.

O B J E C T S O F G R A C E

What about To Be Redeemed From Fire by Fire?

MM: The title of that work comes from a line from T.S. Eliot's "Little Gidding," one of the *Four Quartets.* When I was younger I hesitated to read Eliot's poetry, because it seemed impenetrable. One nice thing about being middle aged is knowing more of the references. I've always tried to build many layers of meaning into my own work. The Biblical narratives were full of allusions to other scripture which gives it complexity. The layers of reference in my work have of late been chiefly from other literature and history. *To Be Redeemed From Fire By Fire* is taken from the famous photograph of the Hartford, Connecticut circus fire. Faces of friends and family replaced those of the people in the original photograph.

I'm curious about the boy in a tiger mask.

MM: The tiger reminds me of Blake's poem, "Tyger Tyger burning bright . . . What immortal hand or eye, Could frame thy fearful symmetry?" but also Eliot's reference to Christ the tiger. I liked interweaving these references with other Biblical themes about the refining power of fire. The tiger completes a subtle acknowledgment of the trinity with the grid of eyes of the Father and the plastic dove of the Spirit.

What lead you to **Children of the Apple Tree?**

MM: This work was based on a misremembering of an Eliot line, which really was "children in the apple tree." But it was prompted even more so by *The Lord of the Flies*. I had seen a documentary on gangs of boys in cities throughout the world that reminded me of the book. At the same time, I witnessed the effect of absent parents on the lives of many of my college students. In *Lord of the Flies*, Golding seems to be reacting to Romanticism by showing our tendency to sin even in a pristine natural environment. I placed the boys in a perfectly controlled man-made garden to suggest that even if man

were to have the absolute dominion he desires, the results would be the same. I see this as the effect of the fall.

You're showing the impact of "Original Sin."

MM: Yes, that theme keeps reappearing in my work. But there is also always some expression of hope in each piece. In that work there is glued in the upper right on a perfectly trimmed conical topiary bush, a little brass Christmas tree with children dancing around it. I don't have a totally negative view of things, because Christ has ransomed us from sin, and there is always the hope of His return.

This conceptual tension in your work between good and evil is matched by a tension between some of the scenes, such as the infected body of Lazarus being licked by dogs, which are quite repulsive, and the beautiful and seductive way in which the works are made.

MM: The artist has to cause the viewer to want to look at the work. That is the first, most basic requirement. My hope is that my work can be read on many levels over time and by a wide audience. I want to make my work accessible to children but also interesting to an art historian who might recognize more of the symbolic or compositional references.

As an art historian, something that really caught my attention was the expression of the woman in David and Bathsheba. *Although this is a subject often represented in art, commonly an opportunity for voyeurism, the psychological impact of these events on her is rarely a concern of the artist. I can only think of your work and Rembrandt's famous image of Bathsheba holding David's letter as dealing with this psychology. How did you decide to make a work on that subject?*

MM: I've always had an interest in film, and I was going through a book that had some old film noir publicity stills when I came across one of Barbara Stanwyck and Robert Taylor. He was helping her on or off with her coat, you didn't know which. I remembered the image, and it occurred to me that this would be an interesting way of representing David and Bathsheba. When you are dealing with subjects that have been painted by so many great artists over the years, it can be intimidating. The only way to approach those subjects is to try to come at them from a totally different way. I liked adapting this image because the viewer doesn't know if Bathsheba is coming or going, but that she feels the gravity of the moment.

This shows how you represent David and Bathsheba as contemporary figures. Every generation deals with the Biblical narratives, these eternal truths, in new ways. We live in a world that is very different from both Bathsheba's and Rembrandt's. So, there is a need for artists to help us see these stories again.

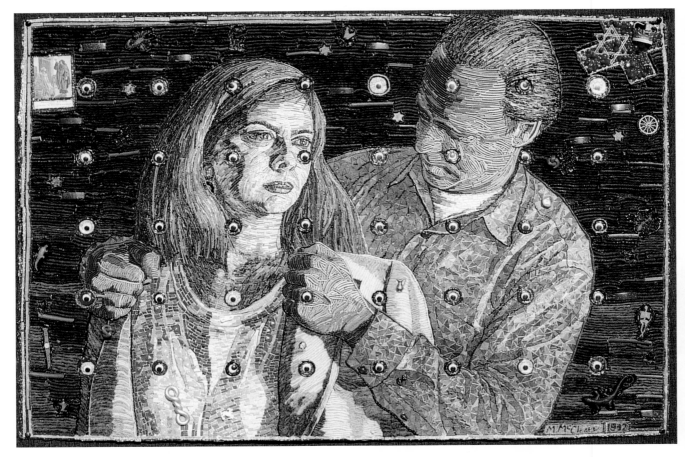

MM: Human nature hasn't changed, so it is easy for me to identify with the people in the stories. The big challenge for an artist working with these narratives is to avoid clichés—Christian artists don't have a monopoly on clichés; they are frequent in beginning painting classes and in art shows everywhere. But it is easy for believers with the very best intentions to fall into creating predictable, Sunday-school type illustrations. Selecting as subject matter stories or concepts of great importance is not enough. The art itself needs to be visually significant, powerful and imaginative. The consequential subject can appear trivial when it is portrayed in a superficial way.

This issue of relating image and text to each other, without the image becoming a didactic illustration is one that you take head on. In a work like Lazarus the Beggar, *how do you take on the idea of the parable?*

MM: Christ's use of parables was a way of veiling some of the content from people who might not be able or ready to understand. Taking that as a model, art has to be subtle. You have to lead the viewer slowly through the story into the content. Artists have been coming back to these parables for years because the narratives capture our imaginations, and are about things in our everyday life. We have all seen beggars. That parable affects me, because like the rich man, I don't stop and give to them. Very often I chose my subjects because they are about spiritual issues with which I struggle.

The parable of Lazarus the beggar is one in which Christ pulls back the curtain of eternity and gives us a glimpse of Heaven. C. S. Lewis describes, in The Great Divorce, *the arrival of an artist in Heaven. He is told, "When you painted on earth...it was because you caught glimpses of Heaven in the earthly landscape. The success of your painting was that it enabled others to see the glimpses too." What do you think of this description of the artist's vocation?*

MM: I appreciate what Lewis is saying. Perhaps he is referring to glimpses of God's grace in our fallen world. I trust in my collages there is a sense that this earth is not all there is. Sometimes the viewer has to hunt to find grace and hope, but that is appropriate. I dealt direct-ly with a heavenly vision in *Martyrdom of Stephen,* but the only way that I could was in a self-consciously naive way with glitter and aluminum foil. I included that verse, "No eye has seen, no ear has heard, no mind has ever conceived what God has prepared for those who love Him." That was my way of acknowledging that there was no way for me to deal with Heaven as subject matter.

The paradigm of art making as a vocation in the service of God has as a foundation the recognition of the source of that creativity or the creative gift. How do you relate to this marvelous and mysterious gift of human creativity?

MM: By acknowledging that my creativity is a gift from God. I look back on my life and think of the influence of the family where God placed me, and the encouragement and opportunities He provided through them. I was born in a time and place where women can aspire to be artists. I suspect there is even a genetic component to my being able to do the work I do, since generations of women before me made beautiful handwork requiring the patience and attention to detail I seem to have inherited. All of this is from Him.

What does it mean to be created in His image?

MM: Dorothy Sayers, in *The Mind of the Maker,* writes that when we are told in Genesis that man is made in God's image, the only thing we know about God is that He is creative. Therefore the first thing we learn about man is that he is

also creative. Sayers goes on to explain that no one is able to create matter, but that all of us, regardless of occupation, spend our lives rearranging it into new forms and patterns. She suggests that of all people, the artist is able to come closest to creating something out of nothing, since art is more than the sum of its parts. As an artist, I mirror God's creativity in only the most minuscule way; I am all too aware of my limitations. Each new project is a struggle. Though all humans have creative potential, some work harder than others do to develop their gifts. There are also different kinds of creative outlets, many not involving the arts.

These limitations you refer to are in part the result of the Fall. Can you expand on what you see as the effects of the Fall on our creativity?

MM: Well, it has impacted everything. Our creativity had certain limitations even before the Fall, but the Fall compounded these limitations.

The temptation that led to the Fall was, "if you eat the fruit you will be like God." The paradigm that many artists today are working under says, "you can be a god." How do you respond to that?

MM: I am very troubled by the Romantic vision of the artist as genius who is above moral law or the artist as seer, prophet, or shaman. That elevated view of the artist has always seemed pretty silly when I've looked at myself and my artist friends who don't have any more insight into the "big questions" than anyone else. Jacques Barzun, in *The Use and Abuse of Art,*

writes how art in the nineteenth century became a religion: "the supreme expression of man's spiritual powers, the ultimate critic of life and the moral censor of society." It's easy to buy into that elevated concept of art, and I would recommend Barzun to anyone who questions the role of artists in our culture. I'm skeptical when artists seek to justify any form of art as "expressing themselves." I hear this more from students than professionals and suspect they have picked up this cliché from well-meaning art teachers and parents. I would run out of things to say in thirty seconds if I had only myself to express, because I'm finite. This egotistical looking inward is a dead-end. I believe the best art is about things bigger than we are: the created world, shared experiences of being human, the great ideas and events of history. That's why I recommend a strong liberal arts education, lots of art history as well as studio classes to anyone interested in a career in art.

<div style="font-size:small">

OPPOSITE and RIGHT
The Whole of Creation Groans in Travail
1992, mixed media collage on paper 48" x 42.75"
Collection of The Museum of Fine Arts, Houston

</div>

Continuing with this discussion of creativity and the Fall, I'm reminded of your work, **The Whole Creation Groans in Travail.** *How do you think the artist can participate in or respond to this travail?*

MM: The longing for Christ's return is something that I feel more strongly some days than others, as I am more aware of my own sinfulness and that of the world around me. I've always been very enthusiastic about being alive in this world, but I also feel a longing for restora-tion. I am often conscious of the fact that things are not quite right, and I look for opportunities to express that in my work.

How can an artist be a spiritual light in the world?

MM: Only by reflecting the light of Christ, and that is a heavy responsibility for us as frail mortals. There is a need for Christian arts pro-fessionals to be part of the conversation within the contemporary art world and provide an

alternate or additional voice that might be heard among the competing voices of post-modernism. We won't be heard if we are huddled together in a Christian ghetto talking only among ourselves. It's not just how we make our art, which is done in the solitude of the studio, but how we live our lives. That's the tough part.

The contemporary art world is often contentious towards Christianity. How do you relate and respond to the art world?

MM: The art world is not monolithic. There are institutions and individuals in the art world that respond to my work and some that don't. But that is the case for most artists whether they are Christian or not. Few artists have universal acceptance of their work. The majority of the people who have collected my work are non-Christians. My job is to do the best work I can and let God take care of the rest.

The other side of the coin is the difficulty many artists have finding acceptance within their own community of believers. How have you related to your community or Church?

MM: I think that it is important for artists to be involved in their churches and not withdraw. Someone recently, in a conversation we were having about their church, said to me, "we need a separate church for artists." I don't know if he really meant that or it was just a moment of disillusionment, but I disagree with that approach. If we had all the artists in one church, the other churches would be missing out on what artists could contribute to the whole body. That would be a real shame. But it is hard for artists in some churches, since they

are more visually aware than others in the congregation. I struggle with the same frustration with the lack of aesthetic sophistication in the church voiced by others, though my living in a rural area no doubt influences my experience. Many people can recognize a wrong note when it is played during a service, but few appreciate that visual "wrong notes" can be just as disturbing. Aesthetics is one area where everyone thinks that they know what is good without ever having studied it. Have you ever met anyone in your life who didn't think that they had good taste?

Probably not.

MM: I was wondering the other day if bad taste should be considered a sin. I'm joking of course, but when we put ugly things in our environment we are lessening the lives of others around us. It's frustrating to go on a road-trip and drive into town after town where inevitably the ugliest building there is some new barn-like metal church. It wasn't always like that. Often in older communities the church is the most beautiful and most substantial structure you see. Of course evangelicals don't have a corner on the market when it comes to poor taste. Although I have been frustrated with the lack of aesthetics in the Evangelical church, there have been individuals in my church who have been supportive of my work as an artist.

How can Christians become better patrons of the arts?

MM: They can become involved with their local museum or art center. These non-profit organizations always need volunteers. Christians can

O BJECTS OF GRACE

become more informed by reading books or taking classes. And they can buy art. A Christian family recently bought two of my collages, the first time in many years that has happened. My Christian friends usually spend their money on boats, clothes, cars and vacations but not art. Most of the people collecting my work are non-Christians, because they are the ones most engaged in the art world.

What do you see as the relationship between art and faith?

MM: It takes a certain amount of faith to start any work of art. Each collage requires an incredible commitment of time and other resources. An artist never knows if the work will be successful or even if it will be completed. Art has to have a little mystery.

Can you expand on that idea of mystery?

MM: You have to allude to certain things; try and come in the back door when the front door is closed. But you don't just illustrate ideas. That is a particular challenge for a narrative and figurative artist like myself. Good art usually has different levels of meaning and mystery built into it that take time to be revealed.

Is that what you strive for in your work?

MM: It's one part of it. I am my greatest critic and know my own weaknesses. But sometimes, when a collage is complete, I reach a point where I can say, "that turned out all right." There is gratefulness in my heart if I have used my gifts the best I can. I hope He is pleased.

M C CL E A R Y

CONVERSATION WITH **JOHN SILVIS**

December 2001

James Romaine: What inspires you to begin a particular photographic series or video project?

John Silvis: The work generally revolves around issues of identity and how we interact. In the last few years, I have focused on close formative relationships, such as mothers and children or husbands and wives. The work is not just about their relationships to each other but also my relationship to the subject. They are all people with whom I have personal relationships.

So, the work grows out of your life.

JS: Yes. My art is reflective of the experiences and issues I am thinking about and the people I am dialoging with at the time.

I think that the first time that I saw your work was a video projection entitled Talking Heads at the Dia Center space in Soho. What motivated that work?

JS: That work was done as a response to something I saw on MTV. A group of college students were being interviewed about their interests in fashion and music. I started to think about interviews and what kinds of questions I would want to ask. In *Talking Heads,* I asked peo-ple about they thought about when they were in a state of daydreaming, when they were sitting in traffic or waiting for someone.

What were some of the responses?

JS: What stood out to me from these interviews is their preoccupation with succeeding in life and a continual processing of childhood conflicts and memories.

What about the piece Passing Comments, *a video installation in a similar interview format to* Talking Heads.

JS: That work was a continuation of *Talking Heads.* I was struck by the fact that these kids on MTV were so eager to share their thoughts and seemed forthcoming with all their answers. Yet the topics being discussed were superficial; something like the theme of death would never come up. *Passing Comments* was an exploration of how my friends think about death and what they would want to communicate when confronted with the reality of death. Death isn't something that we, as healthy, young, urban people, talk much about. Their responses varied a great deal from some whom were very concerned about death and its meaning to those who didn't think much about it all.

The video is set up so that we only hear the response of the person, without your question to them. Yet it was quickly evident that you were asking them about death. What struck me as interesting was that their answers were mainly about life. They didn't really say much about what they thought about death, what it would be like or what comes after it, rather they reflected on how they had lived their lives up to that point.

JS: Yes. The question I asked was intended to be as much about life as the loss thereof. Most of them viewed life as a meaningful passageway to another world that is more whole and comforting. For some death was a natural biological process that excluded any spiritual element.

One of the issues that came up in Passing Comments *was the problem of meaning and living in a way that is not self-referential. Another speaker talked about the importance of living in the moment.*

JS: If there is one criticism of our generation and contemporary art, it is that we are constantly focused on ourselves. Some of the current philosophies began with important questions but after two or three generations of a closed, self-referential dialogue it has become about dissecting the answer rather than reflecting on the content of the question. I see a lot of art today that comments on art itself, but does not address the concerns that led to its creation.

There seems to be a certain disconnect between the general public and much of contemporary art. The self-referential nature of this dialogue is likely to part of this problem. What do you think can or should be done to help reconnect the public and the visual arts?

JS: One aspect of this problem may be that some contemporary artists have abandoned the narrative of the human condition in their work and many people become alienated by a conceptual framework that is removed from their context.

That is certainly a problem, especially with art that is intentionally abstruse. Art can engage issues of mystery and the viewer at the same time. One of your video works which I think does this well is **Silent Requests.** *What was the central issue behind that work?*

JS: In that video, I asked people to talk about things that are unresolved or a mystery to them. The title *Silent Request* was to suggest making a request of God, a question of why certain things happen in life.

The piece also forces the viewer to come to terms with things that we don't understand. The first and last speakers are in German, which not everyone would understand, and there is a cow bell in the background. Also, the figures are hanging upside down; at first this looks odd because we are used to seeing the mouth below the nose and eyes but after a while the mind begins to adjust.

JS: That was part of my intention in the piece. I didn't make the piece expecting to find an answer but simply raising certain questions, opening up the viewer's dialogue with those questions.

While none of the silent requests are directly answered in the piece, I did sense that the work did more than simply raise a set of questions. In hanging the people being interviewed upside down as they voiced questions to God about things that they did not understand, were you meaning to suggest, as could be inferred from the work, that these things don't make sense to us because

of the inverting impact of sin? I mean, in a way, we all live our lives upside down from how we were created to be. What is truly alarming is when this upside down world begins to look right side up.

JS: Yes, that is a theme embedded in the work.

One of the issues that has come up in your work, raised by the individuals being interviewed, is that of facades and honesty. Obviously that is an important issue in our relationships with each other, but what about between the artist and viewer?

JS: I don't know if I aspire to honesty in my work. I think of it more as being direct. Honesty is somewhat overrated. I ask the people I'm interviewing in my videos very direct questions. I want a certain immediacy or frankness but to expect complete honesty is asking too much. Even though I have a certain level of trust and rapport with them, there are things they think or daydream about that they would not reveal to me or would manifest themselves very differently if they were interviewed by someone else.

Your videos, like **Talking Heads, Passing Comments,** *and* **Silent Requests,** *mainly represent other people. We hear their voices, though not always in sync with their faces, and their statements. But we never see you and rarely hear you as the interviewer and director. It's a bit like the game show* Jeopardy *in that we get the answer and have to figure out the question.*

JS: It's all about the questions.

But how are you present in the work?

JS: The topics, questions and relationships are all reflections of issues I think about. The people in the interviews each relate to me in specific ways, they represent aspects of me. That choice of relationships in itself is a worldview and those relationships in turn further shape my worldview. I've done work that specifically addresses those issues.

Your presence as an unseen creator of the work suggests an analogy to a directing presence in the world of an otherwise unseen creator.

JS: That is part of it. I tend to see myself as a facilitator both in my work and other aspects of my life.

Photography and video are both media that create a sense of distance between the viewer and the subject. But your work creates a sense of closeness. It seems that the relationship you are able to establish between us as viewers and the people who populate your pieces is at the crux of your work. Is that correct?

JS: Yes, I try to use the medium to express a sense of intimacy. Even though it is not in real time, I mean the video is edited, I think that video as a medium, at least in the way that I use it, is very intimate. The questions I ask are very personal and, since the videos are always projected, you get the sense that the person speaking is there present with you as the viewer.

Because the video is captured and edited before it is presented to the viewer, and the projected video image is not a physical object, as a painting or sculpture is physically present with the viewer, there is a sense that video is in fact more removed from the viewer. How do you overcome that distance?

JS: I overcome that distance primarily through the questions I ask and the relationship I have with the person I am interviewing. If you look at my work, or the work of Nan Goldin or Diane Arbus, you can tell our work apart by the different kinds of relationships we have with our subjects. That is the key element to the work.

Your art seems to capture the dynamic space created by the relationship between the artist and the model. How do you translate that into a piece that creates a dynamic or charged relationship between the piece and the viewer?

JS: This dynamic is created through the interaction of the subject and myself. That is why, when I photograph strangers or people I don't know very well, it is hard to create that kind of space. I tend to work in the home of the person being photographed or in a specific studio space, a space that is neutral. It has to be a space that is comfortable for my subject or myself, or preferably both.

It seems like your work is done in private as opposed to public spaces.

JS: Yes. I've never done work in public space.

But your work is shown in a public space, a gallery or museum for instance. Perhaps one of the achievements of your work is that, as the video is projected and fills the space or a series of film stills line a wall, the space is transformed into one that feels private. The viewer is not left outside the piece but is invited into the private or intimate space you have created.

JS: Yes, it takes the neutral white box of the gallery and makes it personal.

As we have already noted, video projection allows the work to enfold the viewer in a way which most painting does not, although the ever expanding size of paintings suggests a desire to create work that likewise envelops the viewer; nevertheless, there are some other unique challenges that confront an artist working in the relatively new field of video. Bill Viola, one of the leading artist in video today, described the digital color video camera as a pencil and a piece of paper, saying that art is just one of the things you can do with it. He notes that the one thing that remains more or less the same is the person using these tools. He predicts that a person a hundred years from now will not know what to do with a video camera any more than most people today understand the creative possibilities of a pencil. He criticizes artists who have fallen prey to the propaganda of ever advancing technology wishing that, if only they had the latest camera equipment, then they would really make good art. In summary, Viola notes that our focus on tech-nology always seems to lead us away from ourselves. What is your impression of this challenge?

JS: I would agree with Viola. I've always viewed the photographic and video technology as a means to an end. I do not have a profound knowledge of photographic equipment. The technology is a tool to communicate with and I learn as much as I need to know to do the work. The improvements in computer technology and digital imagery make it easier to do my work but the technology itself doesn't fascinate me. I am more engaged by the issues of the human condition.

Your use of this advancing technology and the way you engage the issue of identity in your art may relate to an issue of what has been called the Post-Human. This was an exhibition curated in the early 90's by Jeffrey Deitch which dealt with the question of what it means to be a human being in a society driven by technology that in many ways defines, forms, and reforms our conceptions of ourselves. What did you think of that show?

JS: The show impacted me on several different levels. It opened up a dialogue for me with other artists who are using new technology in different ways and how that relates to how we live in this contemporary context of being surrounded by technology. I found the show very compelling but I think that my work is very different from many of the positions being taken by artists in the show. My impression of the *Post-Human* show was that many of the artists were engaging in the question of how technolo-

RIGHT and PREVIOUS
Husbands and Wives #5
1999, Triptych/ Projection,
Variable size

OPPOSITE
Husbands and Wives #6
1999, Triptych/ Projection,
Variable size

gy is impacting us and how the artist can use technology. I am interested in asking why these technologies are desirable or important. I think that technology only superficially influences how we live and relate to each other. For example, technology has drastically changed how we conduct war. But the reason we go to war, to free ourselves of someone else's control or take control of someone else, remain the same. In my own work, the issues of identity are much the same as they were before the technologies that I use to represent them.

In discussing the issues of identity and intimacy, how is photography similar to and different from, not necessarily better than but just different from, painting? Not just how it "represents" the world but how it deals with the "inner world."

JS: I don't know if I can answer that in a general way, but I can speak about it from a personal point of view. I used to be a painter; I studied painting in college. I felt like I was able to control the outcome of a painting much more than a photographic image. There is a certain kind of artistic distance involved in photography that I didn't find in painting. The medium of photography creates an indirect representation and there are certain steps along the way of which I am less in control. This allows me to create something that expresses my inner world more deeply when I am in too much control of the process. In my work I deal with light and time and space, exposed on photographic film, which limits my control. The video interviews that I do require a greater amount of collaboration from the sitter than if I were painting their portraits. I the artist respond to the dynamic of the interaction.

It is interesting that, by letting go of a certain about of control, you feel that you gain in the process. It seems almost antithetical.

JS: I think that a good work of art has to just happen. The best ideas come to you when you aren't expecting them. Jackson Pollock did his best work when he had given up on the conventions of painting.

O B J E C T S O F G R A C E

Pollock said that when he was "in" his paintings, that he was not aware of what he was doing. It's only afterwards that he could see what he had done. He said that there were absolutely no accidents in his work and that he had no fears about making changes or destroying the image because the painting had a life of its own; he just tried to let that come through. It was only when he lost contact with the painting that the result is a mess. Otherwise he was able to create a pure harmony, an easy give and take, with the painting.

JS: Yes, there has to be a balance between the control and freedom. The best work comes when you allow the divine to inspire you and use your human capacity to express it. Too much control means that you allow the negative aspects of your being such as fear or pride overpower the work of the imagination.

Do you see your work as a dialogue between yourself and God?

JS: Definitely. The relationships in our lives are divinely given, whether we acknowledge it or not. They are a mystery. We don't know why we have the parents we do or fall in love with a specific person. These are things that human knowledge cannot explain.

The Couple Series is one of the photographic series in which you have explored some of the mysteries of our relationships.

JS: I've renamed the series *Husbands and Wives* because I think "couples" is too vague. That work was specifically about engaging the dynamics of a marriage relationship. This is a very basic relationship that is the core of society; it is the source of family and children. It is a mysterious relationship that can be discussed but rarely defined in concrete terms.

Can you be more specific how your work, and the triptych format you employ, deal with this relationship?

JS: The triptychs format, aside from its historical function as an altarpiece, lends itself to articulate the reality of two separate individuals who become one.

The ideas of the Enlightenment, and its progressive view of humanity, greatly shaped the art of the twentieth century. Do you see a shift in the thinking of artists today about Enlightenment ideas, particularly as they relate to faith and art?

JS: Modernists of the twentieth century had great faith in progress and hoped that we could transcend many limitations faced by past eras and cultures. Today, however, I think that artists hold a much more cynical view of life and the future. I think a certain disappointment in the attainability of an "ideal" world has crept in.

As an artist working here in the New York arts community, what is your engagement with the art world?

JS: It is a fairly active one, though I would like to be even more engaged in current dialogues in the art world. Entering into that dialogue, however, will involve some confrontations. I should add that I welcome this confrontation. People of faith in the art world are a minority and are often seen as naive, so my faith in Christ will result in friction. The pursuits of modern thought and science have experienced ongoing conflicts with the orthodox Christian faith. We have talked about this idea of the "Post-human" and faith in man's progress and ability to transcend his own limits, which inevitably represents a conflict of interests with the Christian emphasis on man's reliance on God.

How has the community of believers of which you are a part encouraged you and empowered you to engage in this dialogue?

JS: Engaging in the kind of dialogue that I envision would require a tremendous amount of support from my community, my artistic peers and influential people in the art world to dialogue with. It exists as invitation only. You can't just show up and expect to be heard. There are a lot of voices out there. The ones that get heard are ones that have the support of someone that is already established and opens the right doors.

Your recent video work, Like These, *focuses on the faith of children. How did that work develop?*

JS: Over the past few years, I have had many interactions with children and have become increasingly interested their worldview. The first question I asked them was how they related to God, about the spiritual aspect of their lives. I also asked them how they prayed. I appreciated their lack of self-consciousness; even though their responses were articulate and well thought out, there was a certain candidness that I enjoyed. I intentionally filmed them in a neutral environment, not in their homes, because I didn't want them to be distracted by the associations of that environment.

One of the questions you ask the children is how they imagine God. I'd like to ask you the same question. How do you imagine him?

JS: The mental image I have of God was heavily influenced by the images of Warner Sallman. Growing up in a Christian home, that image of Christ is branded in my mind. In terms of describing God's character, that is a much more complex question.

The way in which the art of Warner Sallman has had an enduring impact on how you visualize God reinforces the formative influence the visual arts can have on our understanding of God, as well as other aspects of our lives. Yet many people do not make conscious and informed decisions about art in their lives. They don't seek it out or seek to understand it. They think of it as nothing more than a backdrop to more important things but its impact is greater than that. The art we live with, and our contemporary culture, impacts how we see and think about the world and God. That is another compelling reason why we can't afford not to be actively engaged in the arts and culture.

JS: Something that shaped my becoming an artist was the art history class I took in high school. I realized that these artists, like Vincent van Gogh, Arshile Gorky, and Martin Puryear weren't just passing time and doing art instead of milking cows. In fact, their work was an expression of a philosophy of life, both an expression of their inner world but also of the times in which they lived, or, in the case of Puryear, still lives. None of these artists are photographers; my work is very different but they inspired me to think about my own vision, to make art as a life, a vocation.

Do you think your work might shape how someone sees God?

JS: My work doesn't portray a specific image of God. It focuses on people and our relationships. In that way it points to God. I think it celebrates the uniqueness of each individual, made in the image of God.

Do you feel that you get to know God in new ways through your work?

JS: Absolutely. When I am working on a body of work or a particular piece, it is usually the most spiritual period of my life. Not only am I expressing a vital part of my humanness, but I am also more conscious of my need to rely on Him. I find that I reach my limits very quickly. Any artist who experiences a moment of creative insight knows that it is not of themselves, that they are not the origin of it. It is a mystery. I definitely acknowledge it as a gift.

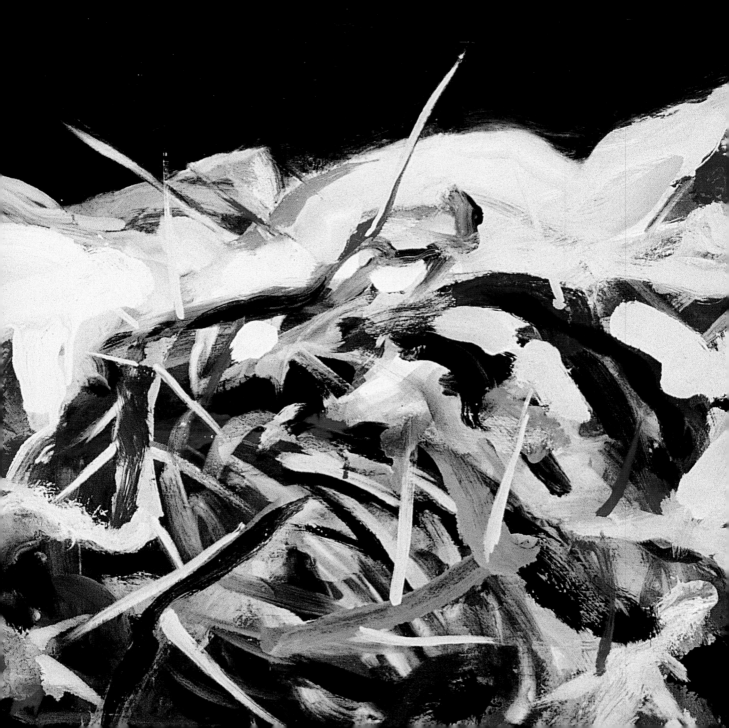

James Romaine: How did you begin working with narrative?

Edward Knippers: My use of narrative dates from the summer of 1983 when I had gone to Paris to study the figure. One evening I went with my wife Diane to the ballet.

The figure had become a dead issue in some ways for artists because we had shunned the use of the narrative. Before that evening at the Opera House, I had had a vague notion of rooms filled with large canvases of figures. But the "why" of their being there was missing.

I have come to realize that it is in action that we become truly human. There is both good and bad action, also some that has significance and some that doesn't. (Meaningless activity, Dorothy Sayers has reminded us, is sloth.) There is also action without physical movement, such as thought and prayer. The narrative can provide significant activity that places the aesthetic presence of the human form in a larger context than the figure alone will allow. It is this larger context that allows the artist to speak of our true significance as human beings. I could not have articulated this that night in Paris, but seeing the almost nude body of the Prodigal Son returning to the Father's arms was an epiphany for me. The figure in the narrative tradition was to provide the future development for my art.

How did you end up going to do figure study in Paris?

EK: I had been doing large still-life paintings in which the figures were peripheral. Then as a result of some exhibitions that came to the National Gallery the figure became more and more significant to my work. The most important of these shows was *Painting in Naples from Caravaggio to Giordano*. I went to see it several times not particularly understanding its relationship to my work. But soon after, the figure was no longer peripheral. I realized that it might be possible for me to significantly use the figure in my work—that the human form might not be beyond my abilities. So, I went to Paris to study the figure; I drew six hours a day during the week and seven hours on Saturday for six weeks.

What is the role of the viewer's engagement in the narrative of a painting?

EK: The viewer has got to be more involved to understand the narrative in a painting than when you are led by the hand in a movie. Painting is more subtle. It may only dawn on the viewer later what was going on in the work. As the artist, I can point the viewer in a certain

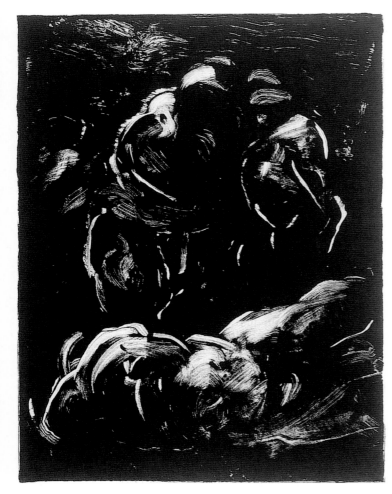

showing the Magdalene with a skull and candle. But sometimes the tradition is beyond my knowledge or ability, or it may simply be beside the point of my intent in a given work and an old subject ends up in a new way. I should add that I do not try to be "new" for its own sake. The aim of the artist should not be the "new." A work is stronger if it grows out of a history of representation as the artist comes to grips with the traditional in relation to our own time. I have often said, "If Cézanne was a 'primitive' in a new way, I am a 'primitive' in an old way." The work should cause people to imagine again the Biblical narrative as something important to their lives; but as you said that requires an active engagement on their part. Then people who see the work may say, "I know that story but I never thought of it in that way."

Would you say that your art shows us old things in new ways?

EK: Yes, but I don't think that is the most important point. My aim as an artist is to be "true" not "new." If I aim at the truth and make the work as strong as I can, on as many levels as I can, then the rest will take care of itself.

The issue of "truth" is always important to art but not always easy to deal with. A lot of contemporary art has turned to irony because of a lack of faith, faith in the existence of Truth and faith that, even if Truth exists, painting can convey it. There is a double doubt, a double skepticism, with which many artists have to contend. How do you contend with this atmosphere of skepticism?

direction with a title. I can build the work in such a way that the viewer can read the narrative, maybe point in a direction that the viewer would expect or suggest a direction that would be surprising. Sometimes I represent Biblical narratives in a very traditional way, for example

EK: I begin from a confidence that I know the One who is the Truth, and the Way and the Life. In saying this I have no room to boast that I have "found the Truth," for in reality it is the Truth that has found me. The challenge I face is how to present the Truth in the language of art. My work relates directly with the tradition of the narrative and the figure. This is central to my enterprise of building a visual language for Truth, for the body is central to humanity and therefore humanity's confrontation with God.

For many artists the narrative/figurative tradition no longer engages their imagination. They say, "it has already been done." For them it is irrelevant, unrelated to contemporary art. They say, "But, Ed, people just don't do that any more." My answer to them is that of one of Flannery O'Connor's character, "They do if I do it." My work does not often consciously quote from past artists but I am working out of many of the same impulses, even if my work is different. These impulses are Christian, of course, because Christianity is at the heart of the European painting tradition. My work draws from the echo of the greatness of that tradition. What is most important is that the work rings true for the viewer. If the work engages the viewer's imagination, that's all I can do. I hope my work can be a guidepost, a touchstone, of what it means to be human in a world that God has created.

Maybe we could discuss the use of narrative in your work by talking specifically about a particular work, a monotype, you did of Job and his friends. I have this image over my desk and I have looked at it daily and over a long time; the image continues to work out its narrative, the interaction between the figures, in new ways.

EK: I think that is the allusiveness of the image of a person. A human image by its very nature has ramifications in a number of different directions. It is a wonderfully complex package. If you do away with any one of its components the image becomes like a cardboard cutout. The wholeness of that package creates the poetic presence of the work.

The allusiveness of the image relates to what you said earlier about the necessity of an active engagement on the part of the viewer. Who do you see as your audience?

EK: At this moment, you are. [laughing] I am also an audience. I have to paint what I like to look at. Getting to your question, though, I would hope that my audience would be anyone who might come in contact with the painting. I think of my work, like Flannery O'Connor described her characters, as out there butting its head against our day-to-day society. The paintings are public not private. I wouldn't work on the scale that I do if they were meant to be private— preciously personal. Perhaps the work will catch people off guard, and then they will have to deal with it.

My art has gotten a lot of attention within the Christian community, in part because many people have been upset by it. But I hope that my audience as much larger than that. We often think of society in terms of segments, such as Christians and non-Christians. Some have wanted to categorize my work as "church

paintings," because of the Biblical subjects. But many in the church don't see it that way. Therefore my work tends to be somewhat homeless. If I were to have a commission for a church, I don't know how I would resolve that issue. I wouldn't want to be coy about the nudity but if the work is to be in a liturgical setting, it would have to take second place to or have a symbiotic relationship with the worship. Anything that would distract someone from the core of the worship would not be right. Its job would be to expand the worship, not simply as background but to make added room for epiphany.

The paradigm of art taking second place is different in many ways from the more recent idea of art at the center. Not only do many artist today think of their art as self-sufficient, requiring only the white walls of a gallery or museum but this paradigm has also impacted how we see the art of the past. For example, the Sistine Chapel is more of a museum than a worship space; the art has taken center stage in a way Michelangelo never intended it.

EK: They are trying to maintain an air of reverence in the Sistine Chapel by shushing people and making them take off their hats. But they also charge admission. This is a contradiction. On the other hand, the art is keeping the faith before a whole segment of people who would have no reason to go to church if there wasn't art there. Maybe, in certain times of unbelief, the art has to function as a cultural presence intriguing enough to engage the imagination with spiritu-

al questions. Maybe someone will go to the Sistine Chapel to see the art and be moved to faith in Christ.

There is a lot of pressure put on artists today to be at the center of their work. You see the artist at openings, surrounded by the work, having their picture taken with it. Could it be liberating for an artist not to think about themselves as being at the center of the art?

EK: I don't think that the artist is the important actor. The focus should be much more on the work. I enjoy openings; it is a chance for me to see the work out of the studio and to see the paintings interacting with each other. That is when I can begin to assess how the work holds up. At that point, it is almost like I didn't make it; the work is on its own and I become a viewer as well. It is my work and I am expressed in what I make, but that is not the point. Art making should not simply be self-expression. It should be something larger than that.

It goes back to the most important question of where the artist finds his identity. There is a lot of art about the artist's search for identity or art in which the artist's identity resides. It seems to me like your work is an expression of identity but that identity resides somewhere else, outside of the work, in Christ, and the art simply reflects that identity.

EK: That is something I had to settle a long time ago. My identity is not in my work; my identity is who I am in Christ. That makes all the difference in the world. If the Lord brings me to a time when I can no longer work, my identity will be unchanged.

Do you think that the rise of the centrality of the identity of the artist is connected with the suppression of narrative in art, that the story of the artist has taken its place?

EK: I think that is true. The real danger I see is that, as the identity of the artist has been privileged, people think that the whole point is just being an artist and not what the artist makes. I don't think you are an artist if you aren't making something. But many want to claim the title of "artist" because they think that will make their life important. You don't have to do anything, just be an artist. But it really doesn't work that way.

One of the reasons so many people want to be artists, at least to think of themselves as artists or to be seen as artists, may be that they want to be a part of a story.

EK: Excellent. I think that is exactly right and well put. They have a hunger for authenticity in their lives. Again, I don't think the "self" is a very interesting subject for art. What we as human beings are able to accomplish can be interesting. I think art grows out of our God-given ability to act and that our actions have meaning, they have consequences. I have a Jewish friend who says that the angels are envious of us because we can act. The fact that God created us as beings of action is unbelievably interesting but the self as Self is not.

Let's tie this in with your work representing people acting in Biblical narratives. It suggests that we can be participants in history.

EK: Yes, and even more, in the history of human salvation. That is why our lives have meaning and value. Secular humanists want us to care about people, about the poor, etc. but from their worldview, why should we? Without a dimension of transcendence we are merely trapped in a Machiavellian world of power politics. As Christians, though, our concern for people is based on something even more important than the fact that each person being created in the image of God, as central as that is. Our concern grows from the fact that God thought human beings important enough to die for, giving each individual a personal worth.

As your work represents the figure or figures in action, participating in the narrative of history, it often deals with themes of conflict. This conflict could be between man and man, man and God, man and himself. Do you see the human condition as one of struggle?

EK: The interest I have in art is one of action and struggle. For the reasons we just talked about, the figure in action is more important to my art than one in repose. There are many great artists whose artistic vocabulary involves the figure in repose but that is not what my art is about. There is violence, there is struggle in life and my art speaks to those things. But I don't see these images of conflict as the overriding statement about humanity. There is love and contentment as we live out our lives in a Grace-filled world.

A lot of the discussion around your work has centered on the figure and the nudity of the body. However, I have gotten the sense from looking at your work that the figures grow out of the action of the narrative. The narrative is not just an excuse to show off the body. Is that right?

EK: Yes. It is important that the action of the figures gives meaning beyond their nudity. Many people criticize my work because they associate nudity with pornography. Inactive figures displaying their beautiful bodies opens a door for pornography, but nude figures in real narrative action most often place the intent of the art outside of the pornographic world. Figures in action are able to speak of a larger humanity — the figures have a greater life than just their sexual presence. The figure in action is able to speak of a larger humanity.

The nude figure in repose or on display privileges the viewer. Your figures contend with the viewer as equals.

EK: Yes, thank you. I never thought of it that way but I would certainly hope that is the case. I am trying to engage the viewer in such a way that they have to contend with their own physicality in response to the work—come to grips with who they are as physical beings. Without that reality, the spiritual aspects of life will tend toward fantasy. In any practical day to day sense, we cannot have the spirit without the body. That is the nature of human existence.

Of course the life-size scale of your work is important to this relationship between the figures in the work and the viewer.

EK: Definitely. If the scale of the work is small, then the viewer is completely in control of it. On the scale in which I generally work, the painting overwhelms the viewer. I hope that my work confronts the viewer with a fully formed person who therefore has some aspect that is familiar to the viewer and yet at the same time is fresh and new. I think that many of the people who find my work troubling or intimidating are responding to its overwhelming physicality as much as they are reacting to the nudity of the figures.

Why is the physical intimidating?

EK: I don't know exactly, but it may be that we are living in a Gnostic age. Gnosticism has always been a problem but it is particularly evident at a time when we want to have everything clean and pristine. We don't want to deal with the body which is unpredictably and uncomfortably in constant need of being maintained and cleaned. But if we are just dealing with the mind, and deny the body, we lose something of ourselves. The body defines who we are, not entirely, but to some degree. And with the computer and Internet, the temptation to escape the body, to take on a different identity often in contradiction to our physical form, is even greater.

Talking about the issue of our identities and our bodies makes me think of what the Apostle Paul wrote about "the old and the new man." How does that "struggle with the flesh" come into play?

OB**J**E**C**T**S** OF GRAC**E**

EK: In Romans 8 the NIV substitutes "sinful nature" for the King James' "flesh." This makes it clear that what Paul is talking about is not so much our physical being as our fallen nature. In Romans 8:10 Paul speaks of the death of "the body." In Romans 8:11 he speaks of the spirit quickening "our mortal bodies." I think that living in the world of our "sinful nature" is to live as though there is no God and no transcendence. This is to live in a world that we think we can manipulate to our own ends and desires. Christians and non-Christians fall into this temptation when we live our lives as though we can create our world as we would want it to be, as if there are no prior givens. All of the totalitarian tyrannies of the Twentieth Century have believed this lie. If there is transcendence and God has created us, then there are certain things, including our bodies, which are part of who we were created to be. We must come to grips with the reality that our bodies, and much else, are not inconvenient limitations but are gifts God has given us to pursue creatively His designs. Sin is the misuse of these gifts.

But isn't the temptation always to go the other way—to go toward the misuse?

EK: Yes, constantly; and the body can lead you in the other way in pursuing the pleasures of this world contrary to God's design. I'm not denying that the issues of "the flesh" can't be about "the body," but the two aren't the same. I think to confuse the two is to diminish both the breadth of what Paul is warning us about when he talks about "the flesh" and also potentially to diminish our ability to enjoy the gift God has given us in our physicality. Here is an example. I was visiting a monastery in Spain where they weren't anti-art, because they had art everywhere, but they had a room set aside in which to pray after they had eaten, to repent of their need to eat. But God made us with the need to eat and he made a world full of wonderful things for us to eat. We are not supposed to build our lives around food so much that it becomes the point of our lives, that would be "living in the flesh," but that doesn't mean we need to repent of eating altogether.

Although these monks haven't rejected the visual arts, hasn't this same type of reasoning, denying the value of the physical, been used to disavow our human creativity and the place that the visual arts might have?

EK: Yes, in some circles the visual arts are seen as a dispensable luxury or worse, even a vice. Some do not realize or acknowledge that visual creativity is a good and wholesome part of our God-given capabilities. I would hasten to say that being uninterested in art is not a sin and people don't need to repent of it in the same way that you would of adultery. But art grows from a part of who we were created to be. It is a gift from God that humanity can even conceive of something like art. Therefore there may be some need for repentance or reconsideration in some circles because we have rejected that gift of God instead of developing it. It's like living on just bread and water when he has given us wonderful fruits and vegetables to nourish and delight us.

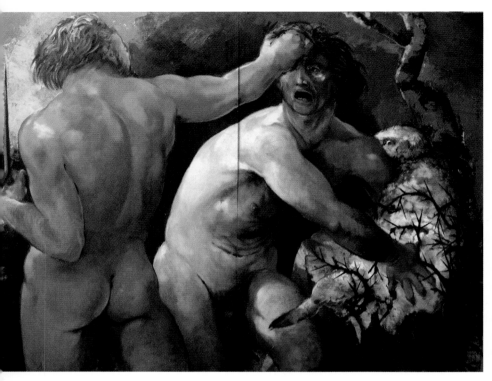

Council of the Christian Church we would have no Art as we know it. To realize this fact is to see how uniquely special painting in the West is. Here, painting has come to be not merely decoration, but an agent that can provoke complex thought and contemplation.

In talking about contemplating painting, and your paintings in particular, we should differentiate between the emphasis on physicality in your work and the Romantic objective of the mystery of "the sublime."

EK: Certainly, but I would hope that the physicality of the work would have a symbiotic relationship with a spiritual

So, we have to deal with art in terms both of our physical and of our spiritual beings?

EK: That is where the Incarnation comes in. The Christian faith is emphatic about the fact that the spiritual is not superimposed upon the physical world, it is part and parcel of the stuff of life. Matter is not evil, it is not antithetical to the spirit. This is central to our Western idea of painting. Judaism and Islam do not make images, Christians do. We do because of Christ's true Incarnation. Christianity has said that if God came in the flesh He can be pictured without idolatry. Without the Seventh Ecumenical

presence. I believe that art is spiritual by its nature in the same way that water by its nature is wet. The question, then, is what kind of spirituality we are talking about. Profound art, drawn from the deep well of Reality which is the Gospel, can help us resist the vapid spirituality of Romanticism or the sentimentality of much Sunday School material.

The spiritual, the mystery, resides in the reality of the work?

EK: If you are speaking of "presence," I think that it is a package deal. But you mention "mystery," which too often is equated with obscurity

in contemporary thought. I think that there is more mystery in the obvious than the obscure. Take for example *The Slaying of Abel* which at first seems to be just two figures, one with a knife and the other picking a lamb out of a bush. But when you start thinking about the confrontation of one human being against another, the malice of one brother against another, all that has a resonance with what has gone on throughout history. Then there is the fact that Abel is helping a lamb out of a bush an echo of Christ as the Good Shepherd. His sacrifice for us is prefigured in this image of the first shepherd about to be slain. Hopefully this poetic allusiveness will compile a richness in the work that will draw the viewer back to it again and again. But "the perfection of the thing made," one definition of art, is how well the art object interlocks with its poetic parallel—or its poetic underpinnings—to form "presence." Too often we have misunderstood "perfection" to mean surface polish.

The companion piece to **The Slaying of Abel** *is an image of Cain sitting in his field, looking rather frustrated with God's rejection of his offering. Why do you think Cain's sacrifice was unacceptable to God?*

EK: Part of his problem was his self-sufficiency. Having been thrown out of the Garden of Eden, he went out into the world and wanted to bring order out of that chaos and was successful in cultivating this wonderful farm. We see him here sitting amongst his turnips and down by his feet is a snake and a hoe, a common garden tool. The snake is at his feet but with the hoe there is also a way of escape. The devil is at your door but you don't have to entertain him. Cain probably thought of himself as a good person, he was a hard worker, and he was astonished that God had rejected his gift.

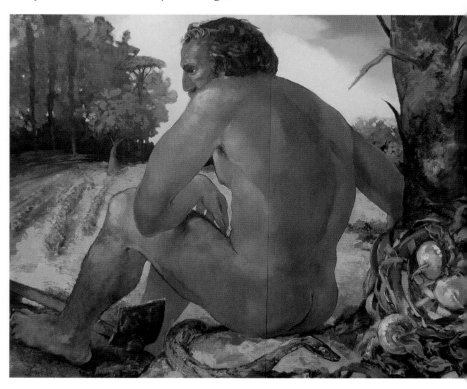

Perhaps we could think about Cain's self-sufficiency and the unacceptability of his sacrifice in relation to the artist's work. His sacrifice was something he had made. As such, Cain's sacrifice was about who he was, what he had done, not who God was and what He has done. Nevertheless, many artists think of their work as an offering to God in a similar way.

EK: Perhaps so, but I don't think I've ever thought of my work as an offering to God in that way. For me, it is simply the work He has called me to do. I am making things that our Lord might see fit to use in the world for His Glory. How He uses them is up to Him. I try not to make any grandiose claims for the work. I hope God gets pleasure from them and that others like to look at them. But I've never thought of the work as a sacrifice to Him; painting is His gift to me. I am simply doing the work He has given me to do, using the tools that He has placed at my disposal.

Still, the desire to be self-sufficient is a problem common to humanity and artists are not immune to that temptation.

EK: You're right; that is what we as artists often want to do. We are not satisfied with what we have been given and we definitely don't want anyone telling us what to do. For many, not having anyone tell you what to do is the definition of being an artist. Many artists are afraid to acknowledge God because they fear that would take away from their own creativity.

Perhaps a better attitude, one more in line with the scriptures, would be for artists to acknowledge their weaknesses and allow God to work through them.

EK: This is definitely true, but not in some mystical sense of God doing the painting through a mindless robot. As I have often said, I don't want to blame my work on Him. It is more a case of God helping a mechanic to fix a car in the best way possible. He has made Himself available to us all, artist and mechanic alike. To acknowledge our need for help in our daily work does not diminish us. It is only facing the fact of our humanity. Too often today artists seem to feel a need for unfettered freedom. By this they mean no help or hinderence from outside the self. Yet early in the last century Georges Braque said "I find my greatest creativity in my greatest limitations." Life always has limits.

In that vein, we must also recognize that painting can't do everything. I think as Christians we get into trouble when we think painting can do more that it can, when we try to make it preaching or systematic theology — something outside the purview of images. I am not doing preaching in my art, except as the Gospel narratives do it. The majority of my paintings give accounts of certain events of salvation history. All of the theology is implied in those simple narratives and the way they are presented. They tell of God's interaction with our ancestors and show what God demands of us. There are other parts of the Bible, such as the letters of Paul, that are more complex and teach in a different way, but they are less conducive or even impossible for painting.

Continuing with the theme of sacrifice in your art, one of the works I found most compelling represents Elijah's sacrifice, his competition with the prophets of Baal. It is such a terrifying image of the figure being thrown backwards, towards the viewer.

EK: He's pushed back by the falling fire.

What always impressed me about Elijah was how he put himself on the line past the point of no return. Either God was going to send down fire or Elijah was going to look like a fool and probably be killed.

EK: As well as the fact that he added water to the sacrifice.

Yes. He was taking a great risk and people thought he was nuts. That is where I was headed with comparing him to the artist. In an essay by Timothy Verdon entitled "Violence and Grace in the Art of Edward Knippers" he writes that you have "made [yourself] available to the timeless and unpredictable, unpopular and painful power of truth vibrating through life." That seems like a great risk.

EK: Yes, it probably is a great risk but one should not think of the peril, but of the truth. I cannot predict how these works are going to turn out. I paint right on the panels. I usually have a theme that I am going to try and work out. I set a stage and try to convey a sense of physicality. I ask artistic questions like, "Where do I want the weight to be? High up in the picture plane, above the viewer or down on the same level as the viewer?" Once you orchestrate all of that you aren't in control anymore. The Lord has to be in control. And he is a very present help in times of trouble. Time and time again, I have gotten instant answers to prayer in the studio.

What you describe as immediate answers to prayer in the studio and God giving you inspiration for the work is comparable to God's answering Elijah's prayer and sending down fire from heaven. "Send forth your Spirit" is the artist's prayer, and the title, by the way, of a work by Anselm Kiefer.

EK: I have found the studio to be, at times, holy ground, but I should again add that I am not claiming that God is working through me any more than he works through everybody who makes themselves available to Him—wants God's will above all else in their lives.

Turning from the vertical relationship your work sets up between you and God to the horizontal relationship of your work as it engages the history of art and the history of Christianity and the visual arts, how does that impact your art?

EK: I realized early on that what needed to be done by artists in our time was exactly what had been done by artists in the past, particularly in the period of the Baroque. I didn't set out to do Baroque painting—in fact I had been taught not to like the Baroque because it was too emotional, too much of everything. But I experienced a resonance with the intent of that work. The artists of the Baroque were working at a time of crisis in the church, because of the Reformation. Art can help to establish collective meaning; the Baroque artists were trying to impress upon the viewers

the power and importance of Mother Church. As Christian living and making art in an age of unbelief, I am trying to impress upon the viewer the power of God in the world and how He is acting in it. So it is not a coincidence that I have ended up using some of the same vocabulary as the artists of the Baroque, particularly using the human figure in the same way. I wasn't aiming to have a particular style. I was aiming at Truth and the style developed. I think it is a mistake that so many artists, particularly young artists, are in search of their style, as though that was what was most important about art.

It's only recently, in Modernism, that the visual vocabulary of art has also become the subject of art. Today there is more interest in "content," but much of that "content" is either the artist's identity, a subject we have already touched on, or social agendas of an art world that has become very self-referential.

EK: I think that one of the great challenges facing us today is a failure of imagination that is flying under the banner of the "avant-garde" or the "shock of the new" as Robert Hughes put it. Being shocking has become equated with being significant; you can see this in the sameness of so many shows and museum collections of Contemporary art. The emphasis on youth and therefore youthful rebellion may help account for the establishment of the artist-as-social-critic as the desirable model for the artistic life. We should not substitute an extra-artistic, social or religious agenda for artistic merit.

This is as true for a "Christian artist" as it is for an artist/activist making work deriding the government for not funding some program. The sincerity of the artist's intentions is no substitute for the integrity of the work, which is defined by the artist's creative and knowledgeable use of the language of his or her art.

EK: Thomas Aquinas wrote in the Summa, "The test of the artist does not lie in the will with which he goes to work, but in the excellence of the work he produces."

Returning to our discussion of your figures, I have noticed that they are neither classical nor are they like the people we see on the subway. How did you arrive at the kind of figure, the vocabulary that has become your "signature style?"

EK: I don't know. I was just trying to make figures that held their space. There is a particular body type that shows up, which is, I guess, my style, but I was really

PREVIOUS and RIGHT
Elijah's Sacrifice 1995, oil on panel, 8' x 12'

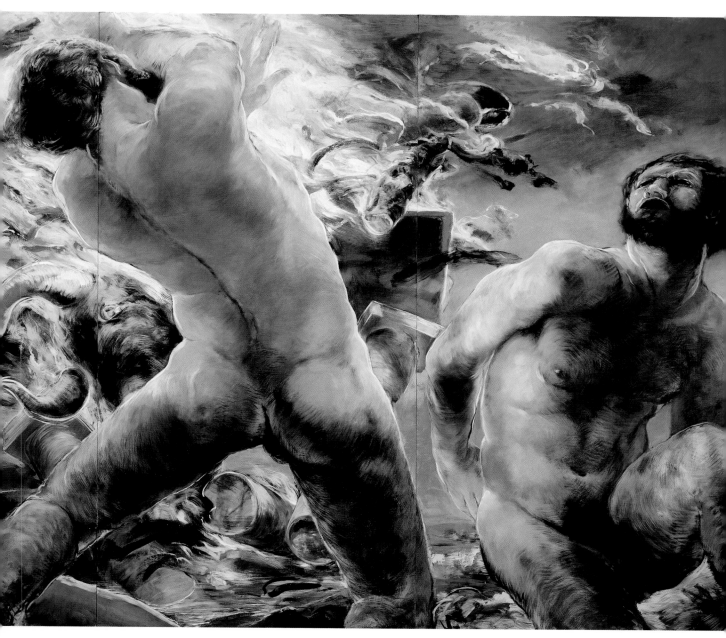

trying to make figures that had a sense of presence about them. I think about the action in which the figure is engaging and how the muscles look in that action. I am trying to show something about the presence of a human being acting in the world.

Talking about making your figures "hold their space" sounds very theatrical.

EK: My art is very theatrical, just as much Baroque art was theatrical. I had a speech and drama major in college, along with a major in art. This is an aspect of my work which has been recognized by its inclusion in a show at the Los Angeles County Museum of Art called "Setting the Stage."

How do you use the figure in your work to address issues of faith?

EK: I think the body by its very nature is the meeting of heaven and earth; the Incarnation showed us that. We, as human beings, are part of a history, a history of people. The only way I can relate to the past is to think that somebody was there; some body was there. The main relationship that I have to those people—my ancestors — is not sociological or in terms of the way they dress but that they had bodies. As I read the scriptures and realize that those people had bodies, like I have a body, and that God spoke to them, even taking on a body Himself, then I realize that God can speak to me.

Your work affirms and celebrates the value of humanity.

EK: Humanity is valuable because God said that we are valuable enough to die for. Separated from that, we are just meat. That goes back to what we discussed about "the flesh" as a view of the body that does not acknowledge its transcendence. In representing these Biblical figures in the nude, I am trying to show that these characters were individual people, just like we are. I am challenging the viewer to come to grips with their own physicality in order to have the fullness of life that God has given us.

In defining the value of humanity in terms of Christ's Incarnation and Passion, what does "the Word become flesh" mean to how we understand physicality?

EK: "The Word become flesh" means that Christ, who is eternal, came and took on human flesh to the point that there is now, and forever, a part of the Godhead that is flesh. That is amazing. In the Old Testament, God talked to us in words but in the New Testament he came as an image in order for us truly to understand who he was.

That's a powerful defense of the value and unique place of the visual arts.

EK: Exactly. God sent His prophets in order to turn us to His way—to save us from our own destruction. But we didn't listen, we didn't understand. So then He sent Christ, the Icon, the True Image of God. As I have said, all of Western painting hangs on this fact. Whether or not one is a believer does not change this reality. Bryan

Appleyard writes in an essay entitled "The true face of art" in the London Sunday Times, "that the entire western way of making art...with its dependence on the material drama of human life, and the emotional repertoire of the old masters were inspired by the intense significance of everyday objects and activities in the story of Christ. Without the physical detail of the Gospel story, there would have been no novel; without the face of Christ, there would be no coherent fine-art tradition."

Yes, Christ, His Incarnation, Passion and Resurrection, is the glue that holds western art together, not just in giving artists a story to tell but a strategy of how to tell it. Let's discuss how you develop a vocabulary to represent Him. Earlier in this conversation, you said something like, "a work is stronger if it grows out of a history of representation as the artist comes to grips with that tradition in relation to our own time." Can you expand on this idea in terms of representing such a solemn and significant theme like Christ's Passion? Perhaps we could talk specifically about a work like Christ Falls Under the Cross *in which you convey the weight of the Passion by the way the figure of Christ is trapped between the form of the cross and the edge of the picture plane.*

EK: As an artist, I depend on what has come before and then work within the language of art with all the grace at my disposal. Then, with our Lord's direction in the process, surprising things can happen. One of the things that fascinates me is the idea that Christ could have walked

away from these unspeakable events at anytime. But he wanted to be obedient to the Father. Then, of course, there is the Resurrection which completes the Passion where matter is redeemed. This is why I strive to make my figures as physically present as possible. We don't live in a fantasy world, but in a world that is fallen but redeemed.

What impact has a work like The Sacrifice, *a sixteen foot crucifixion which shows his death in a very torturous way, had?*

EK: At our church, it caused quite a stir when it was up for Good Friday. Some people wouldn't even come into the sanctuary. Others were very moved by the work, it really made his suffering real to them. One woman was so upset by the work that she wrote a letter to the pastor. When they had a chance to talk about it later, she con-

fessed that the work had made her rethink her image of Christ simply as an infant; she had not allow Him to grow up. The work was also instrumental for my godchildren's father in explaining the meaning of Easter to them. He was trying to use Sunday School literature, most of which is sentimental almost to point of heresy, but the children just could not understand. He then remembered that he had a catalogue of my work, with this crucifixion. When the children saw this image, one of them blurted out, "Oh, He really died." If they could not get that truth from the Sunday School material, there is something very wrong. The tragedy of this Precious Moments theology is its need to avoid unpleasantness, even that which leads to our Salvation.

The work was also shown in downtown Washington in Union Station. Our pastor was there one day and he saw this businessman come rushing through the station trying to catch his train. He stopped dead in his tracks. He couldn't pull himself away from the work. He wanted to go; he needed to catch the train, but he kept coming back to the work. My pastor came up and talked with him about the painting. It turned out he was a somewhat lapsed Catholic. He said that the work made Christ real to him in a way his childhood images did not allow.

Your painting definitely demands a response from the viewer and much of that, as you noted, is because of the physicality of the figures. Some people have been angered by it to the point that they have tried to destroy the work. Why do you think they reacted in that way?

EK: Well, in that instance, the vandal just wanted to attract attention to himself. But it does reveal a deep prejudice against the visual arts, particularly representations of the nude figure, that still exist.

Fundamentally, the dispute over art and the body is theological. How can we engage that dialogue and make the point you made earlier that Christ redeemed the material?

EK: To some extent I try to avoid getting into arguments with people who are not going to be convinced anyway. There was a woman who came to the annual meeting of our church, though she wasn't a member. She was an "activist" or something and started screaming about how horrible it was that my work was being shown at the church, that it was pornographic and blasphemous. Some members present agreed, other members of the congregation defended the work. Art isn't for everyone, so I know that my work is not for everyone. But because of letters and conversations over the years I know that the Lord has used it and it has touched some people very profoundly.

If your art deeply impacts some but others are either unmoved or incensed by it, is that enough for you?

EK: I don't claim to be trying to reach everybody. I think the viewer has a certain responsibility—they have to bring a certain understanding about the language of art, to the work. Otherwise you can only have art that aims at the lowest common denominator. I hope that the viewer would be engaged by my work because of the presence of the human figure in the nar-

PREVIOUS and OPPOSITE
The Sacrifice 1986, oil on panel, 16' x 11' (irregular)

O B J E C T S O F G R A C E

rative context. That's my job. In other words, I think it is the job of the painter to make the work emotionally and intellectually viable. The viewer may not know anything about the Bible or the narrative being worked out in the painting. But I have to make the image strong enough that they want to find out about it—it must have a powerful enough presence so that the viewer can't easily forget the encounter. Then, I've done my job.

Turning to a more general discussion about the relationship between the Christian community and the visual arts. What do you see as the state of that relationship today?

EK: We have a whole new generation of artists coming along now that did not have the same struggles that I had when I began to work. They don't need to have permission to be artists. My generation had to ask the question, "Is it possible to be a Christian and an artist?" That question has been answered in the affirmative. Another problem we faced in my generation was the perception that art was frivolous, not important to this life or "advancing the Kingdom." The importance of art has also been affirmed. Now that we don't have to defend what we do as much, we have more freedom as artists. The question becomes what to do with that freedom.

How would you answer that question?

EK: I would say look at art history. Christianity and art have a long and rich history; we are standing on the shoulders of giants. We don't have to start from scratch. A lot of what I am doing, for example, in my work comes out of a single statement in an art history book. It said that the one thing that Christianity brought to the visual arts was a story to tell. Artists had the language of the body from classical antiquity but Christianity brought a story to tell. It was the theology of St. Francis that allowed for a Giotto to begin the reinvention of the classical tradition in Christian terms. This produced what we call the Renaissance. In the same way, our response to all that

ABOVE
The Mocking of Christ
lithograph, 11 3/4″ x 8″

has come before in the light of our present world will define our contribution to the artistic endeavor. Can today's Christian artists produce what art historians in the future will call a renaissance? We have the heritage to do it if only we don't have a failure of imagination.

Artists of the past who have wrestled with developing a language for representing the Christian story are a "great cloud of witnesses," to borrow a familiar term. So today an artist who is a Christian has a firm foundation and a strong community from which to make work. But what about the issue of patronage, developing patrons for the visual arts among the Christian community?

EK: This has a very long way to go. In recent years there has been a lot of hoopla over the National Endowment for the Arts, but many in the Christian community have not put their money where their mouths are. I want to say, "If you don't like the kind of art that is being done, the kind of art that is being promoted by the art world, then you need to financially support artists who are doing the kind of art that you want to see in the world." There is a great story about how BB King became a Blues player. He wanted to be a Gospel singer and, when he played Gospel music, church people would pat him on the back and tell him what good of a job he was doing. But when he played the Blues, people gave him money. So, he stopped playing Gospel because he needed to eat. How many potentially great artists have we lost because of an absence of patronage?

What advice would you give to a potential patron of the arts?

EK: Collecting is an act of faith. It is a statement that there are things worth owning and preserving for generations to come. I would urge them to buy one major work of art every year for five years. A "major" work of art could cost as little as

O B J E C T S O F G R A C E

$100, if you are intentionally looking to buy. They should save a little each month towards that purchase. At the same time as they are doing this saving, they should be looking at as much art as possible, including visiting museums so that they learn the language of great art, before they make their purchase. Perhaps a group of people could get together and keep each other accountable. There is too much good original art out there for people to have reproductions in their home.

As a collector yourself, and people should know that you practice what you have just described in an extraordinary way, what do you look for in a work of art that you might buy?

EK: I am looking for the best art I can afford. I know my art history pretty well. Also, the more I collect, the more I see how particular works will fit into our collection. Perhaps it will fill in a particular gap in the collection or there become particular groups of artists or periods that interest me. Some things I simply like to look at.

So, is there some truth to the "I know what I like" approach?

EK: More to the point is that we often like what we know. But we should not stop there. This is where much looking is important.

There are many good reasons to collect art, and as you suggested very few reasons not to, but it seems to me that the attitude of the collector is that art is something you live with. Art isn't something "over there," separate from life, or in a museum that you visit on vacation. Art is part of the everyday.

EK: Yes. And there is good art available almost anywhere for just about anyone. I believe that even a homeless person can go to a Goodwill and find something, an original work of art, that is worth living with. One of the major components of my collecting practice is prayer. I pray for a good find and God answers prayer, again and again. He knows what I can afford and He amazes me with what He brings my way. I once found a Jacque Callot being sold at a flea market. I literally picked the work up off the street. But God made that possible—I had prayed for a good find that day.

Finding something beautiful in the everyday, seeing God's hand in the everyday, that is one of the central themes of your art. Am I right?

EK: Yes. That is what is so important about the Incarnation; God came into the very fiber of our lives, right into the middle of our world. Because of that everything is transformed, everything is made new.

Is it fair to say that your work is driven by the dynamic energy of God's transforming work—that you try to find a way to express and perhaps even participate in that drama, that ongoing and eternal narrative, through your work?

EK: Yes. We live in a dynamic world full of His Grace and the weight of His Glory if we will only open our eyes to see. I pray that my art will be used by our Lord to open many eyes.

CONVERSATION WITH **ERICA DOWNER**

October 2001

James Romaine: There are a lot of people talking about Post-modernism and even what might come after it, but there isn't as much clarity about what it is. I won't ask you to look into our future, but how would you describe our present?

Erica Downer: Post-modernism means different things to different people. It is a post-enlightenment paradigm; one of its principal characteristics is a lack of faith in universal truths. Everything is perceived as relative, so there is no commonly held belief or accepted truth. This manifests itself in many different ways depending on whether one is talking about architecture, the visual arts, literature, or popular culture. Whatever the specific instance, it is important to remember that Post-modernism is constructed on a false foundation. If there is no given and accepted foundation, you have to make up your own foundation; a foundation you've made up yourself is not really a foundation at all because it isn't founded on anything except the one who is depending on it. As an artist, I try to show that there is a permanent and fixed foundation, who is God.

How do you see this played out in the visual arts today?

ED: One of the problems of Post-modernism, as a philosophy of the arts, is that it doesn't believe that any real and meaningful communication is possible. Art grows out of an urge to communicate but Post-modernism denies that possibility. What happens in the visual arts is a lot of deconstruction, taking the language of art apart.

I don't disagree with what you are saying, but, at the same time, I see a lot of contemporary art that engages issues of faith. In some ways, Post-modernism creates an environment, not without its challenges, which is nevertheless more open to Christianity than Modernism.

ED: I agree with that completely. There are many people who are searching for truth and a lot of them are looking for it in or through art. You can also see evidences of this searching in popular culture as well. Even though there are many people who see Post-modernism as a continuing decline in culture and morality, what has happened, almost as a reaction to an atmosphere of hopelessness, is that people are more honest about their searching. Sometimes things have to touch the bottom before they get better, as opposed to those who are satisfied just living

"good lives," thinking that is enough. The kind of searching evident in a lot of contemporary art is a great opportunity to talk about faith.

How do you, as a Christian and an artist, respond to this situation?

ED: The work of an artist who is a Christian will naturally reflect their faith. For example, as a Christian, I have hope and I believe that my art can express that hope—the hope that this world is not the end and only thing, but that we were made for something greater. At the same time, it is really important that our work be honest about our struggles. That honesty can show that we are dealing with some of the same issues as everyone else, the questions of our time, but that we come at them from a position of hope.

I see my work as a response to the idea that everything is relative and I have based my work from the very beginning on the faith that there is an ultimate truth and foundation. That comes out in my work in ways such as the fact that the metal structures on which the works are built are all based on the grid. The grid is a loose grid, it is flexible, but at the same time it retains its consistency.

How does your work speak to our struggles?

ED: I think that our human condition is one of being broken. The very fact that we mourn over our brokeness is an acknowledgment that there was something better before, there was something that was perfect and complete. While we are here on earth we are never going to be complete in that way. A lot of my work has to do with

that sense of brokeness and the damage that has been done. I am speaking of the damage done by sin. My work also deals with the issue of sin and its lasting impact. It also deals with redemption and how we are in the process of transformation. I believe that even though Christ has died for and redeemed us from our sins, those sins still have repercussions in our lives and damage us in many ways. My work is concerned with representing that damage, that broken quality.

Your objects look like they do not "fit in." Is that an issue you have wrestled with, as an artist, as a Christian, or as a woman?

ED: Definitely. In every way possible, I do not feel like I "fit in." People tell me that I don't look like an artist, I don't wear the right clothes, have the right hair, or have a flashing sign on my head with an arrow pointing at me saying "artist." As a woman, I have a lot of qualities and interests that are considered "masculine." When people get to know me, they find out that I am very feminine and that confuses them even more. So there are a lot of contradictions, or seeming contradictions, that feed my work.

It seems like you're talking about the problem of judging from appearance, which is a very interesting issue to deal with in works of visual art, which are naturally judged by their appearances. How do viewers respond or react to these rather peculiar works?

ED: My work is very much concerned with the idea of what I am on the inside being different from how I appear on the outside. The fact that many of my works have an inside that is

exposed to the outside is both vulnerable and truthful. It makes the work truthful about what it is.

When it comes to making works of visual art, I think that beauty is very important. But I think of beauty very broadly, not necessarily in the traditional sense. But it is important for the work to draw people in, to intrigue them in some way, to bring them back to look at the work again. I think it is important for the visual arts to be visually stimulating; the work has to communicate in visual terms. What makes good art is when the message and the materials are so intertwined that you can't pull them apart. After the viewer has been drawn into the work, you begin to notice things and recognize things; there are discoveries and manifestations of ideas through these objects. So, the appearance of the objects is very important but it is as a means to draw the viewer into what the work is about.

Many people think of beauty and virtue as being the values of art. How do your works represent those ideals?

ED: Well, the Greeks, our Classical heritage, held that Beauty was truthful and that Truth was beautiful. But Hellenistic art often showed people who were not "ideal," people who were past their prime or people who were somehow imperfect. I think of my work in terms of that kind of beauty, a beauty that is not ideal. It is not the flower at the height of its bloom, but it's about that time before or that time after. It's about the process, how things move and change. Often, as things get less beautiful on the outside,

they get more beautiful on the inside. A person may get older, their skin all wrinkled and such, but if they are in the process of being sanctified by Christ, they are becoming more and more pure on the inside, that's true virtue. Beauty does correlate to truth, but the truth is God.

So your work is in transformation, disintegration and regeneration. They are grotesque, as Bakhtin would use the term, and ludic or playful.

ED: I think that those ideas would certainly apply to my work. I think of the grotesque as two things that don't go together but which have been put together in such a way that they can't be separated. What makes it grotesque is that you can no longer identify something as this or that—either way it has become malformed. This describes the human condition and my work responds to that.

How does a work like Awkward, Awkward, Grace respond to the human condition.

ED: Like most of my works, this piece is organic in form; the organic are things made by God that are alive. I see my works as still things which were alive but have been stopped in time, but they still retain that sense of "being made."

Awkward, Awkward, Grace, with its long legs, looks a bit like an insect. The legs are so small compared to the headless body of the piece that you wouldn't think that it could stand. But despite how big and ugly the body is, these three delicate legs hold it up. It's the same way with faith. My faith is often too small, but it still supports me; it holds me up. It is not that my

faith is so strong but rather that it is in something, or someone, who is strong; because it is in God, it is very sturdy, because of His grace.

How can works of art be an evidence of grace?

ED: I would say that it has to come from the work of art itself, the meaning has to be communicated through the visual forms. In the case of *Awkward, Awkward, Grace,* it is how these wiry legs support the body of the piece. Something on the ground is treated with less respect than something that has been placed up higher. If you care for something you lift it up. Hopefully the viewer will be lifted up by the work. They will find hope in that, while we are still grotesque, grace and mercy make us beautiful.

It seems like you are working out issues of your own faith, in a sometimes difficult journey, through your art.

ED: My work has always been about my spiritual journey. Before I became a Christian, I was convinced that there was something more to life than what I experienced and I was searching for it. I had grown up in a church but I didn't fit in there. I was disturbed by contradictions I saw in Christianity. I even made some works of art about contradictions I saw in the Genesis account of creation. This spiritual struggle forced me to study the Bible very carefully and things began to make more sense as I worked through them in my art.

You described being in a church but not fitting in; that seems to be the experience of a lot of artists. There are many in the church, today and in history, which do not think Christians should be artists. When you became a Christian, did you think it would be the end of your life as an artist?

ED: Not at all. When I became a Christian, while I was in art school, I was fortunate to be surrounded by Christians who supported me as an artist.

How has your thinking about your own creativity developed as your faith has grown?

ED: Before I became a Christian, my whole identity was in my work. I was experiencing some success in through my work. And I won awards, grants, etc., but whenever I didn't get into a show or win an award, it was like the end of the world. When I became a Christian, I had to learn to give up my own selfhood and humble myself before God. It wasn't me who was making the work, but God. He is working in my life through the process of art making. The work is a record of miscellaneous memories. Whatever is going on in my life plays out in my work, and the work impacts my life; it brings about changes in me. It helps me understand myself as being created by God. God has made each individual in a particular way and for a particular purpose. Things were not happening by coincidence, but the He is really in control.

In talking about how your life and art interact, it seems like your work strives for a genuine honesty of expression. That kind of honesty involves a lot of risk and vulnerability. It is a lot easier just to be ironic. Irony is a cheap form of expression.

ED: Yes, it's a way of commenting without engaging or confronting anything, it's a way of not dealing with things. But, I have found that many people aren't really being honest with themselves. This is because dealing with things is painful. My work is painful because it is about the struggles that I have, it is very honest and personal. I want to share these things that I struggle with because I know that there are other people who are struggling with them as well, whether it is in the exact same way or whether it is more metaphoric. Art is about communicating and connecting with other people because God made us to live in community. Of course this goes against the philosophy that communication is futile. Maybe that's where irony comes in—it is an attempt to communicate when you know that you can't. I think that art proves otherwise.

Having said that your art is, at least in part, about your struggles, how do you represent this experience of being broken?

ED: My work often has wires or other sharp things that protrude like weapons that keep the viewer at a certain distance. We are like that as people, because we are afraid of being vulnerable. But these wires are often turned back on the piece itself; it is wounding itself. I think that speaks to how we, in our sin, are self-destructive. There are a lot of artists who are self-destructive because they think it will stimulate their creativity. But I think that good art comes out of facing one's issues not denying them.

Can you be more specific in how this is evidenced in a particular piece?

ED: I'm working on some pieces right now, that are as yet untitled, that resemble maces or clubs. But the way the pieces are constructed, they hurt the user as much as they hurt the person being clubbed. Furthermore, using these

clubs will destroy them as well because, while they are sharp, they are also delicate. They are much like us in that way. The pieces also have doll baby heads on them which creates a juxtaposition of violence and innocence, death and birth, hard and soft, angry and lovely.

The issue of being broken is often represented in my work through something that has been taken away or removed from its original purpose. It becomes a thing that no longer has any function other than to be displayed. I often feel like that we, as human beings, have moved so far from the things we were meant to be and do that the real meaning of life has been lost. For example, our lives are full of idols, things that we worship and put up on pedestals instead of worshipping the One whom we are meant to worship, in whom we find ultimate fulfillment and completeness.

Some other pieces I am working on right now are trophies that resemble horns. They could be shown individually or as a group. One of the things that interests me is to learn about and make use of the history, the baggage, of the forms and materials in my work. The horn has been used as a fertility ceremonial object, before there even was a concept of "art." They would be hung on the walls of shrines. Aspects of this connection between horns and maleness or virility continue even today in that it is not unusual to find a pair of antlers on the wall of a den or some social club. But my work emphasizes how the horn has been torn away from the animal and how it has lost its principal function or purpose. So there is something

dysfunctional about it. I'm also interested in the idea of a trophy as something that symbolizes one's accomplishments or power. But these pieces are displayed in a way that they are more vulnerable.

In discussing these objects whose only remaining function is to be displayed, I see a comparison between trophies and works of art. Specifically in how art is often treated as a commodity in our society and something that is a trophy of one's social status. They way in which many people have expensive paintings hanging on their walls is not that far removed from the antlers in the den. This use or misuse of art seems to be another example of our dysfunctional approach to creation and creativity.

ED: Yes. The result is art that is very superficial, as we have said, its only function is to be displayed. The artist making the work because they want to be "an artist;" they want to be an artist celebrity. The artist, the work and the collector are all exclaiming in unison, "Look at me!"

I like to combine things so that the work doesn't just look like one thing. You can't walk up to the piece and say, "Oh, that's a horn," and walk away feeling like you've taken in the piece.

Getting back to what you were saying about the ceremonial function that these objects had even before they were "art," let's discuss your piece Tender Relic. *Like many of your titles, it is more poetic than descriptive.*

ED: The title is like a zip code to help the viewer connect with the work. *Tender Relic* is similar to *Awkward, Awkward, Grace* in that it stands on three legs. Its top looks like a nest and its shell has a shiny blue quality; this surface may resemble an egg, though its form does not. It is somewhat strange because the nest is inside the egg, another inside/ outside juxtaposition. Also, its surface has a grid pattern that echoes the grid construction that is on the inside. These similarities and contradictions between the inside and outside of the work deal with how we perceive the world, which is often inside out or upside down from how God perceives things. But I think the work has a broad range of interpretations; I wouldn't want it to be just one thing or another. The work has its own personality.

Continuing on with the issue of inside and outside, let's talk about Delusive Desire, *which raises the quandary of simultaneous attraction and repulsion.*

ED: I think that this work is one of my most successful pieces to date. It is a piece that is like a bottle with a stopper. Certain elements of the work, such as the red fabric that are part of bottle and stopper, are seductive and sensuous, plus there is the natural curiosity of discovering what, if anything, is inside the bottle. However, if you reach for the stopper, you will be wounded by the wires that protrude from it. There is something that you want but your access to it is denied.

ABOVE
Untitled 1997,
Mixed Media, 5 1/2" x
7 1/2" x 1 1/2"

OPPOSITE and NEXT
Untitled, 2000,
Pencil on paper, 8"x 8"

These (hardware)nails with (finger)nail color on them, is a clever subversion of the "masculinity" of the nails and the "feminini-ty" of the color. How do you engage these issues of gender?

ED: As a Christian woman, these issues aren't really raised or addressed in the church. Growing up during the women's movement, I was told that I needed to empower myself. That there was no difference between men and women. When I became a Christian, I had to reconsider the roles of men and women. I had to think about the issue of power and submis-sion. This piece represents two different views of the issue. I think that this piece represents how I perceived myself on the inside and how I was projecting on the outside.

One of the artists who would seem to have opened up a lot of space for you to work in is Eva Hesse; not only did she inscribe her fem-ininity in her art but she worked very hard to establish herself as a practitioner in a medi-um—sculpture—dominated by men. What do you make of her art?

ED: I really like her work a lot. She is important for me because she didn't think of herself as a "woman artist" but as a woman who was an artist. She made work that was really conceptu-ally and visually powerful. Again we are back to the issue of power, what makes something pow-erful. Of course, her life was tragically cut short so a lot of her ideas about art were not able to reach further maturity. I think her ideas were still in the process of development but her use of materials was really advanced.

Another piece that seems to deal with this simultaneous attraction and repulsion is an untitled piece that looks like a book. Can you describe how you made this piece?

ED: Using a frame that looks like a book, I cleaned out the inside and filled it with plaster. Then I used a stamp, the kind that you can get at a store, to cover the inside with flowers. The out-side has hardware nails that are painted with fingernail polish. The outside is abrasive and tough. The nail suggests control, if you nail something or someone down, they are submis-sive. By contrast, the inside, has the readymade stamp, a cookie cutter image, of an image of or conception of delicate beauty.

Hesse came along at a time, in the mid-1960's, when the relationship between painting and sculpture became a major issue. Sculpture was suddenly more 'real' in its literalness and physicality, while possibilities for painting and its illusionism were considered by many in the art world to be exhausted. How does your work negotiate between sculpture and painting?

ED: When I was in graduate school, all the women were in sculpture and all the men were in painting. By my second year, I was the only woman left in the painting department. Perhaps it was because Eva Hesse opened up possibilities for women as sculptors but there wasn't a comparable figure working in painting.

When I think about painting, I think of the surface. I love the way the paint of an artist like John Singer Sargent creates a surface on the canvas that draws you in. On the other hand, sculpture has more of an emphasis on form. I try to bring the two together in my painting/sculptures. This is just one more way in which my works bring two disparate things and make them as one. I see myself as a hybrid of conflicting parts and this comes out in my work in the way I combine mediums.

Just to throw another medium into the mix, you have also dedicated a great deal of creative energy to pencil drawings. Some of these are of simple objects like a pair of socks, the cardboard roll from a roll of toilet paper, or the collar of a sweater. How did you begin making these drawings? Why did you start making pencil drawings?

ED: I was motivated by a love for the medium. I had been using fabrics in my painting/sculptures and I started thinking about how I could use it in a two-dimensional way. I didn't want to abandon myself completely to three-dimensional forms.

Those three-dimensional forms are not representative, they just are what they are, but there are figurative.

ED: Yes, that identifies a problem I am having with my work right now. I have found that my two-dimensional work, mainly my drawings, are more about space as landscape but my three-dimensional pieces are more figurative. So I'm struggling translating from one to the other because my goals in each are totally different.

These drawings made me aware of something which is also central to your painting/sculptures, your sensitivity to texture. Texture may be the main thing that all your work, in every media, shares in common and it may even be looked at as a meeting point between surface and form in your work.

ED: I feel like I have found the place I need to be with my work. I have found the textures, forms and materials that I need.

What about the issue of your painting/sculptures as figurative?

ED: I think that the forms of my three-dimensional work are organic and they have parts that relate to the body, thus they are sort of figurative. They deal with associations you would have with the body.

Furthermore, they excite a strong identification with the viewer's body. What do you think about the relationship between the art object and the body?

ED: This is another difference with painting. Painting, even abstract painting, is about another world. But sculpture is in the same space as the viewer. It is occupying space that the viewer could have occupied but now can't because the sculpture is there. So, you experience sculpture more directly. Sculpture is more confrontational, and, in this way, may be more powerful than painting.

It seems like you conceive of your painting/sculptures as being installations with which the viewer interacts. I know that the first time I saw your work, you had set up the space as one piece that was unified by a grid of metal plates installed on the floor.

ED: Yes, that is true. I really like it when museums exhibit work within a recreation of the environment in which they belong. I like being taken into this other world; it is magical and fantastical. By making an environment with my work it forces the viewer to be a part of it rather than being an observer.

Specifically, the installation to which you were referring involved 100 pieces of 12x12 inch sheet metal on the floor. This created a reflective surface, but somewhat distorted. I had seven bell shaped pieces hanging from the ceiling, at different heights. The bells were made out of fabric with buttons as clappers. Because the bells are made of a soft material, they won't make any sound. But there was one bell that hung close to the ground so that its clapper could tap on the floor. To me the work was a metaphor that we are reliant on God, the grid work foundation of the universe, for us to function at all. The bells that were self-reliant were completely dysfunctional but the bell that was the most humble, the one that had come to the lowest point, was in fact the only one that connected with the grid that then gave it life.

The use of the grid in your work suggests a sense of order, a cohesive world view, in which, as you said, God is the foundation. This may be something which Christians can offer to our present culture—something which the visual arts can express in a unique way.

ED:
One of
the important
things about that
installation was that each
of the bells was constructed on a grid wire
armature. Each piece contained within it a refer-
ence or likeness of the grid that held them all
together. Yet each piece was unique.

I am very excited to be an artist working in
this place and time. It confirms my faith that
God does have everything planned out. We are
at a point in history when things are ripe. People
are searching for something meaningful. I feel
like God has placed me, here in New York, where
I can use my gifts in the best possible way.
Because I have had a lot of doubts and
questions and have searched hard for some-
thing that is meaningful, I feel that my work can
speak of hope to some of the questions of our
time. I think good art comes out of a persistent
search for truth. While there are many non-
Christians who do this and are making very
good art, the Christian may be at an advantage
here. However, many artists who know the truth
are held back by not knowing how to represent
or express that faith in a way that doesn't come
off as superficial. That's the challenge.

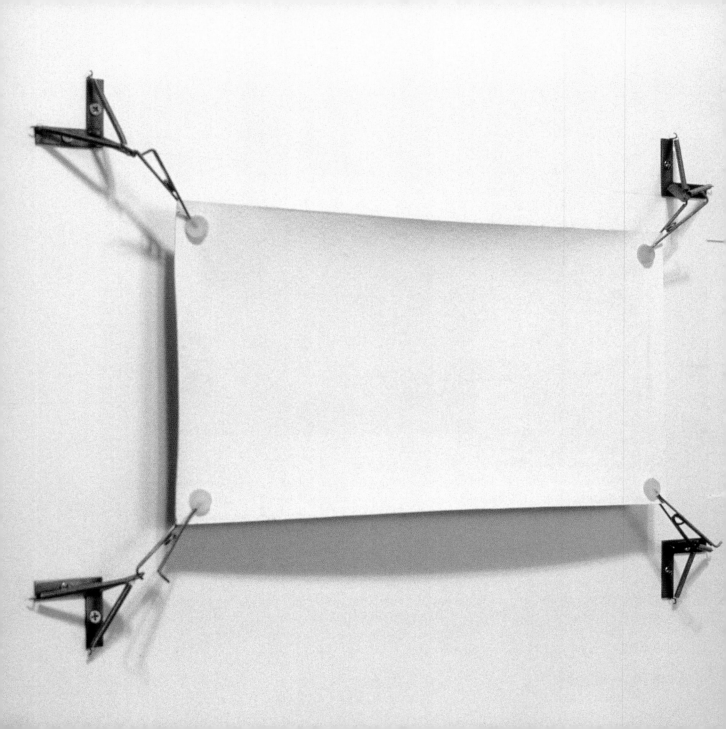

CONVERSATION WITH **ALBERT PEDULLA**

December 2001

James Romaine: How do you deal with the tension or balance between the conceptual and craft aspects of your work?

Albert Pedulla: At the most global level, they are unified. They are each integral to the other. The ability to execute an idea is bound up within the idea itself. I don't imagine a work in a vacuum and then sit down and try and figure out how to make it. I can't conceive of a work without thinking about how it would be made. The process of making things suggests certain technical problems. The work itself is birthed out of the making of the thing, but I don't think of my work as being directly about the craft.

Art is a visual thing and I am not interested in the conceptual side of things for its own sake. The idea is only interesting to me as it is tied up in the visual expression. A great idea can make a lousy piece of art and a simple idea can really make a powerful work of art. My work begins as a visual thing but it also serves to convey something else, something other than itself.

Compared to many works of art, for example a painting by Rembrandt van Rijn, your work is more evidently about a particular conceptual idea since it is not representational of anything else aside from itself. At the same time, your work is also reliant on a high level of craftsmanship, that is also right in front of the viewer. A person may have a limited appreciation for the impact of a painting by Rembrandt without thinking about why or how he made the work, but your art makes this link between the concept and the craft of a work of art, the subject itself.

AP: Certainly Rembrandt was working in a different age, but I think his contemporary Jan Vermeer did certain experiments with the way in which a work of art could "represent" that relates to the concerns of my work. I think that the way a work of art is crafted is completely tied up with what it is about. This phenomenon seems evident to me in Vermeer's work, particularly viewed within his historical context.

I am working in a time in which conceptual art has raised certain issues and the purpose of the work of art has also changed. My recent works, the *Objectification Series,* are visually rather minimal; they are non-representational and limited in both color and form. They are just the paint, the drywall and the brackets which suspend the removed surface area. Another recent work *Springbed,* its full title is *Springbed*

of the Universe (*a working model*), is much larger with many different parts. I think of it as being "baroque" or "operatic" compared to the *Objectification Series* which is sparse and minimal. In each case the conceptual and the physical (craft) drive each other.

SEVEN SILVER BALLS *CORD* *THREAD BRACKET* *ROTUNDA* *GUY WIRES* *PAINTED CLOUD LINING ** *PHOTO* *BOTTLE ROCKET* *CAST CHERUB* *EARS*

How did Springbed *develop?*

AP: It grew out of a problem I was having with drawing and I set out to make a machine that would draw a spiral. I had developed a technique over many years of making large pigment based photographs on which I would then draw and manipulate, using the same pigments. I was working on a very large diptych and kept going to the studio and not drawing on it; I just couldn't muster the will to draw in that way. Eventually, after about two years, I just took the work down and decided that I wasn't going to draw on it. *Springbed* was an answer to a problem of how to make a drawing that seemed relevant.

Why did you become disillusioned with drawing in that way?

AP: I was thinking about the purpose of what I was doing and I felt like these drawings, which were very interesting on a technical level and also very beautiful, were nevertheless self-refer-

ential. There is a lot of contemporary conceptual or abstract art which become a string of art references to the point where a whole world of meaning is created in a cyclical kind of way. The Modernist notion of how we are to make art has become more and more absurd and boring. So, then, the question I was left with was how to make a work that was both interesting to me and also meaningful in some way.

How did a work like Springbed of the Universe *respond to that question?*

AP: My critique of Modernism is expressed or embodied through the work. I don't know if I could precisely articulate these opinions, but part of the joy of making the work is that one gets caught up in that creative process of searching for these answers. The work itself is asking questions about meaning, whereas the earlier drawings were a bit naive in that they suggested that the meaning was contained in the work and is doled out to the viewer. That was the accepted way in which art functioned in Rembrandt's time, so his work does not really question its own purpose, but, having seen how this paradigm was played out in the twentieth century, I found that process was less fulfilling. A work like *Springbed* asks questions about its own origin. So, the work embodies the questions that I have rather than trying to answer them. It deals with these questions in a very practical way.

Can you describe Springbed?

AP: *Springbed* is a linear piece, in two rooms, that is anchored on both ends by drawings. In one case it is a drawing made on the wall, or perhaps I should say burnt on the wall, by the igni-

tion of a bottle rocket, and at the other end it is a mechanically drawn spiral. There is a bottle rocket attached to guide wires (or the more technical term, guy wires) that connects to a chain. That chain hangs from a skylight and connects to seven chains that hold a "rotunda" made of bent plywood. The inside of this cylinder, which is about a foot tall and three feet in diameter, is painted with clouds. The bottle rocket is ignited and travels up the wires to the single chain from which the rotunda hangs. At this point there is a pulley with a cord that runs through it. This cord is held by a thread, which the rocket breaks. This releases a cast cherub which descends by the force of gravity through the rotunda (or "through the clouds"), pulling the cord behind it. This cord runs through the pulley and about sixty feet to the opposite end of the second gallery where it ultimately connects to a set of gears carved out of cherry wood. As these gears turn, they move a drive belt that operates a drawing machine that draws a spiral, in gold, on the wall. On the wall, in proximity to the drawing machine, is a photograph of an old-fashioned bedspring, which is fairly Baroque-looking in its armature. The spiral, drawn by the machine, covers or crosses part of the photograph. The wall itself has been altered in one place within the photograph. The springs in the photograph are funnel shaped and, behind one of them, the wall has a funnel-like depression that recesses into it. The image of the spring spirals down into the vortex of this indentation. Emanating out of, or perhaps into, this vortex is a series of seven silver spheres. The smallest of them is actually down in the recessed part of the wall and they grow in size as they

extend out of the area of the photograph.

So, we have these two drawings which were created through this performance/ mechanical process which takes about a minute, but the marks endure. The viewer, who probably did not witness the initial event, nevertheless has all the necessary visual information to reconstruct what has transpired.

How is **Springbed** *different from a work like Jean Tinguely's* **Drawing Machines?**

AP: Tinguely's *Drawing Machines* were, intentionally, absurd. They were very quirky and somewhat primitive; they did not always work very well. That's not to say that they weren't wonderful or interesting in their own way, but I read them as being about a certain technology gone mad. In this way, they were a critique of Modernism and its belief in the machine.

I don't perceive technology as being a direct subject of my work. I think that both my work and Tinguely's, each in our own way, have a certain degree of tongue-in-cheek, or humorous quality.

Springbed of the Universe *and Tinguely's* **Drawing Machines** *make particular statements about the nature of creativity. Your work represents an open and expanding universe, one in which God is active, while Tinguely's is a closed and collapsing universe.*

AP: I would say that Tinguely's work is pessimistic on one level but it still engages in a search for meaning or even beauty. I think his work is engaging, perhaps even despairing over, what man has done to himself where as my work is asking questions about what is beyond man and beyond our own doing.

How does your work engage and move beyond Modernism?

AP: My art is the process of my thinking through where I stand on that question. I think that what we call "Post-modernism" is really just a subset of Modernism; it's not really separate. My work questions some of the Enlightenment foundations of Modernism and its self-satisfaction. But even though I am critical of this Modernist paradigm, it is still the vocabulary I have to use in order to be engaged with or relevant to this time. I would say we are all Modernists by default. It is the air we breath, it is in the water. My work critiques or subverts the triumphal, overly optimistic, aspects of Modernism.

Can you think of other artists whose work operates in a similar way?

AP: Well, there are some artists who are making work that to some degree looks similar to my work, but I don't know if that means they are pursuing the same issues that I am. One artist whom I am very interested in is Robert Gober, particularly his more recent works (although, if you ask me next week I might be thinking about a completely different artist). Even though his work looks very different than mine, he seems to have a similar ambivalence about Modernism and is engaged in the question of true spiritually as contrasted with the clinical, closed, spirituality of Modernism. So, I feel a certain kindred spirit with his work. Yet, on the surface, I don't think people would categorize us together.

"On the surface," is, in fact, a great way of saying it because both of your work engages the surface of the wall as a literal and metaphoric threshold and works to move us beyond, or rather through, that threshold. Gober does this by embedding what look like sink drains into the wall, turning them into peep holes through the wall. He also engages more traditional methods of moving through the wall by painting it as a wooded landscape, as if the wall had fallen away and the gallery were opened up to the outside world, but the outside world transformed into an enchanted forest. Compared to his work, your **Objectification Series** *can initially seem to be separate from the rest of the world. I mean a painting of a wooded landscape has a*

clear, referential relationship to the world that your wall objects do not. But can they, in fact, reconnect us in a meaningful way to the ultimate reality that lies beneath the reality of the landscape?

AP: I might argue that the image of the wooded landscape is at least once, if not twice, removed from the actual wooded landscape. The painting represents the artist's view of the landscape and is made out of paint that has very little in common with a wooded landscape. My work is about the wall; it is the wall. So, there is a cutting through of the distance between the art work and the world of the viewer. It is just that we have preconceptions of what the work of art should be, and my work questions those preconceptions that would prefer the painting of a wooded landscape.

By removing and re-presenting a piece of the wall, I am asking "what is behind this?" On a literal level, you are seeing what is behind it—the plaster surface—but there is also the metaphoric question of what is behind our understanding of art. The traditional painting of a wooded landscape is not tipping its hand in the same way to question what is behind it. I see Gober's use of the forest as making just such a point. This is why I feel connected to his work.

The walls of the room create the boundaries of that space and the reality that we exist in, at least the physical or material reality that we can experience—also has its walls. By faith we know that there is something beyond those boundaries and prayer is one way of penetrating the threshold or limits of our

universe. Art maybe can peel away some of the surface of these metaphoric walls and explore what is beyond them. You are doing this in a literal way, but art in general does that metaphorically.

AP: I think that is great image for *Wall Object #4*. Like Gober, I am trying to see through or into something else and helping others to see beyond that wall, literally and metaphorically.

Gober's art is very obviously about his own personal issues, which he uses to speak in a powerful way about our collective human condition.

AP: Yes, I see what you mean about Gober's work, but what I take away from it is a certain "coolness" about things and a simplicity or directness of image. I'm interested in assessing his work up against the weight of Modernism's assertion of total objectivity.

I wasn't trying to discount the real kindred connection between your work and Gober's, but I'm curious if you see your work as more "personal" than it appears to me.

AP: Well, my work is personal in the sense that it is (in part) an argument with an art that intrigues me but that also leaves me wanting. I'm thinking of artists like Robert Irwin, James Turrel, or Richard Tuttle, whose work I find to be very quirky and personal. Perhaps because the imagery in my work is fairly distilled, in some cases down to just the wall itself—although *Springbed* is certainly more operatic than the more recent pieces—my work in general doesn't lend it to being categorized as an art of the

"personal." I don't really know if I can answer the question. The work is personal to me.

Springbed *is a very personal piece. The artist, in absence, has a presence that fills the work. Part of the work is the viewer looking for the artist through what is left of his creative action, through his handiwork. The evidence of the hand of the creator is in the details of the work as self-expression or declaration of being. It raises questions about the nature of creativity, creation and the creator (of the gallery piece and the universe).*

AP: *Springbed* is a cosmological piece; it deals with the nature of the cosmos. The piece is a cosmos in itself; so, I, as the artist, have created a symbolic cosmos. But there is a comic element to the piece, like a Shakespearean farce. When the bottlerocket is ignited and explodes it sets off the chain reaction that completes the piece. I jokingly called this the "little bang." Despite this cosmic point of view, the work asks personal questions, questions I am asking the viewer to ask along with me. As the title implies, I am making an obvious parallel to creation as a whole. I am questioning the Modernist paradigm of the detached or self-referential work, which implies a closed universe. This is an open universe; there is also this cherub descending from on high, which looks a bit like a figure from the Renaissance, but with a bit of parody as well.

It's out of Raphael, but through Jeff Koons.

AP: Yes, or at least through WalMart. [laughter] And this cherub also raises questions about the treacly sweet notion of artist as creator and ordained imitator of God the Creator. I think that is a somewhat simplistic and problematic approach. The question is more complex than that and requires a more complex answer.

Could you articulate more clearly the problem you see with this parallel between God as Creator and the human as creator?

AP: Certainly there is an aspect in which we create and God created and those acts have some similarity. But I think that similarity is often overstated. It is true that if God did not create then neither could we, and I also believe that the impulse to create is God–breathed (see the "cultural mandate" in Genesis). But God created out of nothing—ex-nihilo as the theologians say. We can't even imagine what that means, let alone imitate it. As I understand the creation story, on the first day God made the "stuff" of creation. Light—the "stuff" that God created out of nothing— is made distinct or separated from

OBJECTS OF GRACE

the darkness, which is nothingness. After day one God molds this stuff. He separates the heavens from the earth, he separates dry land from the waters, on and on until He molds man out of the dust of the earth. God diversifies reality to a certain point and then he involves humankind in the process. He says that we should continue molding the world and developing the potential that is inherent within it. We should cultivate the land and also cultivate culture. The artist does that, and it can be holy work. But the teacher and the banker do it too. The artist does not have some priestly role that is set apart from other vocations.

I see what you mean; our creativity is imitative, more or less, of God's. I guess conceptual artists, like Sol LeWitt, try, as much as is possible, to make art out of pure imagination rather than push "stuff" like paint around. Much of his work is the playing out of all the possibilities of a selected concept. For example, he takes the four basic kinds of straight lines (vertical, horizontal, diagonal l to r, and diagonal r to l) and their combinations to make fifteen different drawings. What do you think of his work?

AP: As a younger artist, I was very interested in his work. He does many of his works directly on the wall, and my work is also directly on the wall. I find his work to be optically very beautiful but LeWitt's work is less critical of Modernism. I think my work is arguing with him at the same time it is engaging Modernism.

LeWitt is part of a group which have been called "conceptual artists" because the whole of their work is bound up in the idea, or the "concept" that it plays out. LeWitt wrote a piece entitled Sentences on Conceptual Art *in which he lists thirty-five points about, the thirty-five commandments of, conceptual art. The very first one, the one that sets the tone for the rest is, "Conceptual artists are mystics rather than rationalists. They leap to conclusions logic cannot reach." I thought that this statement described a work like* Springbed.

AP: LeWitt is describing an art that leads into the mystical and the intuitive rather than the highly analytic rationalized work that systematizes and requires a specialized knowledge to decipher. I would argue that what he is claiming exclusively for the conceptual artist is true of the whole realm of art. The intuitive experience, the symbolic, are not reducible to rationality. I find it somewhat ironic that LeWitt advocates an intuitive mysticism, yet his work is based on a conceptual process that engages a highly rational, almost mathematical set of permutations. This reveals for me some of the paradox of Modernism. There is a desire for transcendence without the risk of letting go. I hope my work strikes a balance between logic and intuition.

How is that balance achieved, or at least pursued, in the Objectification Series "Wall Object #1-3"?

ABOVE
Wall Object #2 (With
Two Spring Brackets and
Spacer Bar) 2001,
Dislodged drywall surface,
peeled back and held by
steel spring brackets,
12 1/2" x 28 1/2" x 2 1/2"

OPPOSITE
Wall Object #1 (With
Four Spring Brackets)
Painted drywall surface,
removed and suspended
from steel brackets
12 1/2" x 32 1/2" x 2 1/4"

AP: The pieces themselves are created by manipulating the wall. In *Wall Object 1 (With Four Spring Brackets)* and *Wall Object 2 (With Two Spring Brackets and Spacer Bar)*, I cut a seven by thirteen and a half inch section of the surface of the wall and peeled that thin sheet of paint off the wall. This leaves behind a seven by thirteen and a half inch section of the interior of the plaster exposed. I sand and polish this rectangular "scar" to create a very smooth and finished surface. I suspend the removed layer next to it creating two adjacent rectangles. In *Wall Object 1*, this section of the wall's "skin" is entirely removed from the wall and is suspended by four spring brackets directly next to the space from which it has been removed. The result is a white on white diptych of the elements of wall. In *Wall Object 2*, the paper is peeled back on the two long and one short side and is folded back over a spacer bracket and suspended by two brackets. In this case, the back side of the paper is revealed. *Wall Object 3 (With Four Spring Brackets)* is a much longer piece; in this case, the scar is vertical in orientation and the paper is suspended above it in a horizontal orientation, creating a "T."

The works deal with the problem of the picture plane and the question, "What is a painting?" and by extension, "What is art?" In this case, I have taken the painted wall surface and presented or re-presented it to the viewer as a monochrome painting. The work explores and critiques the clinical nature of Modernist spiritually as represented by the monochrome and the sense of awe or mysticism that some critics have attributed to the monochromes of Kasimir Malevich or Robert Ryman. I don't want to be naive about it, but my work is more literal about the fact that it is white paint on a surface.

There is so much visual noise out there, television, advertising, etc., the problem for the artist is how to contend with it. Some artists want to compete with the noise; that strikes me as inept and insecure. I think your quiet approach, using a lot of white space, projects confidence and it probably took a lot of guts for Malevich to do the first white-on-white painting. Like his work, your Objectification Series *also deals with perceptual issues. They explore and expose the inside or other side of the wall, but they also deal with what is happening on the other side of, behind, the eyeballs. What we see in a work of art has a lot to do with what we think art is.*

AP: I fall victim to needing to explain my work analytically but I think the work is also viscerally seductive. I can't explain in words the tactile quality of the work. But the *Objectification Series* is very much about the fact that this is just a wall, and then it is now transformed into a work of art and that raises the question, "What is the perceptual change that happens here?"

How did you determine size the of these pieces? I mean, if they are larger, then their size may have too much impact on the viewer, at the expense of the conceptual aspect of the work, yet they need to be large enough to register with the viewer.

AP: It would be nice to say that it is related to some magical phenomena or mystical mathematical formula, but it is not the case. There were some practical issues to be taken into account. I didn't want to have to encounter the screws that attach the sheetrock to the studs, which are sixteen inches on center; so, the piece had to be smaller than that. I have since developed a way of doing them that would allow me to make them any size, but I also want them to be intimate. Ultimately, the process of finding the right size was intuitive and experimental.

How do you deal with the viewer as part of the works from Objectification Series?

AP: The pieces are very subtle, but the engagment with the viewer begins on an optical level. Because there is almost nothing to them, they have a great deal of presence; they are iconic. They speak very quietly, but it is a noticeable whisper. Because they are so visually spare, the works immediately raise certain fundamental questions. They aren't pictures of my grandmother, in which case the questions about meaning aren't as paramount. They are like *Springbed*—though in a less operatic way—in that you see something has happened and the viewer unravels the processes behind what occurred.

A piece like Wall Object #1, *in which a piece of the painted wall is held up to the viewer, makes us more aware of the space that it occupies. It even casts a shadow on the wall behind it. We are conscious of the work of art as something that is literally other than us and thus become aware of the space between us and the object.*

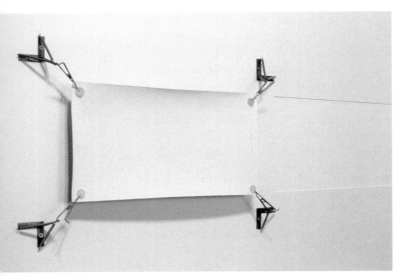

a section of the wall, I became aware of the wall in a new way. We discussed the issue of scale, and the pieces are relatively small in relation to the whole wall, but the transformation of this one small area will impact how the viewer perceives the whole wall. The walls become activated, or at least they seem that way, they envelop us.

That way a change in our relationship to one small area of the wall in turn can impact how we perceive the whole wall, and every wall is an interesting idea that could be more widely applied to art. For example, the Rembrandt painting we were talking about before represents a small part of the world. It represents his vision of that microcosm, but it could have a transforming impact on how we perceive the world beyond the frame of his picture. Would you agree with or want to add anything to that description of a function of art?

AP: The title *Wall Object* suggests a more literal object. Also the idea of "objectification," as in the objectification of women, suggests a relationship to something "other." I think that the viewer's awareness of the space between themselves and the work is a natural extension of the issues I'm dealing with within the work itself. I am working with the wall. We are aware of the walls of a space; we may keep a certain distance so as not to run into them. As you pass someone in the hall, you know how much space you need to avoid bumping into them as well as not hitting any of the walls, but this is all subconscious. Some artists, like Richard Serra, have made works that make you experience that hallway in a different way so that you become very much aware of all these things. In a related way, I am working with a wall, the neutral place where we would expect to view art. When I cut and remove

AP: It seems to me that good art always gives a small picture that reveals something deeper about the big picture. It is the job of a symbol to capture some essence, some concise image of reality which is infinitely complex. A symbol can distill a facet of reality through the selective eye of the artist. A musical note is a selective sound distilled out of the infinite spectrum of sound that envelops us. And like a well chosen note, a symbol can strike a chord that resonates within us, maybe even sounds out truth. The artist's vision, his or her ability to see through the infinite complexity and distill something down to a potent symbol, is the stuff of art. If this symbolic gesture (that is the work of art) has a transforming effect on the viewer, I believe it is

because the artist has effectively carried out her craft. She has poetically tapped into an aspect of reality which has the power to reveal it afresh for the viewer.

The most recent work from the* Object-ification Series, Wall Object #4 (With Fire and Light) *is in some ways less literal. How did that work evolve?

AP: This piece started out as another white-on-white diptych. In this case, the right-hand panel is created by an illumination. The rectangle is cut into the wall; there is a space created within the wall which is illuminated by a hidden light source. The illuminated rectangle appears to be a part of the wall because this hole has no perceivable edges, as though a very intense light were being projected on the wall. But you sense that the light seems to be emanating from within, although there are no visual cues letting your eye perceive what is really going on.

The left-hand panel was a painted rectangle of the same size of white pigment. There is a small fuse within this rectangle and, when that fuse is lit, the flammable pigment intensely burns across the piece. One half of the white-on-white diptych is transformed into the swirling image created by the burn marks. The result is the contrast between a black and a white rectangle. Whereas the earlier pieces had peeled back the surface of the wall, this piece goes all the way through it. The visual sensation of the illuminated panel is such that it seems to float in front of the wall, but it is, in fact, through the wall. So, it is not what it appears to be.

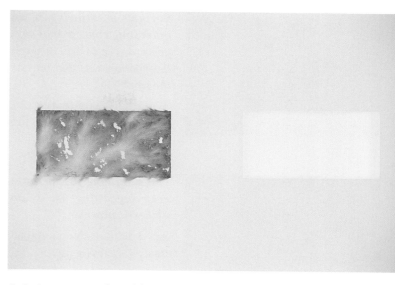

It is interesting that, like **Springbed of the Universe,** *this work begins with the ignition of a fire that propels the rest into action. Is that a coincidence or are you developing a method of drawing by fire?*

AP: In *Springbed,* the drawing is happening independently of the artist's hand. I love to sketch, but the process of direct mark making which turns into an image which is then looked at as "art" can be conceptually problematic for me. That direct mark making as an end in itself is what stopped making sense in my earlier photographic/drawings. Working with fire was a way of making drawings which gave a certain amount of distance and changed the way I engaged mark making. But it is not enough for it to be interesting as an idea. It wasn't merely a conceptual answer to a theoretical problem; the mark had to have the right poetic resonance.

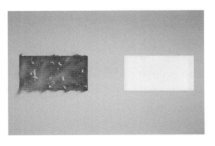

Burning as drawing is an interesting concept that suggests a creativity through destruction; was that part of the work?

AP: Yes, it is a fire that creates. It an interesting paradox; fire can be creative or destructive, or even both simultaneously.

Is it a refining fire, perhaps even suggesting art as an alchemic process?

AP: I didn't really conceptualize it as a refining fire.

Anselm Kiefer has a painting entitled Painting = Burning, **which represents this scorched earth and suggests that art has a rejuvenating power through destruction and a sort of alchemy.**

AP: Some of the same cultural conditions that led and allow Kiefer to use burning in his paintings, allow me to burn the wall. I wasn't specifically thinking of Kiefer. I used burning because it was poetic solution to the problem of how to create without directly applying the hand of the artist.

By removing the hand of the artist, in a direct sense, from the work, you are relinquish- **ing a certain amount of control. Allowing the work to direct itself in a sense.**

AP: I hadn't thought of it in those terms. Since you raise it, I like the idea of giving up some control over the work. Art is a window into a place where there is less control, a realm of the intuitive. I think of a calligraphy master who both has control over his medium, but it is the nature of the ink that makes the particular mark. In my piece, the material follows its own nature but it is confined to the parameters of the rectangle that I have defined.

Whereas the left, burnt, panel is particularly about drawing and painting, I saw the right, light, panel as engaging some of the issues of sculpture, like the work of James Turrell. The process-based installation work that you do is outside some of the historical categories of art. Where do you see your work in relation to the polarities of painting and sculpture?

AP: Ever since I started art school, I was never certain that I knew what the difference was between painting and sculpture. There are some obvious differences historically, but those distinctions seem less and less important today. They may be useful for some artists, but, speaking from my own experience, those categories that we have analytically constructed don't map out to the way I see reality. I conceive my pieces as installations. I like that word because it is descriptive of the work. They are installed in a certain place. They are part of the wall. I'm commenting on painting and I'm commenting on sculpture, but I'm mainly working in the category of "art."

Your work might be engaging what has been called "sculpture in the extended field," a term I think Robert Morris used to describe sculpture after Minimalism. How has art changed in recent decades such that categories like "painting" and "sculpture" are no longer useful?

AP: I would hesitate to say that they aren't valuable or useful today. Only that they aren't valuable or useful to me.

You aren't alone in that; there is a long and distinguished list of artists who are looking beyond these categories.

AP: I guess the nature of life and art today—a world in which your computer is obsolete every eighteen months and the number of books published every day is more than the production of an entire year or possibly decade of the Renaissance—the meaning of carving a larger than life statue out of marble is very different today. The relevance of that has changed, though I'm not saying that it would necessarily be irrelevant. But what was a new direction for sculpture, a revival of a certain art, for Michelangelo Buonarroti would be a statement of resistance to the culture in which you and I live. In a culture where information is traded in a very cross-disciplinary sort of way, the categories of painting and sculpture may need to be reconsidered.

Your answer presupposes a certain conception of art, namely that a work of art is somehow linked to or engaged with its time. I mean there are artists working today carving larger than life sculptures out of marble. These artists aren't ignorant of the world you described, but they feel the need for resistance. Some of these artist are motivated by what they understand to be the calling of an artist who is a Christian.

AP: I wouldn't say that the artists you are describing necessarily have a different conception of art than I do, they may just hold a different position on the role or function of art in culture. Some artists may want to resist Modernism by creating work which harks back to a previous age. I would agree with the sentiment but take issue with the means. I see the role of the artist as one who engages culture, not by creating an other-world culture of longing—longing for a past age or a future age. I believe we are called to be a transforming presence, obediently developing culture in our own time.

There seems to be a disconnect between the general public and the mainstream art world around the question of what is important in a work of art. Even the dialogue that your art is engaged in regarding questions of Modernism's self-referential paradigm of painting and mark making is still an "insider" conversation in which the general public tends to be disinterested. Do you see that? Is it a problem in your opinion?

AP: It is certainly a problem. This divide is one of my disenchantments with Modernism. The idea that art could be created in an autonomous sphere that has nothing to do with the rest of life is meaningless. History has proven that this approach will fail. Morally speaking, a scientist cannot work in the lab pursuing something that

is an interesting problem but has no potential application, or worse, ends up as a neutron bomb. The artist, like anyone else, has to consider the consequences of their work. I think that, to a certain extent, the Modernist artist has done a disservice to culture and the public by not giving back to culture something that is of use.

In terms of my own work, I don't see disengaging with the critical dialogue to make art that would please some section of the public as an option. On the other hand, I don't accept the notion of the artist creating within an autonomous field of art in which the concerns of the viewer don't even exist. A third possibility is the model of William Shakespeare; his plays had something in them for everyone. They operated at several levels simultaneously. There were the bawdy jokes that the peasants got and there was very elevated language together in carefully crafted suspenseful drama. I hope that my work has a certain accessibility to it. They are visually interesting but also conceptually challenging. It's like reading a good novel. When you read through it the first time there is an interesting story, but you can also go back and look up certain references and even read some of the other works that relate to this novel; you get even more out of it. So the model is to have something in the art for everyone but also to reward the engaged viewer in that the more you put into reading the work, the more you will get out of it.

How is peeling the paint surface off the wall achieving that end?

PREVIOUS and ABOVE
Untitled 2002, Painted drywall surface, removed and suspended from steel brackets
12 1/2" x 32 1/2" x 2 1/4"

AP: Well, I hope that I am asking, in a visual way, questions about how we see things. Everyone can relate to a wall and everyone can relate to white-on-white painting, whether they are in awe of the monochrome paintings in the Museum of Modern Art or they make jokes about them. So, my work is about things to which everyone can relate. There is also the element of delicate beauty in the work that I hope will disarm the viewer.

At the same time, there is the choice of the viewer to engage or ignore the work. A writer of literary fiction, no matter how carefully they craft their work or make references that are accessible on many levels, even one as great as Shakespeare, will not attract an audience trained on comic books and harlequin romances. There has to be a reasonableness of expectation on both sides. It is all right to have an audience that is not universal, without engaging only a specialized few.

To continue with our discussion of the disenchantment of the public with contemporary art, although we should note that museum attendance continues to set records so people are still hungry for a visual experience, one group of the public that seems particularly disengaged with the visual arts is the Christian community. As an artist and a Christian, what to you see as possibilities for bridging this divide?

AP: Well, that is a complex problem. I think that I have a better understanding of why there is a disconnect than what can be done to rebuild the connections. There is a long history of icon-

oclasm that has not been fully resolved. The other stumbling block is a holdover from the Enlightenment and Modernism itself that has infiltrated Christian thinking that say, "I'll believe it if you can prove it." This view holds that the real truth is in analytic proof that can be factually verified. This reduces Truth to fact. That has been a prevailing paradigm in the west for at least two hundred years, and I think that we as Christians have unconsciously bought into this deception. That paradigm is very contrary to the scriptures; truth is much bigger than fact. One's faith is judged by much more than the creeds you are willing to recite. Faith is the substance of things hoped for, the evidence for which is still unseen.

The analytical bias which dominates our culture discounts the intuitive. Sometimes I have had the experience of knowing in my heart that I needed to do something or take some course of action, but this action is in conflict with what my head is telling me. The action seems irrational and out of place. Yet in time it becomes obvious that my heart was right. My intuition was ahead of my analysis of the situation. I think this is a common human experience. If I had not trusted my intuition, I never would have asked my wife to marry me. There was not enough information available to fully convince me that this was the right action. Our intuitive self can reveal to us things that our best analysis cannot at that moment explain. Art can touch us at this place of deep knowing. We can experience something that we sense to be true and deep, but we can't explain it. In fact, if we come to art asking for an explanation ("What does that artwork mean?")

then we are keeping it at bay, assuring that it will not speak to us or touch us. This means we must approach art with a certain amount of trust. Trust that art is valuable and has something to give us. Trust that we will not be subverted or corrupted by the power of art if we let our guard down. Trust that God speaks to us not only through logical discourse, but that he also created us with an intuitive intelligence. If the intuition is God given, then we are held accountable for the things God is trying to say to us through this channel. It is no less disobedient to run away from God's truth revealed in a sermon, than His truth revealed in a painting. Of course the power of the intuitive and the symbolic can become an idol. It can become an end in itself which will deceive. But this can also be said of money, or the desire for professional success, or even our involvement in the church. All of these are good things when treated properly, but all can corrupt if our heart is not right.

This brings me back to what LeWitt wrote about being mystical and leaping beyond where logic can reach. Another way of saying this is that the work goes where words can't reach. But at the same time, this mystery can be a stumbling block for a viewer who has a distrust, or even fear, of it.

AP: Without exaggerating one side of the analytic vs. mysterious equation over the other, I think what is interesting about mystery, about the spiritual, is that it penetrates your rational defenses. It disarms us. We were talking before about the relationship between my use of fire and the question of control. There is a lot of

control, or desire for control, in both Modernism and the church, at least some branches of the church; that means to stay in the realm of doctrine and the rational, making sure that all the pieces add up to this neat picture of God. We live our lives towing the right line. It doesn't seem to me that Christ was trying to engage in doctrinal disputes; he was seeing through that doctrine to the heart of the matter.

How can we bridge this gap between the Christian community and the visual arts?

AP: I guess the metaphor that I have for that place of connection is prayer. Prayer is a place where we come with all of our right doctrine and rational understanding and engage in this activity that is born out of faith, where we let down some of those defenses. It is a place where we are changed. I think as artists coming to the Christian community and as the Christian community coming to artists that prayer serves as a model of what we need to do. It has to do with listening to each other; it involves bringing your beliefs with you without making them a fortress that will both protect you and protect you from changing.

On a practical level, I'm talking about community. Artists need to take the opportunity and be given the opportunity to show their work and engage their church community. My church is about to have an arts festival and it will be an integral part of the life of our church community. It is a way in which art will change the community and where the community will change the artists.

At the same time, I think that Christians should be engaged with culture at large. Artists who are Christians should be looking for what they can contribute to the critical dialogues of culture today. For example, there is the issue of art engaging a public that is beyond the elite group of the art world itself. The Christian can represent their faith in an interesting and compelling way within the public sphere. As a Christian community, we need to be supporting artists to be out there. If we want to impact culture, we need to have Christians engaged with the culture; we shouldn't just abandon ship.

Art can be a witness in both what it represents but also how it represents, how it engages the viewer. The Christian who is an artist may, because of their faith, value the viewer more than the Modernist artist, whom we have to a certain extent stereotyped as self-absorbed. So a Christian can make a valuable contribution to a specific problem that culture is facing at the moment, namely its disenchanted audience.

AP: I believe that the "how we represent" is inseparable from "what" we represent. My work is highly engaged in the "how" we represent. But disenchanted audiences are hard to win back. A trust has been broken. We must be conscious of the issues at hand, but we must also pray that we can be agents that help restore trust and wholeness.

To continue with what you were saying about being active in culture, how does a work like Wall Object #4 (With Fire and Light) *speak about your faith?*

AP: I will often delineate between the subject matter of a painting and the content. For example, the subject matter of a painting could be Jesus and Mary. Upon hearing that, one might think it is a Christian painting, but in fact it might be a blasphemous representation of Jesus and Mary. The content is something else. In terms of my work, the subject matter is fire and light or the wall; yet the content is the questions I am raising and the answers to which I point. The content is my faith. It is a visual prayer. I am changed in the making of these works. My hope is that the viewer, coming to them in a spirit of engagement and sensing an authenticity in them, will also be changed. In *Wall Object #4 (With Fire and Light)*, there is a question of light and darkness, about what we think of as darkness and what we think of as destructive. The answers may not be what you expected. So the content of the work is the perceptual shift that can occur in this encounter.

You have used the metaphor of prayer several times to describe an encounter with a work of art. Do you see art as a form of prayer?

AP: I am using as a metaphor that kind of open and receptive experience we have in those moments of deep prayer to talk about art. I think that the act of making art is the closest thing to that kind of prayer; I might even say they are in some ways the same thing. For me, making art could also be a type of praise.

I don't want to tie your work too closely to any particular Biblical reference or suggest that you are illustrating a text, but Hebrews 11:3 raises an interesting issue saying, "By faith we understand that the worlds were framed by the word of God, so that the things which are seen were not made of things that are visible." It seems like your work is engaged the question of the frame but also in making things that are seen out of things that are unseen.

AP: I resonate with that on an number of levels. It connects on the level I was talking about with subject and content. What is seen is the subject; the content is hidden except to those who are willingness to discern it. In *Wall Object #4 (With Fire and Light)*, the fire which is unseen to the viewer creates the marks that are seen. The illumination is created by a light source which is unseen. The idea, the faith, described in that verse also relates to the act of art making in general. It suggest the prayerful attitude that an artist can bring to her work. The artist's work can be a visual manifestation of an invisible prayer. By faith, the artist's prayers may be seen.

CONVERSATION WITH **TIM ROLLINS**
and K.O.S. members **ROBERT BRANCH**
and **NELSON RICARDO SAVINON**
March 2000

James Romaine: A popular perception is that artists work in the solitude of their studios. Your work is the result of collaborative process between Tim and K.O.S. (which stands for "Kids of Survival"). Who is K.O.S.?

Tim Rollins: Around 1980, I was invited to start an art program for special education students at Junior High School #52 on Kelly Street in the South Bronx. I was young, energetic, enthusiastic, idealistic. I started out with this liberal, magnanimous attitude, you know, "Sure, I'll come up from downtown for two weeks and start this art curriculum for these poor ghetto kids..."—a little patronizing and paternalistic. But, when I actually arrived and encountered these enthusiastic and talented young people, I ended up staying in that particular school for seven years teaching art full-time. While I left the public school system in 1987, this year K.O.S. and I are celebrating twenty years of art making and teaching in the South Bronx. I actually live two blocks from the school I used to be afraid to walk to. Now we are working with young folk all over the world, with an emphasis on two other cities: San Francisco, California and Memphis, Tennessee.

K.O.S. is the group of my long-term and most devoted students nationwide. Our South Bronx based team currently has thirteen members ages eight to twenty-eight. Nelson is the elder of the group and is now co-director of the studio along with Robert.

What was your art like before you started working with K.O.S.?

TR: I was a young conceptual artist, curator and writer with a strong emphasis on the politics of American education. I was known in the New York art world at that time mainly because I was a founder of an alternative space called Group Material. We were one of the first art spaces based in the East Village. Group Material was best known for organizing group exhibitions that focused on a particular social or political theme. I worked as a leader of Group Material until around 1984. That was when K.O.S. and I founded our own studio outside and independent of the public school system. We maintain this studio to this day.

How does the workshop collaboration happen between you and K.O.S.? Does each member of the group have a particular role which they carry out in each and every work, or are the roles interchangeable?

TR: We're like the Yankees! Robert told me, "Tim, you're a coach but a player as well. When we need you to, you can go out on the field and hit the home run for the team."

Robert Branch: Tim is definitely a player and coach. The way Tim and K.O.S. work together is very organic, like a perpetual dialogue that results in works of art that people find interesting. There is no management! (laughter) Roles interchange all the time, especially in order to facilitate learning together. We mold art and learning strategies according to each member's particular needs. For instance, when I first joined K.O.S., I needed to work on my painting skills and develop better study habits. We accommodate each member's strengths and weaknesses.

TR: We collaborate first and foremost conceptually. I'll present a text that I intuit will speak profoundly to the kids, a text that can inspire us to create a work of art, a text that confronts us with a genuine mystery. In responding to that text and in trying to come up with a visual motif that corresponds to its themes, we must explore the historical context that the writing comes from. When we eventually find the appropriate visual motif, we have to research its history so that we know what tradition we are working in. For example, in painting flowers inspired by Shakespeare's *A Midsummer Night's Dream,* we had to study the history of flower imagery throughout the world culture, from ancient Japanese landscape painting to Warhol's silk-screened paintings. For the *I See the Promised Land (after the Rev. Dr. King)* works, we researched the astounding history of the trian-

gle and the possible symbolic uses it has had in the past and present. Our entire curriculum is generated from our quest to solve the problem of making literature visible. Not only do we learn, but this learning results in the creation of a work of art that keeps on teaching.

How does your faith shape your attitude toward art?

TR: I think of Hebrews Chapter 11, "Now faith is the substance of things hoped for, the evidence of things not seen." I see art as very similar to prayer. It's as futile, or as powerful, as prayer. It all depends on your faith. Art, like prayer, is futile if you don't bring any faith to it. Many people new to contemporary art are bemused, perplexed, even angered by it. Many non-believers have a similar cynicism when they observe peo-

O B J E C T S OF GRACE

ple praying. But if you do believe, and have faith in God, you know what prayer can do, and you have seen the effect of prayer in your life and in the lives of others. This is the same sort of spirit that we invest in the making of our art. It takes faith to believe that a red triangle painted on book pages truly means something and has power. Artworks have a spirit—they are not unlike other objects you encounter in everyday life. You bring faith to art as you do to God since great art is an instrument of God. I believe that artists are constantly imitating the penultimate creativity of God and that this imitation is the sincerest form of praise. A painting by El Greco is the Holy Spirit demonstrated in paint. That's its undeniable power—there is something deeply spiritual going on in his work. I'm a Baptist with a Pentecostal spirit. Before I had been spiritually revived, about five years ago, I went to the Prado in Madrid but never really understood the work of El Greco. Robert and I returned to that museum last year, but on this trip I felt something. I practically shouted right in front of those paintings by El Greco. I got them and they got me! Robert was kind of embarrassed. Pentecostal power in paint—that's El Greco.

RB: I'm a Catholic and I have learned a lot about my own faith by coming to the workshop. I had to find faith in myself, in the group and the power of art in order for this all to work. There is nothing ordered from down high in here. Art making doesn't come with written instructions, with a step-by-step procedure. You just kind of feel it out. It is a process of faith.

TR: It's like a church choir. I could be the director, or it could be Robert or Nelson or even a new member if I'm not here. What is important is that we all sing a common song to the best of our individual abilities. This common song is the inspirational text that motivates us to make works of visual art. Most of the work in the studio is actually rehearsal. You never know what's going to happen— all the improvisations, the blessed accidents, the fantastic surprises that constantly take place.

There's also a very strong social content in your work. How do you see the role of the artist in society?

TR: Even though I grew up in white rural Maine, I'm a child of the civil rights movement. The experience of that struggle that continues to this day made an indelible impression on me. Many people say that art can't change the world, but I know it's changed my world. It has changed the world of my students. It has changed the nature of our neighborhood in the South Bronx over the last twenty years. I believe artists are prophets—they have the vision to see what most

others cannot. Art emanates a light powerful enough to illuminate what was once invisible or, more likely, hidden. We must be able to see it in order to act upon it. Art persuades us to imagine a reality different from the one we have inherited from history. To imagine—this is a political, social and spiritual act.

Are there any artists, historical or contemporary, whose work you admire for their social or political concerns?

TR: We are influenced by everything we see throughout our culture. My personal influences from art history range from the Russian Constructivists through to the great German expressionist tradition: George Grosz and John Heartfield and its transfigured reappearance in the work of Joseph Beuys. Joseph Kosuth, Conrad Atkinson, Leon Golub and Nancy Spero are all important mentors. I'm also deeply influenced by musicians and composers, from Leonard Bernstein's work with his Young People's Orchestras to the Rev. James Cleveland who revolutionized Gospel music with African American mass choirs. Also, Pier Paolo Pasolini's *The Gospel According to St. Matthew,* with its use of all non-actors, tells the most moving and convincing portrayal of the Passion ever put on film. Any art made out of a group culture teaches me, from tribal societies to the Shakers to Andy Warhol's Factory.

How did the work I See The Promised Land come about?

RB: Our past works tend to lead to new ones. We had just finished *Incidents in the Life of a Slave Girl (after Harriet Jacobs)*, a piece that's festooned with satin ribbons each representing the color of a K.O.S. member's joy. For the *I See the Promised Land* pieces, Tim came to us with the question, "What is the color of your hope?" And we responded, really getting into mixing all these different colors. After we got the colors, we had to work on creating a credible space with these colors on the surface of the text by Rev. King, playing with painting styles, transparencies and so on.

TR: Rev. Dr. King was my hero as I was growing up. As a precocious thirteen year old, his assassination in Memphis was a wake-up call that made me grow up fast. I've become an amateur Rev. King scholar, and when I was invited to work with kids in Memphis, I was compelled to attempt working with that text.

That was his last sermon, right?

TR: Yes, delivered in Memphis at the Mason Temple Church of God on April 3, 1968. He was shot on the balcony of the Lorraine Motel the next day. And in that amazing sermon—it's not a speech, it's a sermon—looking at films of that sermon, you can see that he truly foretold, prophesied, his own death. You can see it in his face, you can hear it in his words, the tragedy, the courage. Reading his collected writings, sermons and speeches I wondered, "Is there a visual motif that flows throughout Rev. King's homiletics?" In discussion, K.O.S. immediately

recognized the reference to mountains and mountaintops. That reminded me of an early sermon called "The Three Dimensions of the Complete Personality." It's one of my favorite of his sermons. Rev. King preaches that, "Life at its best is a great triangle." It possesses the three dimensions of breadth, depth and height. One angle constitutes "me." You must take care of yourself and invest in yourself because your own presence is a gift from God. The second angle represents "we." You're nothing if you don't have love for others. The third angle, the top angle, is that spiritual force that is God that ties it all together. That is a complete personality. This relates to the first lines of his sermon "I See the Promised Land" with its references to the pyramids of the Pharaoh's Egypt, Mount Olympus of ancient Greece, to the Trinity of the Renaissance artists concluding with the mountain top from which he could see the Promised Land. Triangles everywhere. Then we remembered a major triangular painting by one of our favorite artists, Barnett Newman, called *Cathedral.* That work features a triangle bisected by a stripe of light, what he called a Zip, like a stream of water poured down by God.

RB: And all throughout our neighborhood in the South Bronx, all the stores have these lines of little plastic triangular flags in all sorts of colors hanging everywhere. They put them out to celebrate grand openings, then they never take them down!

TR: And so we had the colors of our hope and the triangle motif. We tried different drawing materials and settled on a 2B pencil, drawing a triangle but with the apex of the form running just above the top edge of the book page taken from Rev. King's sermon. No longer a triangle, the form becomes an infinite mountaintop, a highway to heaven, Jacob's Ladder, the Trinity, the Ascension. Rev. King preaches that he has been to the mountaintop, and he has seen the Promised Land. Art is the means to the Promised Land. This Promised Land is a spiritual process. You may never arrive but you are living as if you will get to that mountaintop where a more panoramic vision becomes possible, where you get to Glory.

RB: Granted, when Tim first started teaching about Rev. King, we rolled our eyes. We thought that we already knew everything we needed to know about that "I have a dream speech." But we didn't know everything. We ended up taking this fantastic journey with Rev. King.

TR: We've made this work with over two hundred young people throughout the world. We've had over two hundred kids from all over the U.S., and even from Germany, work on this piece. The version here is made by Emanuel Carvajal, a K.O.S. member for about five years and now a sophomore at the State University of New York at Purchase. The color each participant invents must be unique. It can't just come from the tube.

RB: It's funny, too, because he always wears these red sweatshirts and baseball caps. He's not a Cincinnati Red fan, but he has a Cincinnati Red cap. Of course he didn't realize this when he came up with his color.

How did the work,* Invisible Man (after Ralph Ellison), *with the letters I M, come about?

TR: That painting piggy-backed on the research and development we were doing for *I See the Promised Land.* We had been wanting to do something with the great novel of the 50's, *Invisible Man* by Ralph Ellison for years, but it took forever to come up with a way to visualize the text. We tried and struggled to come up with a visual motif that played with the notions of invisibility and how art is the enemy of invisibility. In researching and studying for *I See the Promised Land,* we had a photograph of sanitation workers on strike down in Memphis. The strikers carried this simple, perfect sign that stated in placard lettering, "I am a man." And it just happened, we had this photograph and a copy of the Daily News in the studio with something about a murder victim. The lettering was large V-I-C-T-I-M. We cut the letters I and M off the VICTIM headline. And that became the image for the painting. The opening line in Ellison's novel is, "I am an invisible man." And our response is, "Oh no we're not." We refuse invisibility. Our art affirms our existence and voice in a hostile cosmos. At the same time, the "IM" motif echoes the Book of Exodus. God appears in the Burning Bush to this special education student named Moses who stutters, stammers, and no one takes seriously. God tells him to go to Pharaoh and tell him to let the people of Israel go. And Moses says "I see you and I feel you, but when I go down and tell my folk about you, what do I say? Who do I tell them you are?" And God in his perfection, simply says just tell them "I am that I am." This is the essential message of art.

RB: One of the first questions people at our openings would ask me was "What does the work represent?" The best answer I gave was, "What do you represent?" You just are. Similarly, our art doesn't represent anything. It just is. It is a way that we connect with other people.

TR: We're having a special exchange that affirms our humanity. Art makes the invisible visible, vision becoming visible, and making hope material, power manifest, and Spirit sensuous.

There are several versions of* Invisible Man (after Ralph Ellison); *one is black lettering on a white field, like the signs carried by the strikers. But there is another which you have creatively modified; it is white on white, very minimalist. It pushes the issue of visibility and invisibility further.

TR: It immediately refers to a painting by Malevich, white on white, where he turned a square turned askew on the picture plane and manifested this as Spirit. Also, we reclaimed the idea of what white represents by taking it over by young people of color. We are questioning the notion of white as right and pure and clean and innocent, white as the admixture of all colors, as a field of possibility, a tabula rasa, a blank piece of paper hoping to be drawn upon.

RB: Some people get upset, but our work is all about breaking barriers. This process is organic. It is not about picketing, holding poorly made signs up. For me, the color white is invisible. You can ignore it, you can say that it is nothing. But in its blankness, white becomes the Great something. In making the white *Invisible Man (after Ralph Ellison)*, I found out that there are infinite colors of white. And we did spend a lot of time finding the white we wanted. We get to the spiritual or metaphysical issue through hard work.

Sometimes the creative process is like Jacob wrestling the angel all night. The artist is saying, "I'm not going to let you go until you bless me," but there is something beautiful that comes out of that struggle.

RB: I believe all good art comes out of struggle. One of the first issues you raised in the interview is that there is a popular notion of artists working in solitude. I think art comes out of social experience. Even if artists want to project the idea that they are the lone architects of their idea, they work within the world. Even if they make a conscious decision to shun it, they cannot deny the everyday world.

TR: As an artist, you are just a vehicle for something passing through you. Like the paint, you're a medium. But something, some spirit is coming through you, making something manifest. It's like climbing Jacob's Ladder or going to the mountaintop. It is a continual climbing to reach a pinnacle that you probably won't see until you see glory.

Another of your works which seems to deal with spiritual struggle is **The Temptation of St. Anthony–the Trinity.** *How did that work bring spiritual and creative struggle together?*

TR: This was a breakthrough work from before I came back to church about five years ago. St. Anthony is one of these hyper religious folk who gets to the mountain top but just sits there—sanctimonious—pious beyond belief. Like some who are so holy that they are of no earthly good. St. Anthony removes himself from humanity and sits all day on a straw mat reading his big old Bible. So of course the devil wants him the most. Satan appears to him saying, "Where am I going? Just now, a glimpse of the shape of the Evil One." The whole play by Flaubert is a dialogue between St. Anthony and the Devil about the real nature of good and evil, heaven and hell. In our church, Memorial Baptist in Harlem, we sing a song, "God's Not Dead, He's Still Alive," But guess what, there is another old hillbilly Gospel song that goes, "Satan's not dead. He's alive, too!" Many people are in denial about the visceral existence of evil, and the power of evil in the world. Evil is a real force we have to contend with daily. Flaubert wrote this fantastic scene at the end of his book. St. Anthony has been attacked all night long and has survived all these amazing temptations and horrific hallucinations. When the dawn finally arrives, St. Anthony sees the face of Jesus in the rising sun. In our interpretation of *The Temptation of St. Anthony*, we actually made these works by mixing animal blood with alcohol and other spirits to create these amazing, phantasmagoric images—poltergeists that are beautiful and revolting, sinister and transcendent all at once. The work shows the Father and the Son and the Holy Ghost assembled as a trinity.

Nelson Ricardo Savinon: What is strange about this painting is that when we were working on it, the images just appeared, like vis-

RIGHT
The Temptation of Saint Anthony—Trinity 1990, South Bronx, Blood, alcohol, xerography on rag, 16"x 12". Courtesy of Baumgartner Gallery, New York

OPPOSITE
I See the Promised Land—Emanuel Carvajal 1998, South Bronx, Acrylic, book page, 9 1/8" x 6". Courtesy of Baumgartner Gallery, New York and the Collection of Sandra and Robert Bowden

OBJECTS OF GRACE

ible spirits. The images just came out. It was almost like this image was already hidden in the text and we drew it out. It was an amazing experience to make that particular work, because it became a form of worship and a sacrifice at once. There are times I sit down to make a work, and sometimes I'm not satisfied with it. And if it moves me, it's just gonna move me. But when you're in a collective, and it moves someone in the group, and then someone else, there's something going on. You can't deny it.

TR: It's like in my church. If you were in a service and the choir started singing, you might begin feeling an intense individual emotional reaction—tears welling up in your eyes. At first you're doubting yourself, thinking, "I'm crazy," until you see five hundred other people sharing that same feelings and tears of joy. This isn't group hysteria. I believe this is an affirmation that something supernatural is going on.

It is interesting that you would be relating the art making process to worship. It seems that this works both in terms of the corporate climate in which you make your work and the individual experience of the viewer that takes your art to heart. Historically, the church has been a major supporter of the visual arts, often incorporating them into the worship experience. Recently, that relationship between the church and the visual arts has fallen on some hard times. Sometimes even artists with faith will feel uncomfortable in church. What has been your relationship with the church in general, and also with the church you attend?

TR: Memorial Baptist Church in Central Harlem is a celebratory church. We are a loud church, a Psalm 100 church, "Make a joyful noise unto the Lord all ye lands...." We're a Psalm 150 church, "Let everything that has breath, praise the Lord." I've found that that exuberant religious ecstasy that I experience in my worship service is similar to the ecstatic experience that I feel in a much quieter way in front of a powerful work of art. What we are making is a form of praise. We're making a joyful noise, but we're doing it visually. It's a visual noise. It's a graphic Hallelujah.

Have you ever made work that was for a church, or for a Christian community?

TR: Yes, the *I See The Promised Land* works. We've done several exhibitions at Trinity Christian College and others. There's this new phenomenon happening where these small Christian colleges that you didn't even know had art departments are becoming very interested in our work. I think they long for an art

practice that engages the Gospel, that engages that agape-love ethos of Christ. But how does that take form in contemporary art? Most contemporary works of art that engage religion have tended to have tormented relationships with the Church, like the wonderful work of Robert Gober or Andres Serrano. We haven't done anything specifically for a church, but we would love to.

You have lent your work, I See The Promised Land **and** Invisible Man (after Ralph Ellison), **for the front and back covers of the 2001-2002** Directory of Christians in the Visual Arts **(CIVA). What would you like to see an organization like CIVA do to encourage artists of faith?**

TR: What really needs to be done is we need to have more institutions like what Father Terrance Dempsey has in St. Louis, the Museum for Contemporary Religious Art. We need to have more artists

and exhibiting places that aren't ashamed of the Gospel of Jesus Christ. We need to have more Christian folks supporting Christian artists. Everyone says that the avant garde is over, but what could be the most radical thing an artist could do now? Praise God through their work and have God manifest Himself through the making of your work. And there has to be a stronger willingness to engage with the world. Christians aren't supposed to hang out just with other Christians. We're supposed to go out there and tell the Good News. Art is a form of ministry. When people look at our work they get encouraged, they are excited, they are inspired by example, not by exhortation.

RB: One of the most exciting things that I remember is going into a museum and seeing an Yves Klein painting, and thinking, "Wow, we can do this."

TR: Now you can say, "I've grown to the point where I feel this,

and I know I'm not imagining stuff." My friends ask, "What do you feel when people start shouting, people falling on the floor?" And I can't explain it. It's like explaining to you "hot." It's hot! You can't explain hot. You just gotta feel it. You know when you feel it and you know when it's being faked, too.

I alluded earlier to the fact that a number of artists have grown up in the church and have left the church: you mentioned Robert Gober and Andres Serrano. Their work deals with Christian themes in ways that turn off a lot of Christians. As a Christian in the art world, how do you respond to what may be called the culture wars?

TR: I say "The battle is not yours, it's the Lord's!" What is funny is that artists like Serrano and Gober, and even Mapplethorpe, were maybe trying to transcend the limitations and boundaries of denominational organized religion by creating these critiques, in which they engaged and challenged church traditions and doctrines. Many people mistake critique for sacrilege. I often wonder what Christ would have thought of *Piss Christ?* I think he would have agreed with the ethos of it, to be frank. I mean, most people think *Piss Christ* is a glorious image, glowing, and they're just ready to shout and get down on their knees and pray until they do find out that it is urine. It is a critique. You have a cheap plastic crucifix that represents how Christ was sold and how Christ really had to suffer rejection and hung out with literally the scum of the earth. But the light that comes out of it, and how

you can make something that beautiful. When I see particular works, like *Piss Christ,* I am moved by the pathos of them. They're not just vandalizing, or attacking people's faith. It's an honest engagement of what these individuals have been through, often negative encounters with the church.

What are some strategies for ending this type of culture war? How can we bring healing?

TR: Talk to the artists instead of staging protests. Have an engagement, have a real dialog with folk. Is there something they could say to the artist to persuade them that perhaps this isn't the most beautiful, or this isn't the way to engage with religion or with God? You know, I don't like religion. I can't stand religion, but I sure love Jesus. It's personal to me. I don't preach in here. Our art preaches. That's why it is very important for us to make things that are beautiful, that are glorious; but that can be critical and vital and political simultaneously. Only beauty—love made visual—can change things. I think that is the ethos of Jesus as well. People come to church and they want some of this. I see it in their faces when the choir starts singing and this glory radiates. I see their longing like, "There is something going on here that I have never felt before and I want to feel." We as human beings are biologically wired for spiritual ecstasy. And we try to get it in every form but a one to one connection with the Almighty. I think art is a way to summon that connection. The glory of God—this is what we seek to demonstrate in our art. This what I feel in front of great works of art.

CONVERSATION WITH **JOEL SHEESLEY**

June 2001

James Romaine: How did you become engaged with American suburbia and the visual vocabulary of swimming pools, soccer fields and living rooms?

JS: I grew up in a rural environment. So, when I moved to Glenn Ellyn, a suburb of Chicago, I was taken by there being no edge of town. As my children got involved in suburban life of soccer leagues and such, I was drawn into it. It was like nothing I had ever experienced and I began to look at it, think about it and to wonder if there wasn't some way I could respond to it.

How conscious have you been that your paintings and the swimming pools or soccer fields they represent are two forms of reconstructed nature, stages on which the human drama can play out?

JS: I was very aware of the artificiality of the whole system. I'm not sure if any cultural setting is anything else; there is always a great deal of artifice, but for some reason this struck me particularly as being a constructed world. It seemed to me like a stage set; when you go to a soccer game, your children are put on the stage. The parents are, in theory, standing on the sidelines but they are also on stage before one another. It seemed like everyone was performing. I've talked about the artificiality of this in the past and some of my friends have chided me saying, "Well, what isn't artificial? Why are you complaining about this? Isn't this what we wanted and worked so hard to have?" They are right in a way, but this environment seems somehow more artificial.

Perhaps because many suburban communities are planned out in ways that make their fabrication very obvious, one is more aware that it is more constructed environment than a small town that has grown up organically. Within that world, the sports field is, as you noted, a particularly staged environment where play on and off the field is governed by rules and delineated areas. How do you relate to that environment as a painter who works on a canvas that is similarly a delineated field with particular rules, such as those of perspective?

JS: I intentionally chose to paint long narrow fields of vision. I didn't have a particularly rational reason for this. The format was a vehicle for stretching that vision out in a way that seemed cinematic, which I liked a lot. There is no question that these works have a long cinematic quality that seem as if we are watching an unfolding drama or film.

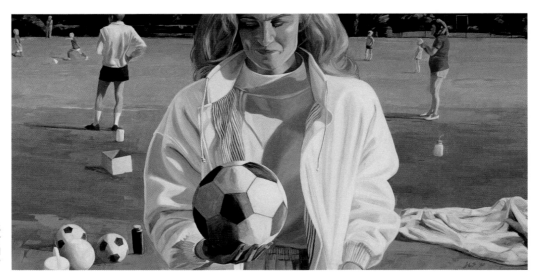

**PREVIOUS
and RIGHT**
Eve in Suburbia 1997, oil
on board, 23″ x 45″

Eve in Suburbia, *represents a woman holding a soccer ball and engaged in a series of encounters. We are encountering her in the course of her daily routine. She seems to be in a moment of encounter or spiritual insight. What struck me about this work, and a lot of works from this period, was how light played a part in the image.*

JS: In that kind of environment, where you have an open field, I chose to work with low levels of light. I liked that kind of evening light because of the richness of the colors that come out in the evening when the sun is low: reds and greens are all more intense. You also get a more active play of long shadows. I could cut in with close-up of large figures that might even be cropped because of this narrow top to bottom space and then gradually work back to smaller and smaller figures out on the field itself. The play of light among all those characters makes a more interesting painting.

Were you working with the painting as a constructed field in which areas of light and shadow are compositional elements?

JS: Yes.

The title **Eve in Suburbia** *suggests suburbia as an attempt to get back to Eden. At the same time, it is a stage on which the human condition of displacement from the garden is evident. Were you trying to put your finger on a tension there?*

JS: I was primarily attempting to imagine the weight of biblical narrative falling on my shoulders and the shoulders of those around me. *Eve in Suburbia* oddly enough evolved from the idea of the pentocrator, but instead of Christ holding the world there is this woman holding a soccer ball. She contemplates this ball with a smile on her face. There is an element of irony in representing that soccer ball as a kind of universe.

O B J E C T S O F G R A C E

There is a strong religious dimension to athletics that goes back to ancient times and is still here today. We often hear athletes after the game talking about how God helped them play and win.

How do you feel the weight of the Biblical subject matter?

JS: I have always felt very insubstantial compared to the characters that we read about in the Bible. They seemed to me to be the heroes and I feel like a small character compared to them. Nonetheless, I'm an inheritor of that story and, as part of the body of Christ, I have a comparative relationship between those Biblical characters and myself in the present. The works help me relate to those characters. For example, Lot figures in a number of those paintings. I think of him as the patron saint of suburbia. He was living in Sodom and Saint Peter says he was vexed because of the immorality that was there. Yet he didn't want to leave; so, there was a conflict within him. He was the kind of person who, when the angel said, "You have to get out of Glenn Ellyn," he said, "Can't I just move over to Lombard?" He didn't want to leave suburbia; he just wanted to go to the next town. This comparison of Biblical characters and ourselves in the present day plays both ways. The weight of it seems heavy for us but, once we assume it, we can start to look at these characters like Lot or Eve as being real people and having real experiences.

Many of your figures seem vexed and none more than John in What John Saw (& Nobody Else Saw). What do you feel like you can see that other people don't see?

JS: Nothing (laughter). I often tend to think of myself as someone who has been given very little, not that I feel that I haven't been given much (still laughing).

We will get back, a little later on, to your work entitled More Than Enough.

JS: All right. At the same time, I feel like I'm just a small player in charge of limited resources. I've always felt that my project is to deal with those resources as effectively as possible. Another metaphor one could employ is that I've been dealt a particular hand and I have to play that hand wisely and carefully. I feel as if bearing witness to the reality I have been given is really a matter of taking that reality seriously by looking carefully and being observant of the real world that is around me. My work is about trying to wrestle whatever kind of significance, beyond the material or naturalistic, that I can find in that reality.

It sounds like you are comfortable with what you have been able to find or what you have been given.

ABOVE
*What John Saw
(& Nobody Else Saw)
1992, oil on canvas,
28" x 53"*

JS: I guess it is comfort; it is also anxiety. There is a sense that you want to be as true as you can to what you have been given and do a good job with it. When I wake up, I try to take notice of my environment; I try to pay attention as I eat breakfast. I do the same thing as I work or have lunch and so on. I try to cultivate a kind of openness to the possibilities that are present in each moment of reality. Waiting and watching so that I can make something of it or respond to it in a way that is true.

How has this openness to the possibilities of the present developed into a visual vocabulary for painting?

JS: When I began to engage this issue, I thought of making all of my art from memory. In other words, whatever images I was going to paint they were going to be based upon what I could remember of the thing. I was not going to look at models or photographs or anything naturalistic. I began to notice how my imagination altered my memory in comparison to any given thing. For instance, if you just take this styrofoam cup, you would think that you could remember what that cup is like. But looking at

the cup you realize there is just tons of beautiful visual information here, so many details that you can't recall them all. It seemed that the way I should go with my work was in the direction of looking at what is there rather than just trying to remember it. So, I moved into the visual vocabulary of realism. I'm talking about realism as a 19th century development where it was associated with truth or bringing something to the fore that hasn't been known. In other words, realism is not a comforting representation that confirms everything you already thought, but realism has a slightly more critical edge.

How has your faith impacted the development of this vocabulary?

JS: That is a difficult question because there is one part of me that wants to say that faith influences everything and there is another part that wants to say that the realist vocabulary is not a matter of faith; it is a matter of sight. As I said earlier, a matter of looking. I know that I would be nothing without the grace of God and without the gift of faith. So, everything is influenced by that; everything is turned upside down. On the other hand, when you really look at it as a realist, using the language of critical realism, you have to admit that there is not that much that is different, when it comes to the issue of painting itself, between me and anyone else. There is a kind of paradox between these two answers.

I'm always hesitant to say that my faith gives me a different way of looking at things because, if that were really true, why wouldn't it be fantastic and world-changing? Why wouldn't it be something visionary? It seems a little false to claim that kind of revolutionary vision when I don't see a revolution resulting from my work. So, it's not that I don't want to give credit to God for everything but I don't want to pretend that somehow my work is more significant than anyone else's, because practically speaking I can see that it isn't.

Yes, the paint does come out of the tube the same for everybody, but beyond that, what about the concerns that drive your art, the concern for looking and representing truthfully?

JS: Well, there is a long history of great realists who were concerned about truth but they weren't Christians. So it's a complicated thing. I wish I could just claim that the presence of God and the Spirit working in me gives me a different way of seeing, but I would claim that easier if I actually saw it happening. Today I was down at the Dallas Museum of Art and there was a work by Gustave Courbet that was pretty fantastic. He was not a Christian, as far as I know.

What you are saying about the realist rather than visionary vocabulary reminds me of a lecture you gave, at a conference in New York, entitled "Reflections on Inspiration, the Transcendent, and the Mundane," in which you talked about the Bible encouraging us toward thinking about the artistic process in terms of cultural rather than divine terms. Could you elaborate on that point?

JS: By cultural terms I simply mean thinking about artistic works. What I was referring to in the Scripture were references to idols where a Biblical prophet denounces them as being merely silver worked by hand. What they are really talking about is the cultural conventions for making an idol. If you want to understand an idol, understand it in terms of those cultural conventions, not as something supernatural, because it isn't. And I feel that art is always obeying cultural and historical conventions. While perhaps supernatural experiences are possible through art, the art itself is constructed by paying careful attention to cultural and aesthetic conventions. In terms of my own work, I've never thought that God gave me these paintings because the truth is I know how to paint by looking at paintings and by studying painting. I've learned by trial and error, not by divine revelations coming through the air from some other place. If the vision were coming from some other place, then how are we even going to recognize it when it gets here? It has to be in terms that we have already understood. If something is going to be completely new, then we won't notice or understand it.

God's own revelation of Himself to man begins with creation, with something we know. The Bible doesn't begin with some sort of abstract idea that we can't understand. The Bible says "look around you. I made everything that you see and everything you can't see." Isn't that Creation the foundation of the artistic practice?

JS: It is. Artistic works are based upon that very initial notion of looking at, watching, studying everything around us. That was what I was talking about earlier is all about. That is what trying to be open and prepared is all about. That is an activity that I, as an artist, want to be involved in. It has dimensions that are cultural, it has dimensions that are naturalistic, it has dimensions that are spiritual, but when you make a painting you are participating in history.

It seems like you are describing both that the work is steeped in a tradition and it is also steeped in a contemporary situation and it is maybe an interaction of those two things. Is that sort of how you see your work?

JS: Oh yeah; it is definitely about bringing things together. The problem is to identify things in the contemporary situation that are pregnant with possibility. The idea is to represent these things in a way that invites the viewer to make larger connections, to realize how the present situation relates to tradition.

How do you think that we as Christians should address our postmodern period?

JS: My own conviction is to be very much committed to the world I am in, the present. Being committed to it doesn't mean I agree with it 100%. It doesn't mean I acquiesce to everything that is going on. It doesn't mean that I can't stand up and protest, but I want to be 100% engaged with it. The present is my point of existence.

There seems to be a lot of contemporary art which is antagonistic to Christians. How do you think that we should be responding to or engaging that kind of work?

JS: I think we are all engaging culture. Even the person who thinks she's retreating from culture and avoiding it ends up addressing it in a sort of backhanded fashion. My personal approach is local and specific. I've recently started to think that maybe all of my work for the last 20 years has been a kind of geographical study, that is a study of a locale, an environment, a place and a person in that place. I'm not so inclined, as I think a lot of artists are today, to speculate about culture in broader more theoretical terms—not that I think that is wrong, but I am more inclined to try to address myself to what's right in front of me. I hope that in the long run when observation on observation on observation is all added up, that you do see something more. I think that, over a period of time, all of my work will actually say something perhaps broader about culture, but it will do that by having addressed very specific, personal, and local things.

In terms of your local community where you live, at a Christian college and in a community that's culturally Christian, have you encountered any suspicion about what it is that you do that you don't think you might have encountered if you were a dentist or plumber?

JS: I think that it is very much a dentist and plumber's world. My feeling about the "Christian community" is that it really is no different from the rest of the country. That may be something that the Christian community will have to answer for, but I don't see that much of a difference between the evangelical community and the rest of America.

So, you don't see the Christian community as any more or less suspicious or antagonistic to the visual arts than the public at large?

JS: The evangelical community is very suspicious of the visual arts. There is a tradition that is anti-visual. Art just isn't a part of their lives; so, they don't have much appreciation for it.

If the relationship between the artist and the Christian community is a 2-way street, often blocked in both directions, how can the artist engage or serve that community?

JS: All I can do is honestly respond to it. My heroes would be people like John Updike who writes about life; he writes about experience. I'm not particularly trying to engage a Christian audience and get a Christian response from the audience.

Your more recent work has moved away from the pieces like* Eve in Suburbia *that reference the Biblical narrative. It has become more in the tradition of a 17th century genre painting where the things of everyday life take on a particular quality.

What has that tradition meant to you?

JS: It slowly has meant more and more to me. Although I don't approach it as the 17th century Dutch artists would because they did not have the Modernist concept of realism. That is they weren't inheritors of the later 19th century concept that realism is inherently a form of criticism.

How did you come upon the theme of the journey?

JS: Just as you suggest, I "came upon it." I mean it occurred to me only after I had been working on a number of paintings that involved these people wandering in suburban waste-spaces. It dawned on me that what I was painting was the journey of these folks through what had become a strange land.

You refer to "the" journey not "a" journey. What was your intention with that?

RIGHT
Encounter on the Journey
1996, oil on canvas,
54" x 66"

JS: "The" journey turns "a" journey into something more symbolic. It turns it into a kind of archetype, something everyone has a share in.

How did you begin to move away from representing cultivated and constructed environments, like soccer fields, to looking at abandoned or undeveloped areas of the landscape?

JS: Well, I was becoming dissatisfied with an ironic or distrustful tone to the paintings I had made of the posh suburban world. I wanted to do something more positive and expressive of my hopes. I began to pay attention to the way Renaissance artist depicted the nativity of Christ. They almost always presented the birth of Christ in a context where everything is falling apart. The hope of the world is presented in the context of decay. How sorely hopeful, after all, would it seem if Christ were born in a half million dollar McMansion? So I began to notice the pockets of wasteland within suburbia, the areas that are overgrown with "junk" trees because the land is unfit to build on or developers just can't get their hands on the property. I began to think that these contexts, not the substantial neighborhoods, might be the environments where one might be inclined to search for hope.

In a work like Encounter on the Journey we, accompanied by the man and woman who are following on the journey, encounter something odd within a familiar setting, namely a man swimming while fully dressed. How did that work come about?

JS: Once I realized my work was actually taking me on a journey I began to be attentive to the signs of the journey that every day offered. One spring we had a lot of flooding in our area and one of the newspapers published a photograph of a man standing shoulder deep in muddy water. As soon as I saw it I knew that were I on a journey I would encounter a man like that and that I would have to figure out how to respond to him.

Relating that man in the mud or the girl doing a handstand in Second Sighting to what you said earlier about your work being a study of a person in a place, let me read a quote by Eric Fischl, an artist whose paintings your work has been compared to, about his sculpture: "First let me say that I make a distinction between pose and posture. A body posed is really about abstraction. It is about formalism and not about emotions or psychology. Posture is quite different. The posture one's body assumes carries with it all the memories of its experiences. These memories bend, twist, stiffen and overemphasize. Posture [is] . . . this sense that the way one carries oneself is the result of an epic struggle between internal forces reacting to external forces." You seem to be using the handstand as both a posture and a pose. What is the psychology of this work as an image of how we relate our surroundings?

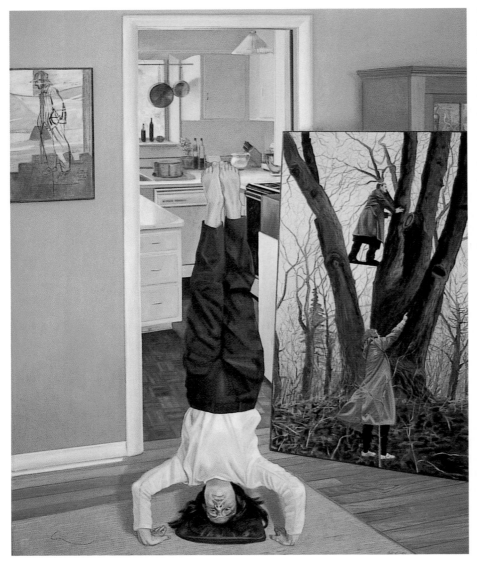

ABOVE and RIGHT
Second Sighting 1999,
oil on canvas, 60" x 48"

JS: Yeah, it's both a pose and a posture. It certainly is an image of a young girl posing in a headstand. But I'm trying to affect the posture of the viewer. I'm trying to get the viewer to actually feel a kind of inversion of her point of view. You know that image was used as the announcement card for my show and I was surprised and pleased by the number of people who tended to turn the card upside down when they looked at it. I figure that if people were inclined to physically turn it upside down, the image was hitting them in the body, it was affecting their posture.

Second Sighting *is set in a room in which an earlier painting,* Sighting on the Journey, *leans against a cupboard. Placing images within images is an interesting way of dealing with the issue of content. What was your ambition for this series of interiors with images representing exteriors?*

JS: Well, the whole idea came about through experience rather than calculation. We almost always have a lot of paintings littered around our house. They lean against the walls and against furniture. Sometimes I hang pictures at home, while I'm still working on them, just to see what happens if I live with them a while. Often an ironing board or a vacuum cleaner stands in front of a painting. I began to pay attention to the visual poetry of all this. And then I realized there was more to it. The paintings bring another dimension of reality into the scene.

This juxtaposition of worlds is the sort of thing Baroque painters made quite a bit of. In *The Burial of Count Orgaz,* El Greco could paint the burial of the Count at the bottom of the picture and fill the top with a scene of paradise. I saw the paintings creating a similar situation—more than one world in a scene—and I wanted to capitalize on it. It was just natural to juxtapose the exterior paintings with the interior world, and of course that introduced the idea of an interior journey alongside the exterior one.

In a paper entitled Content: the Substance of Things Hoped For, *you said, "the important questions about content in art do not revolve around issues of abstraction or recognizable subject matter, but rather around the possibility that human beings can sustain belief in their own existence.... Any crisis of content is always related to a crisis of the self." Can you elaborate on that relationship and how content is the substance of things hoped for?*

JS: There is a sense in which I really don't know what I am looking for in the process of making a painting. The best way I can describe what's going on is to say that I feel that I am reaching out for something. I suppose that I sense what I'm looking for in things, in things that surround me. Yet I really don't have a clear idea of precisely what I'm looking for there. I just begin to work with these things in drawings and paintings until I begin to feel a sense of resolution about them. Finally, if I'm lucky, I get to a

point where the painting starts to satisfy what I have been longing to see. It seems to substantiate the reality of something that I had a hunch was there. What I'm trying to get at is the idea of the substance of things hoped for. I feel like the things that I'm hoping for are the things that seem true about my experience of reality. There is a sense then that the painting can be the carrier of that content. It makes that content visible, physical or substantial.

The idea that the work of art is the material carrier of the immaterial is the foundation of the paradigm of "art as prayer."

JS: When you first asked me about prayer as art or art as prayer, I just thought "No." There are, of course, many different kinds of prayer but the kind of prayer that I'm most interested in is what I would call being open to God. Prayer is being in his presence, not having a whole lot of arguments or wish lists. I feel like painting is all about wish lists and willful intentions. Art is all about studying traditions and conventions, figuring them out using them for one's own agenda. By my definition of prayer as openness, I feel like the painting process is too willful, too intentional, too directed. My art, for myself, is not about a conversation with God; it's about trying to make something happen based on what I know as an honest workman. However, when it's all done, when I have an exhibition and I see ten of these paintings, I feel that they are kind of like my prayers. But it's after the fact. I don't feel that painting is prayer; I feel a lot of times that paint-

ing is just hard work. When it's all done and you can get a little distance from it, the works do seem to contain your hopes, your dreams. So, I would say that in that sense I could say that art is prayer. There are some artists whose art is a kind of meditative prayerful activity but my art isn't; it's work.

In a work entitled* More than Enough, *you seem to be standing with your hands raised in a way that could be read as prayerful. The title suggests that these things that you've hoped for have become reality for you. How has this fulfillment impacted your faith and your art?

JS: "More than enough" to me means that all around me there is more than enough with which to work. Coming back to this simple cup, I want to say, "There is more than enough right here. Let's deal with that." Sometimes my students are so interested in expressing their feelings. I feel like saying, "I don't care about your feelings. There's more than enough right here with this cup. If you can deal with that, you've got it—a treasure house of reality." Deal with that honestly and you'll do fine.

In that painting, the viewer is looking down on me and I'm looking up at you. I am standing in these zucchini plants. Zucchinis are notorious for producing more than enough. I mean they produce zucchinis that pop up hour by hour you're getting another one and they are getting too big. So, "more than enough" means there is more than enough in the simple and mundane.

O B J E C T S OF GRACE

JS: It puts me right back into the middle of things again. I'm not just focused on the transcendent but on what's here. I think, as I'm painting right now out of my own little suburban tract house, there is more than enough right there. It's not the grandiose thing I might have thought of; I am not the grandiose person I imagined I might be or have great things to show for myself, but I still have more than enough.

CONVERSATION WITH **MAKOTO FUJIMURA**
November 2000

James Romaine: Your work combines traditional Japanese painting techniques with a Western approach to abstraction. Could you describe this approach to painting as it has been traditionally practiced and how you use it?

Makoto Fujimura: My training in Japan was in a traditional Medieval technique called Nihonga. I spent six and a half years learning the technique, using materials such as malachite, azurite and other minerals mixed with animal skin glue. This method does not just go back to Japan but also the Western tradition. You will find very similar techniques in fresco painting or Medieval manuscript illumination.

Japan has a unique tradition of importing techniques, whether it be in painting or building automobiles, and refining them. As I studied this technique, I found myself really energized by the materials and the process itself, which is unusual in its inefficiency. You have to grind up pigments and hand place sheets of gold or silver foil onto paper stretched on panels. It takes time; it's a slow process. But the whole process fits my expression; I wanted to be able to use basic water based materials, and yet express this broad range. In this process, I found myself thinking about Mark Rothko and Jackson Pollock. I was impressed by the way Pollock took

an interest in traditional sand painting and then moved from that to drip paint and to walk into the canvas as a sort of performance.

Your paintings also go through a process of transformation. The techniques and materials you use have the potential to change over time. It is, of course not uncommon for a painting's color to fade or change. But you actually work anticipating certain changes, painting in veils that become more transparent and laying on gold or silver foil. What are some artistic and maybe spiritual implications of this technique?

MF: It is a very Japanese way of thinking. Rather than trying to make something permanent, they appreciate what has aged. Once you accept the fact that things are not permanent, you approach the ephemeral with a renewed perspective. You can see the permanent and the ephemeral as parallel tracks and can find value in something that is aged, rusting or decaying. You can find something beautiful in that process. Japanese artists have always considered silver, for example, to symbolize our lives and death because it oxidizes over time and tarnishes. Painters deliberately use this oxidizing process to symbolize time itself. The paintings

Some of your works are painted in various layers of minerals that gradually become transparent over time, revealing new layers. Does that relate to your faith that God has revealed Himself over time, both in history and in your own life?

MF: Yes, each particular work has a history. The whole concept of history is based on the idea that there is a beginning and an end; it's not just cyclical. The underlying world view of Japanese art is cyclical, and yet the technique lends itself to this notion that there is a beginning and an end. This technique emphasizes the process itself, how we mix paint for example, there is the mineral that is being crushed, and these minerals are then applied to the handmade paper. The artist is merging their history with that of the person who made the paper. There is this rich fabric of story being woven as you work. That is something that is very significant to me as someone who has come to understand that his world view is a premise that allows for these stories to come alive. That understanding of the world or looking at yourself, as having a history, is very Biblical. Because there is a beginning and an end, there is resolution; even in death itself there is this purpose.

In addition to merging their history with that of the person who made the paper; it seems that the artist also has the privilege to participate in the story of God who made the minerals. Giving visual form to that on-going history of Creation.

PREVIOUS
and **ABOVE**
Sacrificial Grace, 2000,
Mineral Pigments on
Kumohada Paper 60" x 90"

are made so that, as the silver tarnishes, certain aspects of expression are revealed that would not originally have been seen. In the recent Koetsu exhibition in Philadelphia, many of his paintings were heavily tarnished, but they had this incredible glow to them. He was certainly aware of what was going to happen to these paintings, and here we are 400 years later looking at works that will continue to evolve over time.

MF: If you can embrace that, it clears up a huge question of purpose. I came to a point where I couldn't justify what I did, although I knew that it fit who I was as a person and the expression I was longing for. Yet when it came down to looking at this sublime grace that was flowing out of my own hands, I didn't know how to justify it. The more I thought about it, the more depressing it became. I knew that when I was making art it was very rich, very real, very refined and very beautiful. Yet I could not accept that beauty for myself. I knew that inside my heart there was no place to put that kind of beauty. And the more I painted, the more I realized that this schism between what was going on in my heart and what I was able to paint was growing larger. When I finally embraced the faith that there was this presence, this Creator behind the creation, then I had a way to accept this beauty, because I had been accepted by someone even more sublime. There was a purpose behind everything; Christ came 2000 years ago and lived in Palestine. He walked among us; He felt the same dirt we feel today and that to me was an amazing realization. If this beauty had a home, then I could accept it for myself as small and frail as I am, because of the work that Christ Himself poured out for me. But without Him, it was impossible.

I've heard you describe the creative process in relation to Mary Magdalene, who anointed the feet of Christ. While there is some uncertainty about who this Mary was, images of "the Repentant Magdalene" abound in Western art. But it seems to me that she is most often held up as a model for the viewer.

You are the only person I've known to turn Mary around as a model for the artist. How has she been an inspiration for you?

MF: I am referring to the account in John 12 where Mary comes to the place where Jesus was staying and pours out her perfume. Here, she is the sister of Martha and Lazarus, whom Christ raised from the dead. In this state of complete and utter amazement, her heart was full of thankfulness. She was overwhelmed with emotion and she didn't know what to do. Then she realized that the only thing that she had valuable enough with which to somehow respond to this amazing miracle was this perfume, which was worth about a year's wages. She anointed Jesus with a perfume aroma that He went to the Cross with. That was the only thing He wore on His body on the Cross. She seems to me to be the quintessential artist because she responded with this intuition rather than calculation.

If Mary was the quintessential artist, than Judas was the quintessential art critic. [laughter] His response to that scene was outrage and to condemn it as wasteful. I don't want to go too far with this comparison, but there are many people, both Christian and non-Christian, who view the visual arts as something "extra" at best or a total waste at worst, but not essential in any way. Is there a model in the story of Mary about the value of art?

MF: Certainly. What Jesus said to her, and those around Him including Judas, was "She has done a beautiful thing, and wherever the Gospel is preached what she has done will be remembered." That is an amazing commendation for

someone like me who tends to work from the heart, who tends to work with precious and costly materials. I remember that the extravagance of Christ's love for me prompted an extravagant response. Eventually, I came to connect what I do as an artist with Mary's devotional act. Maybe that is the one act we can look to as the centerpiece for a paradigm of creativity.

It seems very interesting to me that this is an example of something that at first seemed to be either wasteful or peripheral but has become enduring. In the history of Christianity and the visual arts, this is true as well. Many Christians today see the visual arts as peripheral to the faith, but historically they have been central. Much of what we have as our tradition, the history of Christian faith, comes to us in the form of the visual arts. I could imagine being on the budget committee of a hospital in Isenheim and have to justify the wasteful expense of getting Grünewald to paint another altarpiece of the Crucifixion. But the centrality of that work to our being able to imagine the Crucifixion has endured. One could say that wherever the

Gospel is preached Grünewald's image has a place. It has a value.

MF: Yes, it has a value. It takes faith to believe that. It takes faith for an artist to be able to accept that. Because you often get more criticism than affirmation. If you can believe that Christ is there in your studio, you can take risks as you act in an extravagant way that is a powerful and devotional reality.

Robert Kushner described your work as a struggle from darkness toward light even calling it a Pool of Bethesda. What aspect of your work do you think his description captures?

MF: I think it is a wonderful description and I talked with Bob about it. I think it is a serious struggle against sentimentality to keep yourself open and honest about the imperfections that you have. All those things become part of your expression. The Pool of Bethesda was a place where Christ healed a blind man and He first asks him the question, "Do you want to be healed?" It's an amazing question because to me it is so obvious, of course I would want to be healed. The man has been blind all of his life

and he is there begging. I think what Christ wanted to hear was an expression of need. He wanted this man to respond and say, "Yes, I want to be healed." I think that is very significant for us to because that is what artists do. In order to come from darkness into light we have to express what is obvious to us. We have to humble ourselves and express the need to be healed in order to see this mystery, that we have been created so that every minute counts and every word is counted to be worthy. God rewards us when we come to Him with humility and make this very simple request. It's another affirmation that every small painting, every line counts.

You've described working with the gold and silver foil, that as you lay each square down it is another prayer.

MF: Especially with gold because it is an image of the City of God descending to the City of Man. Japanese gold is more thin than gold foil from Europe, which makes it more transparent. You can layer gold, and over time it becomes even more transparent. The more pure gold is, the more transparent it becomes.

As these sheets of gold or silver foil are placed across the pictorial field, they create a repetition of form conducive to meditation or devotion, but they also create a grid or matrix. These grids remind me of the way works of art can represent systems of perceiving and processing knowledge. This repetition of form has both a rational and an irrational aspect that is held in tension. Do you see this as an attempt to balance these two ways of knowing, intuitive and analytical, in your work?

MF: That's a good way of describing it. The work has both architectural and organic sides. Saint Paul said in 1 Corinthians 3:9 "You are God's field, you are God's building." It's a mixed metaphor, but it is an amazing picture of the meditative and analytic, subjective and objective sides of our being. I think what he was trying to describe with these two pictures, the organic and architectural, was the new Jerusalem, which is pure gold. What a lot of people don't realize is that pure gold is transparent and fluid. I am very conscious of this mixture of the architectural and the organic when I am working with these foils of gold.

In two of the panels, currently on exhibition at Saint Peter's Church here in Manhattan, this matrix of repeating squares of silver is broken in some places where the foil has been torn or scraped across. These breaks reveal an underpainting that is indiscernible because we get an incomplete or selective glimpse of what lies behind this silver field. This seems to be a statement about what lies beyond the world that we see, beyond our systems of knowing.

MF: Yes, that piece, a *Mercy Seat,* is made up of two layers of silver. The under layer is intentionally oxidized and tarnished, so it is turning black. The layer on top is untarnished silver. Both of these layers are tarnishing but at different speeds. The two layers create a tension in time. Because silver symbolizes death and beauty, beauty in death, I am always conscious of the 30 pieces of silver for which Christ was betrayed. There is also a redemptive story about Jeremiah buying a field for 30 pieces of silver. This was a Messianic prophesy about the sacrifice and mercy of God. Silver has this unusual and rich layering of meaning. This gives you that glimpse into our own hearts. Because our hearts are so black, without God's mercy.

The relationship between the Old Testament story of Jeremiah with the New Testament account of Christ's betrayal is a "progressive revelation." I think this relates to the way your paintings work. "Progressive revelation" is a theological term but in your paintings it could be an aesthetic description of the way in which the images reveal themselves to the viewer over time. How do you use the techniques of your art to express the idea that the visual arts can show us something that is invisible?

MF: What is inherent in the process of creativity is a theological paradigm that we are progressing to an end which all of nature is waiting for. When foliage turns red and yellow, this is because it is dying. The beauty that we see is death itself. That beauty points to what Paul says in Romans Chapter 8, that the whole of creation waits for it in eager expectation. Through this beauty and suffering we involve ourselves in this process by which suffering takes on purpose. That progression again of going from darkness to light is both an aesthetic and theological paradigm. If you see yourself, as an artist, as a part of this movement, you can begin to grasp how important it is that, though we are finite and not God, we exercise this ability to reveal and articulate what we are becoming. As we are becoming what God has intended for us, even when everything looks bleak and things are very dark, you have this picture of this golden light somewhere on the horizon that will not fade away. To me that is probably the most important thing that art can articulate.

Seeing yourself and your art as part of a spiritual movement from darkness to light is quite a powerful paradigm that is significantly different from the materialist paradigm that pervades the mainstream art world. How do you see your place as an artist working with one paradigm in an environment in which another paradigm is dominant?

MF: I think that we are here because we are meant to give a picture of hope through suffering. Serious artists have always been concerned with spiritual matters. Even sometimes by not addressing these issues they address them. It is important for those of us who see our creativity as part of this progression to exhibit what it means to the world. Throughout history we find artists who have done that with courage. We need to do it because if we don't the whole language of art suffers. It becomes more fragmented, more self-centered and less able to talk to the outside world. It loses its communicative ability.

Steve Turner, the British poet and writer, has said in a short text entitled Being There: A Vision for Christians and the Arts, *"I've always had the conviction that Christians should be involved in the mainstream of our culture. Part of the health of our democratic society is that we debate and that there is always a vigorous discussion taking place about who we are and what truly matters. However, there is often a noticeable lack of Christian contributions to this process." Do you think that a Christian who is an artist has something particular or different to, as Mr. Turner says, "contribute to the process?" And what strategies do Christians need to take to engage the creative debate?*

MF: First of all, we have to be honest about our own conditions. We as Christians are far from having perfected our own condition or having arrived at any perfection. It just shows God's grace and mercy because we tend to be the ones who are misfits. Second of all, artists of faith do need to get together to exhibit. We need to be working as a whole, as a community. Working in collaboration and pushing each other sharpens our calling and our gifts. It is the ultimate way to be able to both grieve with the world but also serve the world that needs love. New York City is full of isolated individuals who are enormously gifted and yet they have no hope. In an *Art in America* interview, Eric Fischl spoke of four tasks artists have historically, within the Christian tradition, been asked to do: to imagine what heaven is like, what hell is like, to imagine the garden of Eden before the fall, and after the fall. He notes that artists have generally become

specialized and that it is rare to find an artist whose work encompasses all of these. This poses a question about our ability to show the grace of God working through us. Can we show the reality of heaven and the reality of hell? To the world they are fantasies but to us these are realities with weighty substance. These are even more weighty than the reality of what we experience today. We need to create with that understanding. I think the world is longing for artists who have the expressive range to create a picture, a vision of where we are going.

Another thing that is very important is to think through theologically what we as artists are doing. The artisans creating stained-glass windows were making theological statements and their windows were what Medieval people had as theological instruction. The artists knew that they were putting forward a theological statement through light and color. That is a different sort of paradigm from the dominant paradigm of the world we live in. I think artists today need to be working with pastors and theologians to work out new ways of Biblically dealing with our world.

In 1997, you had an exhibition entitled Images of Grace. *How does the process of making a painting, using the techniques that you do, engage the idea of grace or give weight to grace?*

MF: The pigments I use have a semi-transparent layering effect that traps light in the space created between the pigments and between layers of gold or silver foil. This creates a "grace arena" in which light which is caught creates space. It is neither the Renaissance system of creating

pictorial depth through perspective nor is it the Modernist emphasis on the surface space. It is much more similar to the stained-glass window. This approach creates the effect of space rising and falling through these veils of pigment. In *Gravity and Grace,* Simon Weil states that there are only two operating forces in the world, one is gravity and the other is grace. That is precisely what I am trying to do with these pigments.

One work in particular that stood out for me from that exhibition was Sacrificial Grace. *It seemed to have one veil of color under another under another that gave it a particular depth. Was it something about the space between the reality that is immanently around us and the eternal transcendence of Heaven with the sacrificial grace as something that might fill that gap?*

MF: Grace rises but sacrifice falls. It descends into us. It is a sort of "the way up is down" idea. That is the truth behind the Incarnation of Christ. There is a reality of sacrifice that is evident in nature, like the color changes of a dying leaf. There is a sacrifice for that beauty. Creativity is a sacrificial process. Some people see art as extravagant and the artist as celebrity, but to create a beautiful work of art takes training and other personal sacrifices.

Your next major exhibition in New York after **Images of Grace** *drew inspiration from Medieval Books of Hours. What influence did this Medieval art, particularly the manuscript illumination of devotional books, have on your work?*

MF: Medieval manuscripts were one of the first places I looked to for inspiration after embracing what Christ had done for me. I was tremendously moved to see these artists using the same materials that I used but in a devotional context. Medieval art has an intimacy and extravagance that a lot of later art lacks. There is a certain innocence in the Medieval assumptions about the world, particularly the belief that God fills the empty space. That is how I began to understand this reality and unifying principle behind everything. My work has always been concerned with issues of time, and I was impressed by the way in which Medieval monks approached time. For example, the mechanical clock was invented so that monks would remember to pray. It was originally an object in service of or in aid to prayer, but today we are enslaved by time. I want to capture a different

sense of time, that is a "time fullness," in my work that each moment is given by and for God's grace.

December Hour *seems to have been a break-through work both aesthetically and also in terms of the role of faith in your work. How did that work develop?*

MF: *December Hour* was a unique work in that I worked on it for over a year and it was really a journey of my own heart trying to come to terms with the death of a friend and the weight of suffering. Working on it was literally a prayer each day. When I started the painting, we had talked about him coming here to New York from Japan to see the exhibition, but by the time the exhibition finally did happen he had already passed away. I had the strange experience of looking at my own work and looking at it objectively, outside of myself. I was thinking about what had happened, still somewhat in shock, and having my own works speak back to me as if to comfort my own struggle. I began to understand in finality there is this responsibility towards death. In some ways art is a way to capture that responsibility. We confront death and we struggle. We move beyond this struggle to hope. December is a month of death, but the new year is coming. I wanted to express the belief that our suffering has purpose and that there is hope.

How do your think your work has changed since that experience of making and being comforted by **December Hour?**

MF: My recent works are more direct and intuitive. Through that time I worked out very complex emotional and technical questions and came to a conviction that I may have a very small role to play in the picture, the story we talked about earlier, but that is all right. I can still contribute in an honest way about where I am today and who I am today. As a result, my work has taken on a greater simplicity and directness.

From December 1999 to February 2000, you had an exhibition at The Cathedral of St. John the Divine. How did you approach the prospect of having a visual art exhibition in that liturgical space?

MF: It was really a tremendous privilege to create works for that space, at that particular time of celebration. What was liberating to me was that as I was installing the pieces and thinking about the exhibit as a whole, I began to realize that it is a great idea to show art in a liturgical setting. One observation that I immediately made was this liberation because I didn't have to

be at the center. The liturgical space already had a focal center, that is the Eucharist table. What that does for an artist is that you have this place of innocence. You can stand not at the center but at the periphery. I enjoyed it so much because I could celebrate who I was and the small role that I have but I color in the borders. I didn't have to justify my own art in that setting because it was enough to simply be who you were. It made me reflect on the exhibitions I have had in galleries in Soho or in museums. These began to seem unnatural and artificial. In these shows, the artist is put in the spotlight. It may be fun, but it is not what art is all about. I enjoy having openings and having people come see the work, but there is still something lacking in the approach to art that these spaces represent.

A group of works for the St. John the Divine project were Mercy Seat *paintings. How did you arrive at those works, and did the creative process give you insights into the concept or belief of the Mercy Seat of the Ark of the Covenant?*

MF: I was interested in the Ark of the Covenant because those Exodus passages, which are very significant about the nature of creativity, are so visually descriptive. While Moses was receiving the Ten Commandments, he was also receiving the instructions to build this art object, a mobile communication box and worship center. The Ark is described in such detail that we could recreate it today and it includes a blueprint of how we are supposed to approach God. There was the law, which was objective, but there also was this experiential arena which called for an intuitive response. I was inspired by this multi-

sensory art space to create these works. These Mercy Seats were 1.5 by 2.5 cubits, a cubit being the measurement from the tip of the middle finger to the elbow. I was amazed to discover, after I had these boxes created, the visual movement within the pictorial field of these dimensions. As a painter, I am always trying to create dynamic movement within a field of given dimensions, and a square is the most difficult because it is static. The dimensions of the Mercy Seat created a field in which there was already a powerful movement. I think it makes a statement about God's spirit even within a two dimensional space. The size is such that it doesn't dominate the viewer but it doesn't disappear either. It reveals so much about the nature of communication and prayer, with sacrifice, beauty and craftsmanship. It is a great paradigm for the artist.

Another of your installations in a liturgical space was at Union Theological Seminary. Could you describe the altarpiece that you made for that space?

MF: The central panel, painted in malachite which had been heated and thus turned dark, is a Gethsemane scene with a tree. The back panel is painted with silver and crushed oyster shell white. The image is of columbine flowers which were an early Christian symbol for the Holy Spirit but which have a more recent association with tragedy and suffering. The wild columbine is a beautiful flower. In the sun their petals turn purple, but in the shade they are an almost transparent white. They are a powerful reminder of the fragility of life and also of our fallenness. In this back panel I

wanted to create a place of resolution, working through the darkness to the other side. There is hope; there is purpose to suffering. Art can create a place where the weight and reality of our darkness and our dreams can be seen.

Part of the history of that Chapel is that Dietrich Bonhoeffer preached there before returning to Germany and eventual martyrdom. What have his writings meant to you and your art?

MF: Bonhoeffer's writings, particularly *The Cost of Discipleship,* are very important to me. Of all the writings of the twentieth century, his stand out as the genuine article dealing with the question,

"What does it mean to live today with faith?" He talks about "costly grace" and "cheap grace." When I paint, with the materials and techniques we discussed earlier, I am trying to depict "costly grace" in a more direct way. I realize to depict it is one thing and to live it is another. Bonhoeffer is a spiritual hero for me because he practiced what he preached. His example is more precious than anything I could create. If I could convey anything with my art, it would be to express the difference between "cheap grace" and "costly grace." If I can do that, I will be pretty happy.

CONVERSATION WITH **MAKOTO FUJIMURA**

December 2001

James Romaine: Living two blocks from where the World Trade Center was, how were you impacted by the events of September 11th 2001?

Makoto Fujimura: It was a truly harrowing experience; as the towers were collapsing and the fires were spreading, my wife and our children were all being evacuated from the area, literally being chased by the clouds of dust, ash, and fumes of jet fuel, and we didn't know when we would return or if our loft would even be there. Judy was at the loft and the children were right around the corner in school so they experienced a lot more than I did. I was trapped in the subway, one station away from the area underneath the towers which collapsed in on itself.

Two months later, having been able to return to our loft, we are just beginning to realize what happened. I feel very protected in that my family was rescued right out of the mouth of the terror. The other side of it is a tremendous feeling of mourning and even anger. Living at Ground Zero is a daily experience of depending on God's grace.

How have you been impacted as an artist by these events?

MF: I don't know how much my art has been directly impacted by these events. I've always worked in the intensity of the "invisible battles" going on, being sensitive to the struggles of life and death all around me. But to actually experience devastation firsthand, I have seen my former vision intensified. Being underground at the time of the attack on and collapse of the towers, I was protected from visually witnessing the destruction as it occurred. Because I am so visual, I may have had much more uncontrollable emotional response; I don't know what would have happened if I had not been underground.

It was an amazingly visual event. I think the film that William Basinski took from his roof in Brooklyn was a powerful piece. That view, more or less, is what I saw from my roof in Brooklyn.

MF: That piece reminded me of J. M. W. Turner's work. The way the cloud cuts across the image is literally a division of heaven and earth.

For some reason, that image reminded me of December Hour. I had thought that December Hour was very much in the spirit of Turner's work.

PREVIOUS
Film Still from
Disintegration
William Basinski,
September 11, 2001

**OPPOSITE
and NEXT**
Remains of the Day
2001, Mineral Pigments,
Gold on Kumohada Paper,
102" x 80"

MF: *December Hour* came out of a very painful period in my life; it was a work that I did as a prayer. Looking back on it now three years later, I am able to see it from the other side of the pain; it also points to a sense of potential survival and even renewal. It has taken me to a new level of awareness of how much of what I do, the art that I did even before September, is so tapped into the reality of the tragic nature of our human condition.

December Hour, *and your work in general, speaks to the potential for creativity and rebirth even in the midst of suffering and death.*

MF: The materials that I use are very delicate and beautiful, so the viewer may not immediately read the work as tragic, but I am aware of the way in which these mineral pigments are pulverized. They suffer to release this beauty, and the paper is stretched out and nailed to the wood to create this area where this mix of beauty and tragedy can take place. These materials create a space in which the light becomes trapped and is literally broken in refraction within the pigments, what I call a "grace arena." My work is about beauty as sacrifice; the events of 9-11, the firemen climbing up the towers even as they were falling down, only give that sense of the necessary sacrifice in beauty a greater, more tangible, intensity.

How is this sense of tragic beauty evidenced in more recent work, like **Remains of the Day?**

MF: I did *Remains of the Day* this past summer. I was trying to find a way to paint that addressed an in-between space, between the ideas of gravity and grace which had been part of my previous work. I was trying to capture something that is very ephemeral, almost painting how something smells. I am using a new way of painting. Instead of painting with the paper on the wall, putting on the materials with brushes and allowing them to drip, I am laying the painting surface out horizontally, parallel to the floor, and moving the paint around by lifting one side or the other. It is almost a performance. You have to watch the paint dry and direct the way it forms areas of color by lifting the work in the right way.

Did you have assistants helping you with this?

MF: I had help in gilding the painting with gold, but I was working alone in the actual painting process.

How big is Remains of the Day?

MF: 102 inches by about 80 inches.

We've talked in the past about the relationship between the artist and the painting being analogous to Jacob wrestling the angel, but here you are really physically wrestling with the work.

MF: Yes. [laughing]

So, the work is a representation of the process, or performance as you called it, of its making.

MF: Yes. I don't think anyone has painted in this way before. At least not that I am aware of, especially within the Nihonga tradition of Japanese painting in which I was trained. This may be the first work in which I have moved beyond quoting from that tradition. Its success will be if the viewer can experience something from the work that is beyond our senses.

Can you say more about the "in-between" space of Remains of the Day in terms of the current creative climate here in New York.

MF: A lot of artists are talking about being at an in-between state. They are able to question what

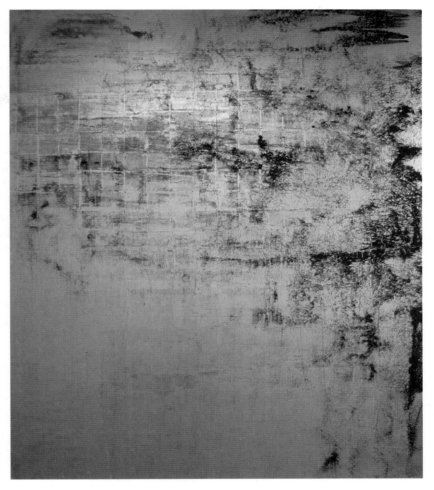

has been going on in our culture, what they are doing as artists and how the art world and the galleries operate.

I have found myself talking to a lot of other artists who live in the neighborhood. We aren't always initiating the conversations by discussing what happened, but it is always there, spoken or unspoken. The dialogue has been

very real and honest engagements of life issues. There isn't a lot of "street talk" or "business talk." This is a very honest period; the artists are in touch with our collective brokeness in very personal ways. This dialogue has been very transforming and healing for me. I have found that the artists are very perceptive and sensitive. They have a way of pushing past the surface and tapping down into the spiritual aspects of these things.

Artists often depend on their sensitivity to the environment for their work. They can't afford to shut off their feelings.

MF: Yes, they are able to articulate it far better. As a culture, we don't yet have a way of addressing this kind of tragedy. This is one of the things we are doing at TriBeCa Temporary, a space I have opened with my studiomate Hiroshi Senju to create an oasis of collaboration by local artists in hope of planting a seed of restoration in our community and the development of a "post-9-11" language for art.

I think this is a good time to consider what role art should play in our lives and what kind of art should be celebrated and promoted. The events of 9-11 have caused us to reconsider what is and what is not important. I think that what is important now are the same things that were always important before, things like faith and family. Looking at the case of the arts, I've heard several artist say that their work now seems shallow and without substance. But it may have been that their work was shallow and without substance before, it's just that they were not aware of it in the same way. Over the last few decades, the art world has become more of a media circus. For example, ArtForum *looks like a fashion magazine; I'm not even talking about the ads, I mean the art. This time of crisis we are going through right now may be a wake-up call for everyone, including artists. I think that good art is important; it was important before and it may even be more important now because we need images to help us process our emotions and remind us of those things which are eternal. Maybe this is a time when art can speak in a new way or contribute something valuable to society.*

MF: I don't know how things will be in the long run, but people are certainly more open to talking about these things now. It is interesting how the people who planned out the attacks of 9-11 used the technology and freedom of our society against us. This is a lot like the way post-structuralism works to undermine the very systems by which it operates. The terrorists accomplished in a single act what no art movement of the past century could have dared. What we have here is a tragedy, in the Greek theater sense of the word, in which human folly is played out. As artists we need to be more careful about what we do and what we are saying. We have to pay attention to the consequences of playing this game of shock art and sensationalism. We are held accountable for playing along until someone else took things to a poisonous conclusion. I don't know what the post-structurelists

would say about this, but I think that now is a time, to use a Christian term, for repentance. We need to stop and turn around and move toward God, to ask ourselves where are we going. We need to move beyond the Enlightenment.

That reminds me of something that Bill Viola, one of the leading artists working today, wrote in a statement entitled "Between How and Why." As an artist who works with the most advanced video technology, Viola is always thinking about the way we, in Western culture, relate to scientific developments. He said that, since the Enlightenment, we have been particularly focused on the material. We have shifted our "inquiry into the nature of the world from religious/philosophical to scientific speculation, from emotive affinities to material causes, from empathy to reason; the celestial becomes mechanical, and the primary mode of questioning the world becomes not why, but how." But he argues that the questions of "how" are not enough to carry us forward. That the "crisis today is a crisis of the inner life, not the outer world...Talk of machines, technologies, capabilities, offers no guidance and is inadequate and irrelevant to the development of our inner lives." Art has historically been the cloister of the "why" side of life. This is a reason that art is so important and vital at this moment in history. How does your work relate to the questions of "how" and "why," as Viola has described them?

MF: A very important question indeed. I am not against the use of technology at all. Even using a Japanese brush is using a form of technology. Craft is technology. But the question of "why" is far more important. We may have all the technology in the world, but have nothing to say to each other. We seek intimacy in relationships, but we, as a culture, do not really know how to love each other. If we have no poetry in the streets, we will not have humanity. I suppose my decision to use an ancient craft indicates my hands-on approach. The "how" and "why" are intricately tied together in form and content. The materiality of an ancient craft brings to bear what is very true in our physical sense. I remember sitting on a panel of presenters at a conference with a great theologian Calvin Seerveld. In answering a question about technology, he retorted in his wonderfully direct way, "We will always make love with our hands."

I am interested in the process of integration, of where form (as defined by "how") and content ("why") meet. Viola impresses me as one of the few artists of our time who allows meditative experience via art. I am interested in the fusion of "how" and "why." Both need to be addressed.

In the conversation we had last year, you talked about your art as an expression of "Costly Grace." While Christ is ultimately the perfect picture of that costly grace, the 9-11 events were another demonstration of the costs of grace.

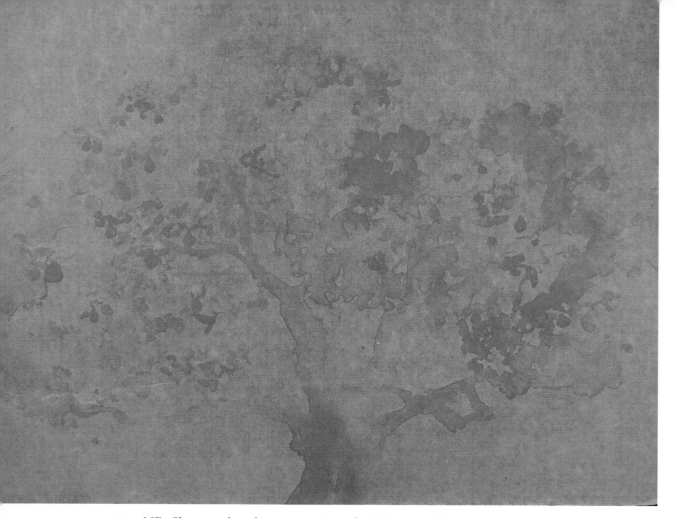

ABOVE
Shalom
2001, Hand Printed
Lithograph on paper

OPPOSITE
Cloud Voices
2000, 22"x22". Tea Room
at Sen Gallery, Tokyo

MF: Christ is the ultimate meeting of God's "how" and "why" of salvation. And grace is the operative word that fuses the two. We saw these firemen rush to save lives, climbing the falling towers. There is nothing more noble than losing one's life to save others. This is the greater love that the Bible speaks of, and that love was exemplified in Jesus.

What we saw were two "art forms." The terrorists' "art" of vengeance contrasted with the heroes of 9-11 whose "art" was their sacrifice. (I am using this "art" in the classical use of the term, meaning anything we create.) These are two clear opposing ways of creating. Any works after 9-11 will be marked by, and defined by, these opposing categories.

How did you begin the process of getting back to creating new work?

MF: On September 12th, I took my family to upstate New York. I had been working at Corridor Press in Otego, NY with master printer Tim Sheesley, who is the brother of painter Joel Sheesley, on a lithography series on the theme of shalom. The image is of a Medieval quince tree that I had sketched at The Cloisters in New York. I had made the drawing for the piece last March but the piece has taken on even more significance. As I thought about this simple image, the work began to speak to me as a small seed within me of shalom. As I saw, for the first time the printed image on thin Japanese paper, I had a renewed conviction about the piece.

What does the word "shalom" mean to you?

MF: I've always been drawn to that word. I've heard it defined in various ways; I think of it not just as the absence of war but the wholeness of humanity. It is the sense of something being renewed moment by moment. It is what the prophet Jeremiah wrote about God's faithfulness when he bought a field in Jerusalem as a step of faith and restoration. It is the peace that I had on September 11th. I had been trapped underground and cut off from everyone and my cell phone wasn't working, but walking back to my studio that day, not knowing if my wife and children were safe, I had this strange sense of shalom, that God was still fully in control. In a sense that was my only real option, I was so completely aware that I had absolutely no control over what was happening. That seed of shalom had taken root in my heart.

How does this shalom evidence itself in your work?

MF: I see my paintings as creating a space where shalom can take place and, as they hang on the wall, extend that into the viewer's space. My works are not complete until they are the backdrop for shalom, an arena where this dialogue and renewal can take place.

Let me talk about that in terms of the Japanese art of tea. This came over from China in the sixteenth century where it became ritualized. The tea master Sen-no-Rikyu invented this design for a tea house with a small entranceway, so that you had to both bow down and take off your sword to enter. What hasn't been discussed much in Japan is the connection between Sen-no-Rikyu and Christianity. This was a time of extensive

missionary work in Japan and Sen-no-Rikyu's wife, one of his wives, and many of his closest disciples became Christians. Sen-no-Rikyu went to Mass and the passing of the Eucharist cup affirmed his conception of the tea ceremony. The tea house became a place of safety in a time of war, a place where outside distinctions, such as the carefully stratified class society, were literally set aside and people served one another. I think art needs to serve a community. That community gives the work its context. TriBeCa Temporary is a place where shalom can take place, were creativity can be renewed.

Could you described TriBeCa Temporary in more detail?

MF: It is a small space, next door to the studio I share with Hiroshi Senju. It is a place where artist can show their work outside of the structure of the gallery system. This is why it is important that it is temporary. We will have six shows and then close the space in April. It shouldn't outlast its purpose, its ministry to heal.

The inaugural show at TriBeCa Temporary included a three-part video called Variations by James Elaine and William Basinski. Could you discuss that work?

MF: I was looking for a piece that would set a tone for TriBeCa Temporary. James and Billy had been working on *Variations* for a long time. James did the video and Billy was working in Brooklyn, NY on the music for the piece. After 9-11, James, who is now working in Los Angeles, called me up and asked me to go over to their studio in Brooklyn to see the piece Billy was working on. The piece begins with a film shot from indoors through a window that is covered in icy rain. There is a sense of innocence and yearning. You can faintly see through the blur that there is a tree outside that has been beautifully transformed into an icy sculpture. The second part was shot by James in 1996, down by the World Trade Centers after a Yankee victory parade. All you see are legs of men and women in suits as they wander from one place to another through the streets covered in paper If the first film represented the innocence of childhood, this second film suggests the perplexity of going out into the world and finding your place as an adult. There is a haunting sense in which this work now prefigures the confusion of the streets littered in the debris of 9-11. The third and final part of the piece was filmed out by Venice Beach in LA which shows the coming in and going out of the tide; you see fish swimming and the sunlight glistening on the crests of waves.

Isn't that last scene a beautiful image of shalom?

MF: Yes. The whole piece is a journey from light to darkness and back to light. *Variations*, which is now being shown at the Rotterdam film festival in the Netherlands, is another example of a work that has taken on an added awareness for the artist about what their work was about. Billy, who experienced spiritual renewal in the aftermath of 9-11, describes the work as a story of his spiritual pilgrimage, even though it was done before that pilgrimage had come to its fulfillment. The piece was prophetic in several ways.

Variations, *both in its video and music is very meditative. It reminded me of James and Billy's work in the exhibition you and I, along with Tim Rollins, curated called "Art as Prayer." What do you think the impact of that show has been, both for visitors but also some of the artists involved?*

MF: I think it has had a tremendous impact. Everything that we are doing at TriBeCa Temporary is a result of that show. Mr. Lim, a very important artist who is now up at TriBeCa Temporary, came to "Art as Prayer." When I saw him just after 9-11, we were able to continue a conversation at that time that began during the "Art as Prayer" exhibition. That show was also very important to Billy as a way to begin a dialogue about art and extend that to questions of faith. The show gave artists, most of whom were not Christians, the opportunity to think about their work in spiritual rather than commercial terms.

"Art as Prayer" suggested a paradigm of creativity, of making art and viewing art, as something that is not self-referential. It seems like that is more poignant now than it was when we did the show last March. The discussion of Rembrandt's **Self-Portrait as the Apostle Paul,** *in the catalogue essay for the show, as an image of coming to a deeper understanding of the sufficiency of God's grace in all circumstances and of how God uses our weakness for His grace were things that I understood only in part; I wrote that essay out of faith but those ideas have become more tangible somehow this Fall.*

MF: That show was a seed that God used to prepare our hearts for September. The show was intended to demonstrate an alternative to the narcissism of art, and with everything happening now that can have a long-term impact.

The piece you exhibited in "Art as Prayer" was entitled **Gravity and Grace.** *How have your thoughts about gravity and grace developed since we last discussed it last November?*

MF: The falling of the towers was so far beyond what anyone could have imagined, I mean there is no movie that can outdo that with special effects. It demonstrated the power of gravity. Gravity may become an important theme in art in the immediate future.

Simone Weil wrote *Gravity and Grace* in a war torn time. Her idea that gravity is linked to our baseness, to what is sinful and selfish, is certainly prophetic. We live our lives in a tension with this gravity; we are always trying to master it, we build into the air and create machines that can fly us through the air. But we have seen the reality of gravity and our sinfulness demonstrated in an irrefutable way.

What about grace?

MF: That is the second law of the universe. It is the only thing that frees us from gravity. I think we have experienced that, as well, in a new way.

So the two are forever linked in our reality and the work of art needs to have both elements. A work of art that has no sense of grace cannot speak to us of hope, but neither can a work that does not have a sense of gravity. The work that has no gravity, no awareness of our human condition, will just float away.

MF: Yes. It probably will not speak to us now. But the art of someone like Richard Serra addresses to the issue of gravity in a way that is very powerful to me today. Art that does not have a sense of gravity and grace will pale in comparison to reality.

Let's conclude by discussing what it means for works of art to be objects of grace.

MF: I have become more and more aware of my own dependence on God for renewal. We are forced to be in a place where there is no option except to look to God. It is humbling and confirming at the same time. I realize how easily I stray from that dependence and begin to think of myself as self-determining. A lot of art in the last century has been about self-determination. That is until we arrive at a point of ground zero. There are ground zeros in everyone's life and we have to recognize that grace flows out of that reality. A pastor tells of an experience of losing

his mother, his wife, and his daughter in a single automobile accident. As he struggled to cope, he began to see a dream in which he was chasing the sunset. He was running as fast as he could to keep up with the setting sun. But still he couldn't go fast enough and the light was slipping away. Then his sister told him that "to get back to the sunlight, what he had to do was turn around and run through the darkness of the night towards the morning." That's a very powerful image for us to think about. We are always chasing the sun until we lose it. We have to turn around and face the darkness. That is probably impossible except for the fact that God sent His son to go through the darkness ahead of us. As He hung on the cross, Christ was experiencing that darkness in its fullness. That His hands are forever marked by those nails is another example of the beauty of sacrifice. We also need to remember that we are not alone in the darkness, we have a community of fellow believers who, throughout history, walked the same path. As artists we are part of a rich history of the visual record of these journeys through the darkness that help us even today to find hope.

We are blessed to have that history and to contribute to what the future will inherit. It reminds me of the Crucifixion *from Mattias Grünewald's* Isenheim Altarpiece. *The function of the altarpiece was to establish a direct link between the supplicant's spiritual devotion and the healing power made possible through Christ. The penitent at Isenheim may or may not have fully invested their faith in the altarpiece's direct ability to heal their*

physical and spiritual ailments, but it certainly stimulated their faith in and devotion to Christ, whose suffering provided comfort and consolation. As an emblem of hope, this altarpiece would have been a rallying point for the suffering community. The altarpiece encourages us to engage in prayer as a meditative act that focuses both within and beyond ourselves. In response to our human condition, prayer can be transformative; while it has the power to affect circumstances, it can also transform our perspective. As a work that changes the viewer, Grünewald's altarpiece is also an "alterpiece." God works on us through the work that we do as an "object of grace;" that is its ultimate end. The idea that a work of art is an "alterpiece" reminds me of something James Elaine said, "We are the project." That is a powerful and mysterious paradigm of understanding our creativity.

MF: Yes, it is amazing that you and I are even sitting here talking about art near Ground Zero. It is literally by God's grace that we live to have this interview. We have to think about what it means to partake in the glorious experience of living at the "ground zeros" of our lives. That is not to minimize the loss or sacrifice that took place, it is what fulfills their beauty and purpose. And we must remember that there were deaths all around us, even prior to 9-11. Art is about life and death, and why we choose life rather than death. Something can be done at this moment of lasting importance, something that God can use, not just for the next five or fifty years but for the next five hundred years.

Square Halo Books

In Christian art, the square halo identified a living person presumed to be a saint.
Square Halo Books is devoted to publishing works that present contextually sensitive
biblical studies, and practical instruction consistent with the Doctrines of the Reformation.
The goal of Square Halo Books is to provide materials useful for encouraging
and equipping the saints.

WWW.SQUAREHALOBOOKS.COM

MoRE on CREATIVITY and FAITH

IT WAS GOOD: MAKING ART TO THE GLORY OF GOD [ISBN# 0-9658798-2-8] is a collection of thirteen essays—including articles by James Romaine, Makoto Fujimura, and Edward Knippers—covering a wide range of topics focused on the practice of making art from a Christian worldview.

"Each essay stands as a testament to someone who has charted the lonely course of living a life of faith while pursuing a life committed to the arts—in a culture that is often hostile towards the former and ambivalent about the latter. ... It Was Good is clearly useful for artists as well as those exploring and engaging in a long overdue dialogue about the arts and faith." —RE:GENERATION QUARTERLY

"This book is a valuable gift to the next generation of Christian artists It offers voices of experience and insight from godly artists who have dedicated their lives and talents to the arts." —SANDRA BOWDEN, *President of* CHRISTIANS IN THE VISUAL ARTS (CIVA)

"This book repays careful and attentive reading, and is particularly interesting because of the inclusion of practicing artists, and their diverse—and at times differing—viewpoints and understanding of creativity and faith. IT WAS GOOD is a useful book which will help us wake up and catch up." —THIRD WAY MAGAZINE

"We recommend IT WAS GOOD: MAKING ART TO THE GLORY OF GOD to you. It will help you think Christianly about art, stimulate you to be creative for God's glory, introduce you to some artists who are seeking to glorify God in their work, and . . . cause you to stop and worship the One whose glory is beautiful beyond all imagining." —CRITIQUE

Available through your local bookstores
290 Pages | 5.25" x 8.25" | Paperback | Color and B+W plates

ned BUSTARD
william EDGAR
makoto FUJIMURA
david GIARDINIERE
tim KELLER
edward KNIPPERS
charlie PEACOCK-ASHWORTH
theodore PRESCOTT
james ROMAINE
krystyna SANDERSON
steve SCOTT
gaylen STEWART
gregory WOLFE

IT was GOOD
MAKING ART
to the GLORY of GOD

FORWARD sandra BOWDEN
EDITOR ned BUSTARD